Edward Weston

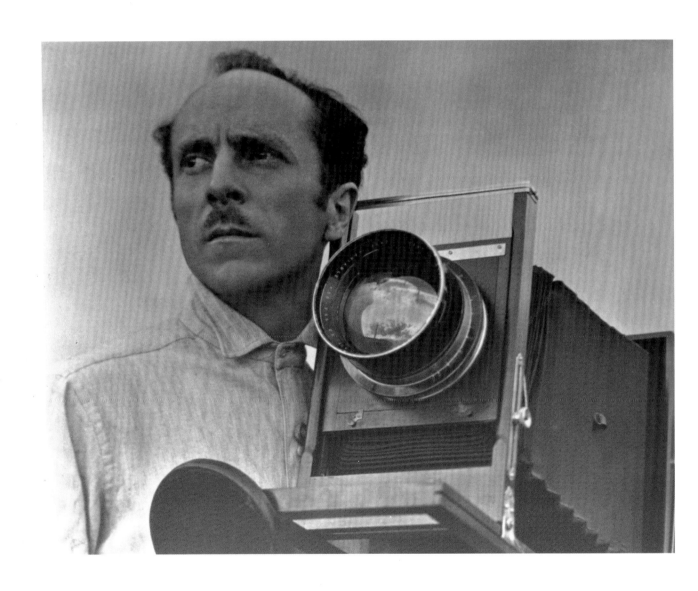

Edward Weston with Seneca View Camera
Edward Weston mit Seneca View Camera
Edward Weston avec Seneca View Camera
Photo: Tina Modotti 1924

Edward Weston

1886–1958

Essay by Terence Pitts
A personal portrait by Ansel Adams
Edited by Manfred Heiting

TASCHEN

KÖLN LONDON LOS ANGELES MADRID PARIS TOKYO

Acknowledgements

To edit a book of photographs by Edward Weston is a challenging but rewarding task. Challenging, because Weston produced an astounding body of work during his very productive period between 1918 and 1945, making any selection extremely subjective. Rewarding, since in putting together this overview of Weston's photography a team of motivated experts and enthusiasts has contributed valuable advice and support making this a highly edifying and worthwhile venture.

In particular I wish to thank Terence Pitts, former Director of The Center for Creative Photography, Tucson, Arizona – where the Weston archives are located – and Dianne Nilsen, Manager of Reproductions and Rights at the Center. I am also grateful to Maggi Weston of the Weston Gallery, Carmel, Denise Bethel of Sotheby's, New York, Jennifer Blakemore, Santa Fe, and Patrick Cooper, Amsterdam, for their contribution to this project. I also would like to thank the team at Benedikt Taschen Verlag, Cologne: Simone Philippi, Bettina Ruhrberg and Ute Kieseyer for their commitment and dedication to this volume of Edward Weston's photographs. Without their collaboration this publication could not have been produced.

Danksagung

Edward Westons Photographien in einem Buch vorzustellen, ist für den Herausgeber eine große Herausforderung, die jedoch reich belohnt wird. Eine große Herausforderung, weil Weston in seinen sehr produktiven Jahren von 1918 bis 1945 ein erstaunlich umfangreiches Œuvre geschaffen hat. Jede Auswahl aus diesem Werk muß deshalb höchst subjektiv bleiben. Hochmotivierte Experten und begeisterte Freunde seiner Kunst haben mit Rat und Tat das Ihre zu diesem Überblick über Westons Werk beigetragen, und die Zusammenarbeit mit diesen Menschen hat mich reichlich belohnt.

Mein Dank gilt insbesondere Terence Pitts, dem ehemaligen Direktor des Center for Creative Photography in Tucson, Arizona – der Heimat des Weston-Archivs –, und Dianne Nilsen, die dort für die Reproduktionsrechte zuständig ist. Außerdem danke ich Maggi Weston von der Weston Gallery, Carmel, Denise Bethel von Sotheby's, New York, Jennifer Blakemore, Santa Fe, und Patrick Cooper, Amsterdam, die alle ihren Beitrag zu diesem Projekt geleistet haben. Danken möchte ich auch Simone Philippi, Bettina Ruhrberg und Ute Kieseyer vom Benedikt Taschen Verlag in Köln, die sich engagiert für diese Publikation eingesetzt haben. Ohne die Mitarbeit aller dieser Menschen hätte dieses Buch nicht realisiert werden können.

Remerciements

Editer un livre des photographies d'Edward Weston est un défi mais aussi une récompense. Défi parce que dans ses années les plus productives, entre 1918 et 1945, le travail artistique de Weston a été d'une formidable abondance et que tout choix ne peut donc être qu'extrêmement subjectif. Récompense aussi dans la mesure où cet aperçu de l'œuvre de Weston a engagé une équipe de spécialistes motivés et enthousiastes qui m'ont éclairé de leurs conseils avisés et ont soutenu cette entreprise à la fois édifiante et gratifiante.

Je voudrais remercier notamment Terence Pitts, ancien directeur du Center for Creative Photography à Tucson, Arizona – où se trouvent les Archives Weston – et Dianne Nilsen, responsable des droits de reproduction. Je remercie également Maggi Weston de la Weston Gallery à Carmel, Denise Bethel de Sotheby's New York, Jennifer Blakemore à Santa Fe et Patrick Cooper à Amsterdam, pour leur contribution à ce projet. Je voudrais enfin exprimer ma reconnaissance à l'équipe des Éditions Taschen à Cologne, Simone Philippi, Bettina Ruhrberg et Ute Kieseyer, pour tout le soin mis dans ce livre sur Edward Weston. Sans leur collaboration à tous, cette publication n'aurait jamais vu le jour.

Manfred Heiting

Johan Hagemeyer and Edward Weston
Photo: Margrethe Mather, 1921

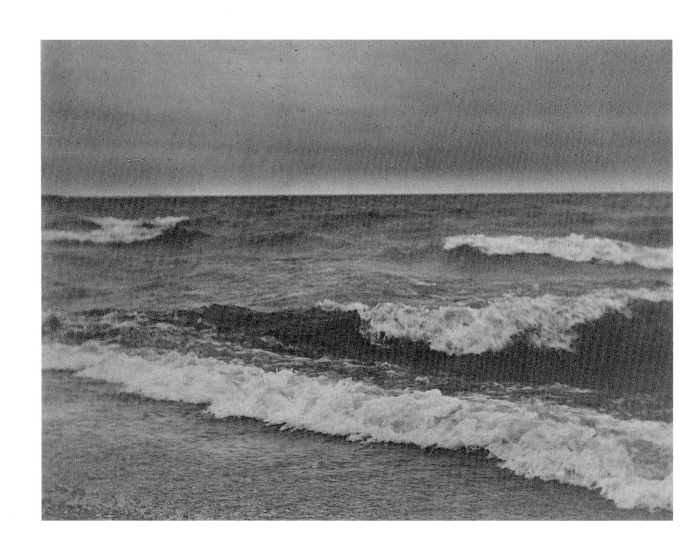

Lake Michigan. Chicago
1904

Contents
Inhalt
Sommaire

On Edward Weston

Excerpt from an article, published in "Infinity magazine" in February 1964.

Über Edward Weston

Auszug aus einem im Februar 1964 in der Zeitschrift »Infinity« veröffentlichten Artikel.

À propos d' Edward Weston

Extrait d'un article paru dans le magazine « Infinity » en février 1964.

Edward Weston, c. 1920
Attributed to Johan Hagemeyer
Johan Hagemeyer zugeschrieben
Attribué à Johan Hagemeyer

Edward understood thoughts and concepts which dwell on simple mystical levels. His own work - direct and honest as it is - leaped from a deep intuition and belief in forces beyond the real and the factual. He accepted these forces as completely real and part of the total world of man and nature, only a small portion of which most of us experience directly. As with any great artist, or imaginative scientist, the concept is immediate and clear, but the "working-out" takes time, effort, and conscious evaluations.

Edward Weston, contrary to so many now practicing photography, never verbalized on his own work. His work stood for him, as it does for most of us, as a complete statement of the man and his art. Edward suffers no sense of personal insecurity in his work; he required no support through "explanations", justifications, or interpretations. He was amused at the guff which was written and spoken about him, but he was nevertheless tolerant of the need of some people to struggle for the truth through complex involvements and slippery intellectual bogs. A frequent comment of his was "Well, if it means *that* to him it's all right with me."

I would prefer to join Edward in avoiding verbal or written definitions of creative work. Who can talk or write about the Bach *Partitas*? You just play them or listen to them. They exist only in the world of music. Likewise, Edward's photographs exist only as original prints, or as [sometimes] adequate reproductions. Look up his photographs, look at them carefully, then look at yourselves – not critically or with self-depreciation, or any sense of inferiority. You might discover, through Edward Weston's work, how basically good you are, or might become. This is the way Edward would want it to be.

Edward ging von Gedanken und Konzepten aus, die auf einfachen mystischen Ebenen angesiedelt sind. Sein eigenes Werk – direkt und ehrlich, wie es ist – entsprang einer tiefen Intuition und einem Glauben an Kräfte außerhalb des Wirklichen und des Faktischen. Er akzeptierte diese Kräfte als völlig reale Bestandteile der gesamten Welt des Menschen und der Natur, von der die meisten von uns nur einen kleinen Teil unmittelbar erfahren. Wie bei jedem großen Künstler oder phantasiereichen Wissenschaftler liegt das Konzept klar auf der Hand, doch die »Ausarbeitung« braucht Zeit, Mühe und bewußte Beurteilungen.

Anders als so viele heute tätige Photographen hat Edward Weston sich nie über sein eigenes Werk ausgelassen. Für ihn wie für die meisten von uns stellt sich sein Werk als eine umfassende Aussage des Menschen und seiner Kunst dar. Edward war sich in bezug auf seine künstlerische Arbeit völlig sicher; er bedurfte keiner Unterstützung durch »Erläuterungen«, Rechtfertigungen oder Interpretationen. Der Unsinn, der über ihn geschrieben und gesagt wurde, amüsierte ihn, und daß einige Leute das Bedürfnis hatten, durch komplexe Verwicklungen und glitschige intellektuelle Sümpfe zur »Wahrheit« vorzustoßen, tolerierte er. Häufig bemerkte er dazu: »Nun, wenn es *das* für ihn bedeutet, soll's mir recht sein.«

Wie Edward möchte auch ich lieber davon absehen, verbale oder schriftliche Definitionen kreativer Arbeit abzugeben. Wer kann über Bachs Partiten sprechen oder schreiben? Man spielt sie oder hört sie einfach. Sie existieren nur in der Welt der Musik. Und Edwards Photographien existieren nur als Originalabzüge oder [manchmal] als adäquate Reproduktionen. Nehmt seine Photographien zur Hand, betrachtet sie sorgfältig, und betrachtet dann euch selbst – nicht etwa kritisch oder mißbilligend oder geringschätzig. Vielleicht hilft euch Edward Westons Werk zu entdecken, wie gut ihr im Grunde seid oder werden könnt. Das wäre ganz in Edwards Sinn.

Les pensées etles concepts d'Edward se développaient sur des bases mystiques simples. Son œuvre personelle – directe et honnête s'il en est – jaillirsait à partir de ses intuitions profondes et de sa croyance en des forces sous jacentes au réel et au factuel. Pour lui, ces forces étaient totalement réelles et faisaient partie de l'univers global de l'homme et de la nature, dont la plupart d'entre nous n'expérimentons qu'une petite partie. Comme chez tout grand artiste ou scientifique imaginatif, le concept est immédiat et clair, mais la « mise en œuvre » prend du temps, réclame des efforts et des évaluations lucides.

Edward Weston, contrairement au grand nombre de ceux qui pratiquent aujourd'hui la photographie, n'a jamais verbalisé son œuvre. Pour lui comme pour la plupart d'entre nous, elle se contente d'être là, affirmation de l'homme et de son art. Edward ne connaissait pas le manque dans son travail; il n'avait pas besoin d'aide, « d'explications », de justifications ou d'interprétations. Il s'amusait des bêtises que l'on écrivait ou disait sur lui, mais n'en faisait pas moins preuve de tolérance envers ceux qui se battent pour la vérité au prix de démarches compliquées et d'embourbements intellectuels. Il disait souvent : « Si c'est ce qu'il comprend, cela ne me pose pas de problème. »

Je préférerais parler d'Edward en évitant de donner des définitions du travail créatif. Qui peut commenter, à l'oral ou à l'écrit, les partitas de Bach? Il suffit de les jouer ou de les écouter. Elles n'existent que dans le monde de la musique. De même, les photographies d'Edward ne vivent que sous forme d'épreuves originales ou [parfois] de bonnes reproductions. Regardez ces photos, regardez-les attentivement, puis regardez-vous vous-même, mais sans critique, ni modestie exagérée ni un quelconque sentiment d'infériorité. Vous pourriez bien découvrir, à travers l'œuvre d'Edward Weston, à quel point vous êtes fondamentalement bon, ou pourriez le devenir. C'est ce que souhaitait Edward.

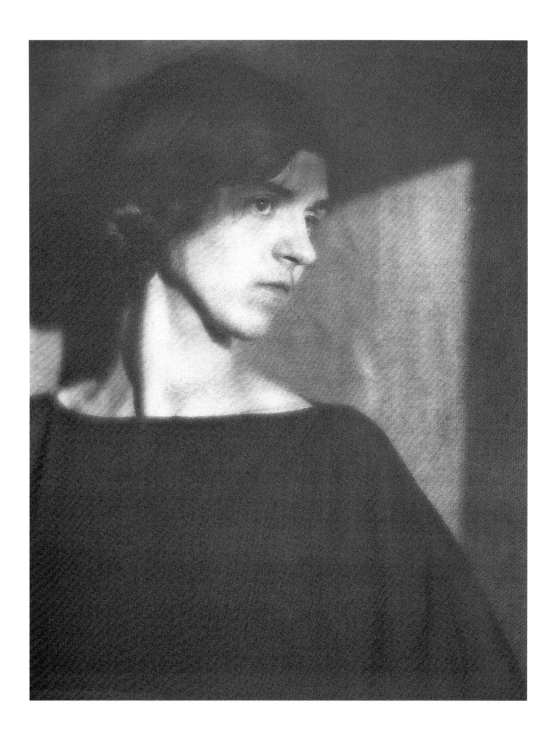

Type Antique
1918

Leo Ornstein
1918

Uncompromising Passion

The Life and Art of Edward Weston

Kompromißlose Leidenschaft

Leben und Werk Edward Westons

Une passion sans compromis

La vie et l'art d'Edward Weston

Terence Pitts

Born March 24, 1886, in the Chicago suburb of Highland Park, Illinois, Edward Weston was destined to become one of the most innovative and influential American photographers of the twentieth century. Through his photographs and his writings he helped create a modern vocabulary for photography, revolutionizing the way photographers could use subject matter, the technical and optical attributes of cameras and lenses, and the printing process.

Weston was also a key figure in the maturation of the art of photography. When he took it up shortly before World War I, most of the men and women who practiced photography considered themselves amateurs participating in an activity that functioned as an organized hobby. Only a handful of people, among them American Alfred Stieglitz, were arguing that photography should occupy a place among the fine arts of painting and sculpture. Through his own example, Weston helped establish the role and the image of a more pure photographer, one whose entire life was dedicated to his or her art.

Weston's father was a doctor. His mother died when he was five. Given his first camera in 1902, the teenaged Weston quickly discovered that photography was deeply satisfying, and he passionately began to make images. From the start, he showed great promise and originality as a photographer. The few surviving prints from his youth are carefully and sensitively composed landscapes depicting snow, trees, and the coast of nearby Lake Michigan.

Even though his formal education ended before high school, Weston knew that one day he would "be a leader," regardless of what path he might take. "I cannot believe I learned anything of value in school, unless it be the will to rebel," he later wrote.

Edward Weston wurde am 24. März 1886 in Highland Park, Illinois, einem Vorort von Chicago, geboren. Es war ihm bestimmt, einer der innovativsten und einflußreichsten amerikanischen Photographen des 20. Jahrhunderts zu werden. Mit seinen Photographien und seinen Schriften hat er nicht nur entscheidend zur Entstehung eines modernen ästhetischen und thematischen Vokabulars für die Photographie beigetragen, sondern auch in technischer Hinsicht Kameras, Linsen und Abzugsverfahren revolutioniert.

Weston war eine Schlüsselfigur im Reifungsprozeß der Kunst der Photographie. Als er sich kurz vor dem Ersten Weltkrieg der Photographie zuwandte, betrachteten die meisten sich selbst als Amateure und ihre Tätigkeit als ein Steckenpferd. Nur wenige Menschen, darunter der Amerikaner Alfred Stieglitz, traten dafür ein, die Photographie wie die Malerei und die Bildhauerei der bildenden Kunst zuzurechnen. Durch sein eigenes Beispiel trug Weston dazu bei, das Rollenbild des Photographen zu etablieren, der bewußt sein ganzes Leben seiner Kunst widmet.

Westons Vater war Arzt. Seine Mutter starb, als er fünf Jahre alt war. Als er 1902 seine erste Kamera bekam, entdeckte der 16jährige Weston schnell seine Leidenschaft für die Photographie. Von Anfang an zeigte er eine große Begabung und Originalität als Photograph. Die wenigen erhalten gebliebenen Abzüge aus seiner Jugend sind sorgfältig und einfühlsam komponierte Landschaftsaufnahmen, auf denen Schnee, Bäume und das Ufer des nahe gelegenen Lake Michigan zu sehen sind.

Weston wußte, daß er, welchen Weg er auch nähme, eines Tages eine führende Position innehaben würde, auch wenn er keinen High-School-Abschluß hatte. Später sollte er schreiben: »Wenn mir die Schule überhaupt etwas Wertvolles gebracht hat, dann war es der Wille zur Rebellion.«

1906, während einer kurzen Reise nach Südkalifornien zu seiner geliebten älteren Schwester Mary, lernte Weston Flora Chandler kennen und verliebte sich in sie. Entschlossen, seinen Lebensunterhalt als Photograph zu ver-

Né en mars 1886 à Highland Park, dans la banlieue de Chicago, Edward Weston deviendra l'un des photographes américains les plus influents et les plus novateurs du XX⁽ siècle. Ses photographies et ses écrits ont contribué à créer un vocabulaire photographique moderne, révolutionnant la manière dont on pouvait utiliser le sujet, la technique, l'optique et le processus de tirage.

Weston est par ailleurs l'une des figures clés de l'accession de l'art photographique à sa maturité. Lorsqu'il débute, peu avant la Première Guerre mondiale, la plupart des hommes et des femmes qui pratiquent alors cette activité se considèrent essentiellement comme des amateurs. Seule une poignée d'entre eux, comme l'Américain Alfred Stieglitz, se battent activement pour que la photographie prenne sa place parmi les arts reconnus. Par son exemple, Weston contribua à établir le rôle et l'image d'un pur photographe, celui dont la vie entière est consacrée à son art.

Le père de Weston est médecin; sa mère meurt alors qu'il est âgé de cinq ans seulement. Après avoir reçu son premier appareil photo en 1902, l'adolescent découvre vite que la photographie, la prise d'images, le passionnent. Dès le départ, il fait preuve d'un talent original et prometteur. Les rares tirages de sa jeunesse conservés sont des paysages composés avec soin et sensibilité représentant des scènes de neige, des arbres et la côte du lac Michigan tout proche. Bien qu'il ait mis fin à sa scolarité avant le collège, il sait qu'un jour il sera «un leader», quelle que soit la voie choisie. «Je ne peux pas croire que j'aie appris quoi que ce soit de valeur à l'école, si ce n'est la volonté de me rebeller» , écrira-t-il plus tard.

Au cours d'un bref voyage en Californie du Sud, en 1906, pour rendre visite à sa sœur aînée bien-aimée, Mary, il rencontre Flora Chandler dont il tombe amoureux. Déterminé à gagner sa vie comme photographe, il rentre en Illinois et suit les cours de l'Illinois College of Photography pendant six mois. Il retourne en Californie, épouse Flora en 1909 et trouve un emploi dans un

During a short trip to southern California in 1906 to visit his beloved older sister, Mary, Weston met and fell in love with Flora Chandler. Determined to be able to earn a living through photography, he returned to Illinois and attended the Illinois College of Photography. After completing the course in six months, he returned to California, married Flora in 1909, and found employment in a photographic studio. He and Flora settled in Tropico [now absorbed by Glendale], an eastern suburb of Los Angeles, and by 1911 Weston had set up a commercial portrait studio of his own.

As a studio photographer, Weston was successful at imitating and improving the popular styles of the day, creating atmospheric and idealized portraits for his clients. He had an affinity for composition and an ability to charm his sitters into natural and appealing poses. And he was also beginning to develop practices and preferences that would one day form the basis for a radical change in his photography. Weston recognized that one of photography's unique strengths was the camera's ability to capture a specific moment in time – a smile or the play of sunlight across a figure, for example. He also recognized the power of natural light: It could convey an emotional state that was in and of itself visually powerful, and it could effectively orchestrate a picture's entire composition.

Perhaps as early as 1912, Weston began seriously participating in the more professional world of photography. He wrote articles for publication, spoke at local camera clubs, and submitted photographs to the international competitions held by various photography associations. He won prizes and soon found an admiring audience for his well-crafted prints and for the reproductions of his work that appeared in photography journals.

suchen, kehrte er nach Illinois zurück und besuchte das Illinois College of Photography. Er schloß den Lehrgang nach sechs Monaten ab und kehrte nach Kalifornien zurück, wo er Beschäftigung im Studio eines Photographen fand und 1909 Flora heiratete. Er und Flora ließen sich in Tropico nieder, einem östlichen Vorort von Los Angeles, der heute zu Glendale gehört, wo er 1911 ein eigenes Porträtstudio eröffnete.

Weston war ein erfolgreicher Studiophotograph, der für seine Kunden atmosphärisch dichte und idealisierte Porträts im Stil jener Zeit schuf. Er besaß ein ausgeprägtes kompositorisches Talent und die Fähigkeit, seine Modelle in natürlichen und ansprechenden Posen reizvoll darzustellen. Und er begann in dieser Zeit auch, die Techniken und Vorlieben zu entwickeln, die später die Basis für einen radikalen Neubeginn in seiner Photographie bilden sollten. Weston erkannte in der Fähigkeit der Kamera, einen bestimmten Moment einzufangen – zum Beispiel ein Lächeln oder das Spiel des Sonnenlichts auf einer Gestalt –, eine der einzigartigen Stärken der Photographie. Er erkannte auch die Kraft des natürlichen Lichts: Es konnte einen emotionalen Zustand übertragen, der an sich visuell ausdrucksvoll war.

Vielleicht begann Weston schon 1912, ernsthaft an der professionelleren Welt der Photographie teilzuhaben. Er schrieb Artikel für Fachzeitschriften, hielt Vorträge in örtlichen »Camera Clubs« und reichte Photographien zu internationalen Wettbewerben ein. Er wurde mit Preisen ausgezeichnet und fand bald ein Publikum voller Bewunderung für seine meisterhaften Abzüge und für die Reproduktionen seiner Arbeiten in Photographiezeitschriften. Internationale Ausstellungen – »Salons«, wie sie gewöhnlich genannt wurden – boten den Photographen Absatzmöglichkeiten für ihre Werke und trugen, wenn auch nur bescheiden, dazu bei, den Status der Photographie als Kunstform zu etablieren. Der vorherrschende photographische Stil der letzten Jahrzehnte des 19. und der ersten des 20. Jahrhunderts war der »Piktorialismus«, der seine Wurzeln unter anderem im Symbolismus und Ästhetizismus

atelier de photographie. Le couple s'installe à Tropico – aujourd'hui absorbé par Glendale –, une banlieue de l'est de Los Angeles et, en 1911, ouvre son propre studio de portraitiste.

Photographe de studio, Weston réussit brillamment à imiter – et à améliorer – les styles alors à la mode. Il crée des portraits idéalisés et pleins d'atmosphère. Il a le sens de la composition et sait charmer ses modèles qu'il amène à prendre des poses naturelles et séduisantes. Mais il commence dans le même temps à mettre au point des techniques qui vont bientôt entraîner un changement radical de sa pratique. Il est conscient que l'un des atouts de la photographie est de pouvoir capter un moment précis, par exemple un sourire ou le jeu de la lumière du soleil sur un visage. Il constate également le pouvoir de la lumière naturelle qui peut non seulement véhiculer des impressions et des émotions, mais également harmoniser la totalité de la composition d'une image. Dès 1912 sans doute, il commence à participer sérieusement au monde professionnel de la photographie. Il rédige des articles pour des publications, prend la parole dans des clubs locaux et envoie des tirages dans les concours internationaux organisés par diverses associations. Il remporte des prix et s'attache bientôt un public qui admire la qualité de ses tirages et les reproductions de ses travaux publiés par des journaux spécialisés.

Les Expositions internationales – ou Salons, comme elles sont alors appelées – offrent aux photographes l'occasion de faire connaître leur œuvre et d'élever le statut de la photographie à celui d'un art, même s'il est encore modeste. Le style photographique dominant les dernières décennies du XIXe siècle et les premières du XXe siècle est le pictorialisme, qui tire ses racines esthétiques de mouvements divers comme le symbolisme et l'esthétisme [l'art pour l'art] ou le mouvement plus contemporain des Arts and Crafts. Face à la critique qui fait remarquer qu'une photographie n'est guère plus qu'une reproduction mécanique de la nature, les pictorialistes se

International exhibitions – or salons, as they were usually called – provided photographers with outlets for their work and helped elevate photography's status as an art form, even if modestly. The dominant photographic style of the final decades of the nineteenth century and the first decades of the twentieth century was called pictorialism, which had its stylistic roots in everything from symbolism and aestheticism [art for art's sake] to the more contemporary Art and Crafts movement.

To overcome the criticism that photography was little more than a mechanical reproduction of nature, pictorialists had to constantly remind the viewer that the mind and hand of an artist were behind the photograph. To accomplish this, they deliberately obscured the technological, lens-based origins of their work in the photograph. Images were rendered in soft focus and were printed in a manner that required considerable manipulation by the photographer during darkroom processes.

During the ten years or so in which Weston produced pictorialist-style photographs [roughly 1912 through 1922], he made many masterful images that show him not only excelling in the idiom of pictorialism but starting to redefine it in his own terms. Most of his photographs from this time are either portraits or genre images in which his friends serve as actors. Using the simple ingredients of light and shadow, texture, and a few props, such as a flower, a fan, a mirror, or a chair, Weston created suggestive images that are believable and original, not artificial or formulaic.

Starting around 1919, he occasionally made compositions that were almost cubist in their angularity; critics at the time complained about such works: "queerness for its own sake," one writer said. Some of his images of nudes pushed pictorialism's genteel boundaries toward an arena of almost-palpable eroticism. Although he

[L'art pour l'art] wie auch in der zeitlich näheren »Arts and Crafts«-Bewegung hatte. Um der Kritik zu begegnen, die Photographie bringe kaum mehr als eine mechanische Reproduktion der Realität hervor, mußten die Piktorialisten dem Betrachter ständig ins Gedächtnis rufen, daß hinter der Photographie das Bewußtsein und die Hand eines Künstlers standen. Deshalb verschleierten sie bewußt die technologischen, »photographischen« Ursprünge ihrer Werke. Die Bilder wurden mit einer Weichzeichnerlinse aufgenommen und vom Photographen in der Dunkelkammer bearbeitet und beträchtlich retuschiert.

In den etwa zehn Jahren, in denen Weston Photographien im piktorialistischen Stil schuf, ungefähr von 1912 bis 1922, gelangen ihm viele meisterhafte Bilder, mit denen er zeigte, daß er das Idiom des Piktorialismus nicht nur perfekt beherrschte, sondern auch eigenständig neu zu definieren begann. Die meisten seiner Photographien aus dieser Zeit sind entweder Porträts oder Genrebilder, in denen seine Freunde als Schauspieler agierten. Mit Hilfe einfacher Mittel wie Licht, Schatten, Textur und einigen wenigen Requisiten wie einer Blume, einem Fächer, einem Spiegel oder einem Stuhl schuf Weston suggestive, glaubhafte und originelle Bilder, denen nichts Gekünsteltes oder Formelhaftes anhaftet. Seit etwa 1919 schuf er gelegentlich Kompositionen, die in ihrer Eckigkeit fast kubistisch waren und damals bei den Kritikern auf Unverständnis stießen: »Merkwürdigkeit um ihrer selbst willen«, wie einer schrieb. In einigen seiner Aktaufnahmen rückte er über die geschmackvollen Grenzen des Piktorialismus in einen Bereich fast greifbarer Erotik vor. Doch obwohl er begonnen hatte, seine Photographie aus den traditionsgebundenen Beschränkungen des Piktorialismus zu befreien, hatte er noch nicht den Weg gefunden, der zu einem völligen Bruch führen sollte.

In diesen Jahren bekamen Edward und Flora Weston vier Söhne: Chandler [1910-1993], Brett [1911-1995], Neil [1914-1998] und Cole [geb. 1919]. Weston begann auch enge Freundschaften mit einigen Künstlern der

doivent de rappeler constamment au spectateur que derrière l'appareil photo se trouvent l'œil et l'esprit d'un artiste. C'est dans ce but qu'ils masquent délibérément l'origine technique de leur travail. Les images sont légèrement floues et tirées d'une manière qui exige de multiples manipulations en chambre noire.

Au cours des dix années environ pendant lesquelles Weston réalise des photographies pictorialistes [de 1912 à 1922], il produit de superbes images qui montrent que non seulement il maîtrise ce style mais commence à le redéfinir selon ses propres termes. La plupart des photos qu'il prend à cette époque sont des portraits ou des images de genre, pour lesquels ses amis servent de modèles. A partir d'éléments simples comme la lumière, l'ombre et la texture, et de quelques décors comme une fleur, un éventail, un miroir ou un siège, il crée des images suggestives, crédibles et originales, qui ne sont ni artificielles ni la simple application d'une formule. A partir de 1919 environ, certaines compositions sont presque cubistes dans leur approche anguleuse, mais les critiques de l'époque ne les apprécient guère : «Etrangeté pour le plaisir» , commente un journaliste. Certains de ses nus commencent à dépasser les limites bienséantes du pictorialisme pour aller vers des images d'un érotisme presque palpable. Weston a donc commencé à libérer sa photographie des limites du pictorialisme dictées par la tradition, mais doit encore trouver la voie vers une rupture complète.

Au cours de cette période, Edward et Flora Weston auront quatre fils : Chandler [1910-1993], Brett [1911-1995], Neil [1914-1998] et Cole [né en 1919]. Weston se lie d'amitié avec quelques artistes de la bohème de Los Angeles, qui est alors une ville provinciale, presque répressive, bien éloignée de la capitale artistique de l'Amérique, New York. Les villes européennes où les grands mouvements d'art moderne voient le jour, comme Paris, Londres, Berlin et Moscou, sont encore plus lointaines. Avides d'expériences nouvelles et d'une meilleure connaissance des différentes formes artistiques,

had begun to free his photographs from the tradition-bound limitations of pictorialism, he had yet to find the path that would lead to a complete break.

During this time, Edward and Flora Weston had four sons: Chandler [1910-1993], Brett [1911-1995], Neil [1914-1998], and Cole [born 1919]. Weston also began to develop close friendships with some of the more bohemian artists in Los Angeles, which was then a provincial, almost repressive town that seemed a long way from America's artistic capital, New York City. Even more remote were London, Paris, Berlin, and Moscow, the European cities where the first modern art movements of the twentieth century were being born. Eager for new experiences and a wider knowledge of the arts elsewhere, Weston and his friends attended music concerts and dance recitals, visited exhibitions, and read and discussed magazines and books on contemporary art and literature. They explored the Los Angeles area, looking for adventure. They spent the day at the beach [which could be reached by railway] or prowled the harbor and the sailor's bars, thrilled, if a little scared by the fights of drunks.

One of the most influential people in Weston's life at this time was Margrethe Mather, a photographer whom Weston met around 1912. Until 1921, Weston and Mather shared an artistic relationship and probably an intimate one as well. She shared Weston's studio at times, and together they submitted prints to photographic salons around the world. Mather, a free spirit with a shadowy past as a teenaged prostitute, introduced Weston to a side of Los Angeles that was bohemian, homosexual, and interested in art and design. Her personal taste, typified by her sparse Japanese-inspired house in downtown Los Angeles, can be seen in many of Weston's pictorialist compositions.

»Boheme« von Los Angeles zu schließen, damals eine provinzielle Stadt mit einer fast repressiven Atmosphäre. New York City, das künstlerische Zentrum Amerikas, war nicht nur in geographischer Hinsicht weit entfernt, und London, Paris, Berlin und Moskau, die europäischen Städte, in denen sich die Kunstavantgarden des 20. Jahrhunderts entwickelten, schienen schier unerreichbar zu sein. Begierig nach neuen Erfahrungen und einem breiteren Wissen um das, was andernorts im Bereich der Kunst geschah, besuchten Weston und seine Freunde Konzerte, Tanzveranstaltungen und Ausstellungen, sie lasen und diskutierten über Zeitschriften und Bücher über zeitgenössische Kunst und Literatur. Auf der Suche nach Abenteuern zogen sie durch die Umgebung von Los Angeles. Sie verbrachten den Tag am Strand oder trieben sich – als faszinierte Augenzeugen mancher Schlägereien unter Betrunkenen – im Hafen und in den Matrosenbars herum.

Eine der einflußreichsten Personen in Westons Leben war damals Margrethe Mather, eine Photographin, die er um 1912 kennengelernt hatte. Bis 1921 verband Weston und Mather eine künstlerische und wahrscheinlich auch eine intime Beziehung. Er teilte manchmal mit ihr sein Studio, und sie reichten zusammen Abzüge bei photographischen Salons in aller Welt ein. Mather, ein Freigeist mit einer dunklen Vergangenheit [als Teenager war sie der Prostitution nachgegangen], führte Weston in die unkonventionellen, homosexuellen und an Kunst und Design interessierten Kreise in Los Angeles ein. Ihr persönlicher Geschmack – verkörpert in ihrem schlichten »japanischen« Haus in Downtown Los Angeles – tritt in vielen piktorialistischen Kompositionen Westons in Erscheinung.

Als er ein Jahrzehnt später auf diese stürmischen und befreienden frühen 20er Jahre zurückblickte, beschrieb Weston sich selbst als einen unerfahrenen jungen Mann in der Gesellschaft von Leuten, die »belesen, weltklug und geistreiche Gesprächspartner« waren. Sein neuer Freundeskreis konnte Lieder der radikalen Arbeiterbewegung singen und die Thesen der

Weston et ses amis assistent à des concerts, à des ballets, visitent des expositions, lisent et discutent de livres, de magazines d'art et de littérature contemporains. Ils explorent la région de Los Angeles, à la recherche d'aventures. Ils peuvent passer des journées entières à la plage – où ils se rendent en train –, à traîner dans le port et les bars de marins, fascinés mais un peu effrayés, par les batailles d'ivrognes. Une des personnes qui a le plus d'influence dans la vie de Weston à cette époque est Margrethe Mather, une photographe rencontrée vers 1912. Jusqu'en 1921, Weston et Mather vivront une relation artistique et probablement intime. Elle travaille quelquefois dans le studio de Weston et ils soumettent ensemble des épreuves aux Salons de photographie du monde entier. Mather, un esprit libre au lourd passé d'adolescente prostituée fait connaître à Weston un aspect nouveau de Los Angeles, la bohème, les homosexuels s'intéressant à l'art et au design. De nombreuses compositions pictorialistes de Weston reflètent son goût personnel, caractérisé par sa sobre maison d'inspiration japonaise située au centre de Los Angeles.

Dix ans plus tard, en se remémorant ces années 20 libératrices et troublantes, Weston se décrit comme un jeune homme sans expérience mêlé à des gens qui sont « cultivés, connaissent le monde, discutent intelligemment ». Ses nouveaux amis « pouvaient entonner les chants de l'Internationale, citer l'anarchiste Emma Goldman sur l'amour libre ». Ils lui apprennent à boire, à fumer et à séduire. Mais plus important encore, ils l'aident à donner corps à son désir profond d'être un artiste photographe et non un petit commerçant ayant un studio de portraits.

Bien que sa réputation de photographe pictorialiste soit déjà internationalement reconnue et qu'il appartienne à certaines des plus prestigieuses sociétés de photographie, Weston se rend compte de plus en plus qu'il doit transformer à la fois le contenu et le style de ses photos, et accepter les propriétés mécaniques de l'appareil et des objectifs comme une force non comme une

Looking back on the heady and liberating early 1920s from the perspective of a decade later, Weston described himself as an inexperienced young man who found himself involved with people who were "well-read, worldly wise, clever in conversation." His new set of friends "could sing iww [International Workers of the World] songs, quote Emma Goldman on free love." They taught him to drink, smoke, and have affairs. More importantly, however, they helped him confirm his inner desire to be a photographic artist and not a small businessman operating a portrait studio.

Although Weston had already gained international recognition as an important pictorial photographer and had been made a member of several prestigious photographic societies, it gradually became clear to him that he must change both the content and the style of his photographs to accept the mechanical properties of the camera and lens as the strengths – not the weaknesses – of photography. For him photography had become a process of seeing the real world rather than creating an imaginative world.

In 1922, Weston decided to visit his sister, who had moved to Ohio, and to try to see Alfred Stieglitz in New York. Weston felt that a pilgrimage to see Stieglitz, the great photographer, gallery owner, and tastemaker of American modernism, was a necessary step in his artistic development. While staying at his sister's house in the industrial heartland of Ohio, Weston visited and made several photographs of the nearby Armco Steel mill.

These photographs [he probably made no more than a half-dozen different negatives] represent the pivotal point that he had been edging toward for years. They were unlike any he had made before. The subject matter was industrial and thoroughly modern. Weston let the powerful verticals of the smokestacks and buildings, the sweeping curves of the pipes, and the delicate lines of the telephone wires guide his compositions. The harsh

Anarchistin Emma Goldman über die freie Liebe zitieren. Sie lehrten ihn zu trinken, zu rauchen und Liebesaffären zu haben. Vor allem jedoch bestärkten sie ihn in seinem inneren Wunsch, als Photograph ein Künstler zu sein, kein kleiner Geschäftsmann, der ein Porträtstudio betrieb.

Obwohl Weston bereits internationale Anerkennung als ein wichtiger piktorialistischer Photograph erlangt hatte und in verschiedene angesehene photographische Gesellschaften aufgenommen worden war, wurde ihm immer bewußter, daß er sowohl die Thematik als auch den Stil seiner Photographie ändern, daß er die mechanischen Eigenschaften der Kamera und der Linse als die Stärken – nicht die Schwäche – der Photographie akzeptieren mußte. Für ihn war die Photographie zu einem Prozeß geworden, in dem es nicht darum ging, eine imaginative Welt hervorzubringen, sondern darum, die Welt, wie sie wirklich war, zu sehen.

1922 beschloß Weston, seine Schwester zu besuchen, die nach Ohio gezogen war, und sich um eine Begegnung mit Alfred Stieglitz in New York zu bemühen. Eine Pilgerfahrt zu Stieglitz, dem großen Photographen, Galeristen und Wegbereiter der amerikanischen Moderne, war für ihn ein unabdingbarer Schritt in seiner künstlerischen Entwicklung. Während er sich im Haus seiner Schwester im industriellen Kernland Ohios aufhielt, photographierte Weston mehrmals das nahe gelegene Armco-Stahlwerk. Diese Photographien stellen den entscheidenden Wendepunkt dar, auf den er sich seit Jahren zubewegt hatte. Sie unterschieden sich in jeder Hinsicht von seinem früheren Schaffen. Die industrielle Thematik war ganz und gar modern. Die ausdrucksvollen Vertikalen der Schornsteine und Gebäude, die schwungvollen Biegungen der Rohre und die zarten Linien der Telefonleitungen bestimmten Westons Kompositionen. Die schroffe und kantige Massivität des Stahlwerks und die zarten Linien der Drähte vor dem Hintergrund des Himmels sind so gegeneinander gesetzt, daß die moderne Technologie und Nutzarchitektur in ihrem tiefsten Wesen erfaßt werden.

faiblesse. Pour lui, la photographie devient un procédé pour voir le monde réel plutôt que pour créer un monde imaginaire.

En 1922, il décide de rendre visite à sa sœur qui s'est installée dans l'Ohio, et tente de rencontrer Alfred Stieglitz à New York. Il sent qu'un pèlerinage auprès du grand photographe, galeriste et maître à penser du modernisme américain, est une étape nécessaire dans son évolution artistique. Pendant son séjour chez sa sœur dans la région industrielle de l'Ohio, il visite les aciéries d'Armco Steel dont il prend plusieurs photographies. Ces photos – il n'a sans doute pas réalisé plus d'une demi-douzaine de négatifs – représentent un tournant vers lequel il s'avançait depuis des années. Elles ne ressemblent à rien de ce qu'il a fait jusque-là. Le sujet est industriel et profondément moderne. Il laisse les puissantes verticales des cheminées et des bâtiments, les courbes amples des tuyaux et les lignes délicates des fils téléphoniques guider ses compositions. La massivité angulaire et rigide de l'usine et la finesse des câbles qui se détachent sur le fond du ciel s'opposent en captant intuitivement l'essence de la technologie moderne et de l'architecture utilitaire.

Juste avant d'entreprendre ce voyage à l'Est, Weston écrit dans ses *daybooks* – son journal – que l'artiste doit réagir à « l'architecture de l'époque – bonne ou mauvaise – et la montrer d'une manière inédite et fascinante ». On ne sait pas très bien comment il en est arrivé à cette conclusion, mais elle prouve que lorsqu'il traverse les Etats-Unis en 1922, comme beaucoup d'autres artistes américains, il est délibérément à la recherche du moyen qui fera des gratte-ciel qui s'élèvent un peu partout et de l'économie industrielle le sujet de son art. Peintres, graveurs, sculpteurs et photographes commencent alors à faire de la fonctionnalité des machines un style que l'on appellera le précisionnisme.

Fidèle à l'adage qu'il aime tant – la forme suit la fonction – Weston prend également conscience que le sujet moderne requiert des méthodes de représentation différentes. En tant que forme artistique [comme le cinéma]

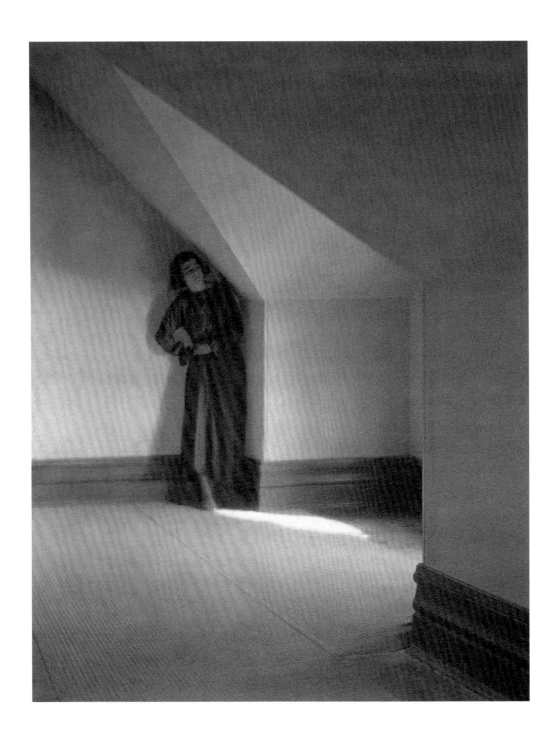

Betty in her Attic
Betty in ihrer Mansarde
Betty dans sa chambre mansardée
1920

and angular massiveness of the mill and the delicate lines of the wires against the sky play off each other in a way that captures the essence of modern technology and utilitarian architecture. Just before beginning his trip back East, Weston had written in his daybooks – as he called his journals – that the artist must respond to "the architecture of the age, good or bad – showing it in new and fascinating ways." Exactly how he came to this conclusion we do not know, but it demonstrates that, as he crossed the United States in 1922, Weston – like a number of other American artists – was searching for an opportunity to turn the new architecture of America's booming sky-scraper and industrial economy into subject matter for art. Painters, printmakers, sculptors, and photographers were beginning to transform the functionality of the machine into a formal aesthetic now called precisionism.

True to the adage that he loved so much, "form follows function," Weston also realized that modern sub-ject matter required different methods of depiction. And, as an art form [along with cinematography] that actual-ly took advantage of a machine, the traditional concept of what constituted an acceptable photograph had to be completely rethought. For Weston, the change seemed to come naturally and instantly. He decided that photo-graphs of steel mills and telephone wires required a level of specificity not sanctioned by pictorialism. In the Armco photographs, the details are crisp and clear, the implication being that clarity equals truth. Almost overnight, Weston had become a modernist.

In New York, Weston visited museums [where he noted that contemporary artists Pablo Picasso, Con-stantin Brancusi, and Henri Matisse, whose work he had admired through reproductions, were poorly represent-ed] and met numerous artists, including Gertrude Käsebier, Charles Sheeler, Clarence H. White, Paul Strand, and Georgia O'Keeffe. Weston's meeting with Stieglitz made him ecstatic. Stieglitz' criticism of Weston's prints, a

Unmittelbar vor seiner Reise in den Osten der Vereinigten Staaten hatte Weston in seinen »daybooks« – so nannte er seine Tagebücher notiert, der Künstler müsse auf »die Architektur seiner Zeit, sei sie gut oder schlecht« reagieren, sie »auf eine neue und faszinierende Weise zeigen«. Wir wissen nicht genau, wie er zu dieser Schlußfolgerung kam, doch sie zeigt, daß Weston, als er 1922 die Vereinigten Staaten durchquerte, wie viele andere amerikanische Künstler nach einer Möglichkeit suchte, die neuen amerikanischen Architekturformen der überall aus dem Boden schießenden Wolkenkratzer und Industrieanlagen zu einem Thema der Kunst zu machen. Maler, Graphiker, Bildhauer und Photographen begannen in dieser Zeit, die Funktionalität der Maschine in eine formale Ästhetik umzuwandeln, die heute als »Präzisionismus« bekannt ist. Getreu dem Wahlspruch, den er so sehr liebte, »form follows function« hatte Weston auch erkannt, daß moderne Themen neuer Darstellungsmethoden bedürfen. Und da die Photographie eine Kunstform war, die [wie die Kinematographie] sich tatsächlich techni-sche Mittel zunutze machte, mußte die herkömmliche Konzeption von einer künstlerisch akzeptablen Photographie vollständig überdacht werden. Weston scheint unvermittelt und wie selbstverständlich auf seine neue Konzeption gekommen zu sein. Er kam zu dem Schluß, daß Photographien von Stahlwerken und Telefondrähten eines vom Piktorialismus nicht sanktionierten Präzisionsgrades bedurften. In den Armco-Photographien sind die Details scharf und deutlich zu sehen. Damit wird impliziert, daß Klarheit mit Wahrheit gleichzusetzen ist. Fast über Nacht war Weston ein Modernist geworden.

In New York besuchte Weston Museen [wo er vergeblich nach Arbeiten der zeitgenössischen Künstler Pablo Picasso, Constantin Brancusi und Henri Matisse suchte, die er bewunderte] und begegnete zahlreichen Künstlern wie Gertrude Käsebier, Charles Sheeler, Clarence H. White, Paul Strand und Georgia O'Keeffe. Seine Begegnung mit Stieglitz stimmte ihn euphorisch.

profitant d'une mécanique, la conception traditionnelle de ce qui constituait jusqu'alors une photographie acceptable doit être totalement repensée. Pour lui, le changement semblait venir naturellement et instantanément. Il décida que les photographies d'aciéries et de fils téléphoniques exigeaient une spéci-ficité qui ne pouvait se retrouver dans le pictorialisme. Dans les tirages Armco, les détails sont nets et précis, ce qui implique que la clarté équivaut à la vérité. Presque du jour au lendemain, Weston était devenu un moderniste. A New York, il visite des musées – où il note l'absence des artistes contem-porains qu'il a admirés en reproductions, en particulier Pablo Picasso, Constantin Brancusi et Henri Matisse – et rencontre de nombreux artistes dont Gertrude Käsebier, Charles Scheeler, Clarence H. White, Paul Strand et Georgia O'Keeffe. Ses contacts avec Stieglitz le ravissent. La critique que celui-ci fait de ses images – mélange de louange et de beaucoup de sévérité pour l'exécution bâclée et la faiblesse de conception – ne fait que confirmer à Weston qu'il est sur la bonne voie. La rencontre avec ce maître inflexible et égotiste lui confirme que l'art peut constituer la base – serait même la base morale – de l'être. Weston semble presque prendre plaisir à voir Stieglitz « mettre en pièces » le portfolio d'épreuves qu'il lui présente. « Au lieu de me détruire ou de m'enlever mes illusions, il m'a rendu plus confiant et plus sûr de moi, et m'a donné une compréhension plus fine de mon médium », écrit-il à son ami Johan Hagemeyer.

Les images de l'Amérique industrielle le placent parmi le très petit nombre de photographes partis pour révolutionner la photographie : entre leurs mains, elle devient un outil d'observation et d'exploration. A son retour en Californie, Weston s'active et décide de tout miser sur son avenir de photographe. En août 1923, en compagnie de son fils aîné Chandler et de sa nouvelle compagne Tina Modotti, il s'embarque pour le Mexique.

Modotti, rencontrée en 1921, est une immigrée italienne qui a joué dans plusieurs films muets à Hollywood. En 1922, elle se rend à Mexico au chevet

mixture of some praise and much condemnation for sloppy execution and failure of conception, seemed to confirm to Weston that he was headed in the right direction. His encounter with the uncompromising, egotistical Stieglitz assured him that art could be the core, if not the moral core, of one's being. Weston seemed delighted as Stieglitz verbally tore into the flaws he saw in the portfolio of prints that Weston showed him. "Instead of destroying or disillusioning me he has given me more confidence and sureness – and finer aesthetic understanding of my medium," he wrote his friend Johan Hagemeyer.

The images he had just made of industrial America had placed him among a very small number of photographers who were in the midst of revolutionizing photography, which would become a tool for seeing and exploring form. His return to California clearly left him restless and willing to gamble everything on his future as a photographer. So, in August 1923, with his oldest son Chandler in tow, Weston and his new lover, Tina Modotti, embarked for Mexico by boat.

Modotti, whom he had met around 1921, was an Italian immigrant who had acted in several silent movies in Hollywood. In 1922, when she traveled to Mexico City to be with her dying husband, she had taken some of Weston's photographs and had succeeded in getting them exhibited at the Academia de Bellas Artes. The public response surpassed anything that had ever happened to him in the United States.

While most American artists had relocated to Europe for their expatriate experience, Weston was one of the first Americans to head for Mexico. For artists and writers such as Paul Strand, Marsden Hartley, Henrietta Shore, Hart Crane, Wallace Stevens, and others, Mexico proved to be artistically regenerating and exciting. Revolutionary fervor had given the artist in Mexico a central place in society. For a brief period during the 1920s and

Durch Stieglitz' Kritik an seinen Abzügen – eine Mischung aus etwas Lob und manchem Tadel an der nachlässigen Ausführung und der fehlenden Konzeption – sah Weston sich offenbar darin bestätigt, die richtige Richtung eingeschlagen zu haben. Das Zusammentreffen mit dem kompromißlosen, ichbezogenen Stieglitz bestärkte ihn darin, daß die Kunst den Kern, wenn nicht den moralischen Kern des menschlichen Daseins ausmachen konnte. Weston schien entzückt zu sein, als Stieglitz verbal über die Mängel herfiel, die er in Westons Photographien sah. »Statt mich zu Boden zu werfen oder mich zu desillusionieren, hat er mir mehr Selbstvertrauen und Sicherheit gegeben – und ein besseres ästhetisches Verständnis meines Mediums«, schrieb er seinem Freund Johan Hagemeyer. Die Bilder, die er soeben vom industriellen Amerika aufgenommen hatte, plazierten ihn unter die sehr kleine Zahl von Photographen, die in dieser Zeit die Photographie revolutionierten und zu einem Instrument der Wahrnehmung und Erkundung der Form machten. Im August 1923 schiffte er sich zusammen mit seinem Sohn Chandler und seiner neuen Geliebten Tina Modotti nach Mexiko ein. Modotti, die er um 1921 kennengelernt hatte, war aus Italien eingewandert und in Hollywood in mehreren Stummfilmen aufgetreten. Als sie 1922 nach Mexiko-Stadt gereist war, um bei ihrem im Sterben liegenden Mann zu sein, hatte sie einige von Westons Photographien mitgenommen, und es war ihr gelungen, sie in der Academia de Bellas Artes ausstellen zu lassen. Die Reaktion des Publikums übertraf alles, was Weston je in den Vereinigten Staaten erlebt hatte.

Während die meisten amerikanischen Künstler ihre Auslandserfahrungen in Europa machten, gehörte Weston zu den ersten Amerikanern, die es nach Mexiko zog. Für Künstler und Schriftsteller wie Paul Strand, Marsden Hartley, Henrietta Shore, Hart Crane oder Wallace Stevens erwies sich Mexiko als eine künstlerisch erneuernde und aufregende Erfahrung. Der revolutionäre Eifer hatte den Künstlern in Mexiko eine zentrale Stellung in

de son mari mourant et emporte quelques photographies de Weston qu'elle réussit à faire exposer à l'Academia de Bellas Artes. L'accueil du public dépasse tout ce qu'il a pu connaître aux Etats-Unis.

Alors que la plupart des artistes américains se rendent en Europe pour compléter leur expérience, Weston est l'un des premiers à prendre la route du Mexique. Pour des artistes et des écrivains comme Paul Strand, Marsden Hartley, Henrietta Shore, Harte Crane, Wallace Stevens et d'autres, ce pays est à la fois un lieu de régénération et de stimulation. La ferveur révolutionnaire qui prévaut à cette époque confère à l'artiste une place centrale dans la société mexicaine. Pour une brève période, pendant les années 20 et 30, le créateur a l'impression de produire pour un public capable d'apprécier. A un autre niveau, le Mexique révolutionnaire est à la fois libérateur et terriblement dangereux. La première nuit que Weston passe à Mexico est marquée par un échange de coups de feu sous sa fenêtre. « Je ne suis pas venu ici pour retrouver le calme bien rangé de Glendale », note-t-il.

Weston et Modotti rejoignent rapidement l'entourage de peintres et écrivains révolutionnaires comme Diego Rivera, Rafael Sala, Jean Charlot. Modotti pose pour Rivera et quelques autres artistes, et prend elle-même des photographies. Pour Weston, le Mexique est une révélation à de nombreux égards. Dans son journal, il décrit la vie des rues dans la capitale comme « un brillant chatoiement de contrastes extrêmes… vital, intense, noir et blanc, jamais gris ». Par contraste, Glendale et la Californie lui semblent maintenant « ternes, sans esprit, d'un gris uniforme – peuplés d'exploiteurs qui ont violenté un pays de rêve ».

Pour gagner sa vie, Weston fait la seule chose qu'il maîtrise : il ouvre immédiatement un studio de portraits. Mais Mexico se révèle aussi plus riche de collectionneurs – beaucoup sont américains ou étrangers – que la Californie, et il réussit à vendre quelques tirages qui lui permettent de régler ses dettes à maintes occasions. Outre ses portraits de commande, il réalise également

1930s, an artist could feel that he or she was producing art for an appreciative audience. On another level, revolutionary Mexico was also liberating and appealingly dangerous. Weston's first night in Mexico City was marked by gunfire beneath his bedroom window. "I did not come here for the ordered calm of a Glendale," he noted.

Weston and Modotti quickly became part of the artistic circle of revolutionary writers and painters centered around Diego Rivera, Rafael Sala and Jean Charlot. Modotti modeled for Rivera among others and took up photography herself. For Weston, Mexico was a revelation in many ways. In his daybooks he described street life in Mexico as "sharp clashes of contrasting extremes … vital, intense, black and white, never gray." By contrast, Glendale, California now seemed "drab, spiritless, a uniform grey – peopled by exploiters who have raped a fair land."

To earn a living for the three of them, Weston did the only thing he knew: he immediately opened a portrait studio. But Mexico proved to have more collectors than California – many of them Americans and other foreigners – and on more than one occasion, the sale of a few prints pulled him out of debt.

In addition to commissioned portraits, Weston found himself making portraits of friends and acquaintances – as well as nude studies – a growing part of his artistic work. He referred to one series of portraits of friends and artists as his "heroic" mode. In these, the camera looks slightly up at the subject's head, which is full-frame against the sky. In another remarkable series, made late in 1925, he photographed Modotti's tilted head and highly expressive face as she recited poetry. Within the span of twenty minutes he had made three dozen negatives.

Fascinated by the many pieces of folk art and traditional crafts that could be found in the markets, Weston began photographing them in his studio while waiting for portrait sitters to arrive. He found these objects to be the honest, direct expressions that he sought to achieve in his photography.

der Gesellschaft verschafft. Für eine kurze Zeit zwischen den 20er und den 30er Jahren konnte ein Künstler spüren, daß das Publikum seine Kunst zu schätzen wußte. Im revolutionären Mexiko herrschte eine sowohl befreiende als auch spannungsgeladene und gefährliche Atmosphäre. Als in der ersten Nacht, die Weston in Mexiko-Stadt verbrachte, unter seinem Schlafzimmerfenster Schüsse fielen, bemerkte er nur: »Ich bin nicht hierhergekommen, um die geordnete Ruhe von Glendale wiederzufinden.«

Weston und Modotti gehörten bald zum Kreis revolutionärer Schriftsteller und Maler um Diego Rivera, Rafael Sala, Jean Charlot und anderen. Modotti stand für Rivera und andere Maler Modell und begann selbst zu photographieren. Für Weston war Mexiko in mancher Hinsicht eine Offenbarung. In seinen Tagebüchern beschrieb er das Leben auf der Straße in Mexiko als ein »scharfes Aufeinanderprallen entgegengesetzter Extreme … vital, intensiv, schwarz und weiß, niemals grau«. Das kalifornische Glendale erschien ihm dagegen jetzt als »trist, leblos, ein eintöniges Grau – bevölkert von Ausbeutern, die ein schönes Land vergewaltigt haben«. Um für sich, seinen Sohn und Modotti den Lebensunterhalt zu verdienen, tat Weston das einzige, was er konnte: Er eröffnete sofort ein Porträtstudio. Doch es zeigte sich, daß es in Mexiko mehr Sammler gab als in Kalifornien – darunter viele Amerikaner und andere Ausländer. Zusätzlich zu seinen Auftragsarbeiten schuf Weston Porträts von Freunden und Bekannten, die – zusammen mit Aktstudien – einen ständig steigenden Teil seines künstlerischen Werks ausmachten. Er bezeichnete eine seiner Porträtserien von Freunden und Künstlern als seine »heroische« Folge. Auf diesen Porträts blickt die Kamera ein wenig zum sich gegen den Himmel abhebenden Kopf des Modells hinauf, der das ganze Bild einnimmt. In einer anderen, Ende 1925 entstandenen Serie photographierte er Modottis geneigten Kopf und ihr ungemein ausdrucksvolles Gesicht, während sie Lyrik rezitierte. In einer Zeitspanne von zwanzig Minuten nahm er drei Dutzend Negative auf.

ceux de ses amis et de connaissances ainsi que des études de nus, qui commencent à prendre de plus en plus de place dans son œuvre. Il parle d'une série de portraits d'amis et d'artistes comme de son mode « héroïque ». L'objectif est orienté légèrement au-dessus de la tête du modèle, sur un fond de ciel. Dans une autre remarquable série, réalisée fin 1925, il photographie le visage penché et très expressif de Modotti pendant qu'elle récite des vers. En vingt minutes, il prend plus de trois douzaines de négatifs.

Fasciné par l'art populaire et l'artisanat traditionnel qu'il voit sur les marchés, il commence à les photographier dans son studio en attendant ses clients. Il trouve que ces objets sont honnêtes et offrent le type d'expression franche qu'il recherche à travers son art. Les artisans qui les fabriquent sont, à ses yeux, spontanés et sans calcul, qualités qu'il ne retrouve pas chez des artistes comme Man Ray ou László Moholy-Nagy, dont l'irritent les photographies racoleuses et maniérées. Il se surprend à passer des heures à organiser et réorganiser des compositions de petits objets – jouets, figurines, terres cuites – à la recherche d'une manière de les photographier qui fasse écho à la simplicité et à l'économie avec lesquelles ils ont été fabriqués.

Au cours d'une visite au Musco Nacional pour voir les trésors des civilisations précolombiennes, Weston admire le talent des peintres et des sculpteurs à mettre au point les conventions, les abstractions et les motifs décoratifs qui jouent un rôle central dans leur art. Ceci force Weston à se demander « à quoi peut le mieux servir l'appareil photo » ? Il décide que la photographie doit prendre une orientation différente de celle des autres arts. « L'appareil doit servir à enregistrer la vie, à rendre la substance et la quintessence de la chose elle-même, que ce soit un morceau d'acier poli ou une chair palpitante ». Vers le milieu de l'année 1924, poursuivi par d'incessants problèmes d'argent, il commence à penser à déménager. New York lui semble une destination prometteuse pour sa carrière. « C'est le lieu logique pour mon retour », écrit-il. Mais il a aussi envie de retrouver ses trois autres

The artisans who made them were, in Weston's eyes, spontaneous and uncalculating – qualities he found lacking in artists such as Man Ray and László Moholy-Nagy, whose highly touted photographs struck him as irritatingly mannered. Weston began to spend hours or days arranging and rearranging simple objects such as toys, figurines, and clay jars, ironically searching for a way to photograph them that echoed the simplicity and economy with which they were made.

During a visit to the Museo Nacional to see the archaeological treasures of Mexico's great pre-Columbian civilizations, Weston admired the ability of painters and sculptors to develop conventions, abstractions, and decorative motifs as a central part of their art. This forced Weston to ask himself "For what end is the camera best used?" Photography, he decided, must take a different avenue than the other arts. "The camera should be used for a recording of life, for rendering the very substance and quintessence of the thing itself, whether it be polished steel or palpitating flesh."

Halfway through 1924 and worried about money, Weston began to contemplate his next step. New York City seemed an appealing destination for a career move. "It seems the logical place for my return," he wrote, but his heart ached for his other three sons in California. By the end of the year, he was determined to return to see them, unsure whether or not he would go back to Mexico. Shortly after New Year's Day, he and Chandler were back in Glendale. He spent nearly eight months of 1925 in California, much of that time in San Francisco and Carmel. He was overjoyed to see his sons and be with many of his old friends again. But in August he found himself on a boat headed back to Mexico, accompanied this time by his son Brett and wondering if he was doing the right thing. Mexico, he acknowledged at the time, still seemed like "an unfinished period of work and life." But

Fasziniert von den vielen Volkskunst- und traditionellen Kunsthandwerksobjekten, die auf den Märkten zu finden waren, begann Weston diese Objekte in seinem Studio zu photographieren, während er auf Porträtmodelle wartete. In diesen Objekten fand er den ehrlichen, unmittelbaren Ausdruck, den er in seiner Photographie zu erreichen suchte. Die Kunsthandwerker, die sie fertigten, waren in Westons Augen spontan und unberechnend – Eigenschaften, die seiner Ansicht nach Künstlern wie Man Ray und László Moholy-Nagy fehlten, deren stark beachtete Photographien er für manieriert hielt. Ironischerweise verbrachte Weston Stunden oder ganze Tage damit, einfache Objekte wie Spielzeug, Figurinen und Tonkrüge zu arrangieren und umzuarrangieren, um einen Weg zu finden, in seinen Photographien ihre Einfachheit und schlichte Machart wiederzugeben.

Als er das Museo Nacional besuchte, um sich die Schätze der großen präkolumbianischen Zivilisationen Mexikos anzusehen, bewunderte Weston die Fähigkeit der Maler und Bildhauer, Zeichen, Abstraktionen und dekorative Motive zu entwickeln und zu einem zentralen Bestandteil ihrer Kunst zu machen. Das löste in ihm die Frage aus: »Welchem Zweck dient die Kamera am besten?« Die Photographie, so seine Schlußfolgerung, muß einen anderen Weg nehmen als die anderen Künste. »Die Kamera sollte dazu verwendet werden, das Leben festzuhalten, die eigentliche Substanz und Quintessenz der Sache selbst wiederzugeben, sei es polierter Stahl oder zitterndes Fleisch.« Mitte 1924, geplagt von Geldsorgen, begann Weston darüber nachzudenken, wohin er als nächstes gehen sollte. New York City schien ihm ein vielversprechendes Ziel für einen Karriereschub zu sein. »Es scheint sich als Ort für meine Rückkehr anzubieten«, schrieb er, doch er sehnte sich sehr nach seinen anderen drei Söhnen in Kalifornien. Gegen Ende des Jahres war er entschlossen, zu ihnen zurückzukehren, und er war sich nicht sicher, ob er nach Mexiko zurückkommen würde. Kurz nach Neujahr waren er und Chandler zurück in Glendale.

fils. A la fin de l'année, il décide de retourner les voir, sans être certain de revenir à Mexico. Peu après le Nouvel An, il part pour Glendale accompagné de Chandler.

Il séjourne près de huit mois en Californie, dont une grande partie à Carmel et à San Francisco. Il est tout heureux de retrouver ses fils et beaucoup de ses vieux amis. Mais en août, il se retrouve néanmoins sur un bateau en route pour le Mexique, accompagné cette fois de Brett, et se demandant s'il a pris la bonne décision. Il reconnaît que le Mexique est encore pour lui «une période de travail et de vie inachevée». Mais il comprend aussi qu'il essaie d'éviter quelque chose en Californie. «J'ai fait ma valise et je suis parti avant de me retrouver trop impliqué dans un bourbier de routines ou de responsabilités imaginaires», écrit-il.

Le second séjour mexicain – un peu plus de quatorze mois – se révèle beaucoup plus difficile que le premier. La violence politique et anticatholique s'accroît, rendant parfois pénible la vie quotidienne, et enlève à Weston au moins l'un de ses amis, le sénateur Manuel Hernandez Galvan, assassiné par un autre politicien.

S'en référant une fois encore à «la forme suit la fonction», Weston commence à entrevoir les possibilités qu'offrent des objets fonctionnels courants, produits en série, comme la cuvette des W.-C. en céramique de sa maison de location. Il se bat pendant plus d'une semaine pour arriver à la photographier comme «un brillant réceptacle émaillé d'une extraordinaire beauté». Son but est de le décrire d'une façon qui supprime toute connotation ou signification – humoristique, scatologique, obscène ou autre – et d'exprimer une «réponse esthétique absolue à la forme». Lorsqu'il obtient finalement l'image qu'il souhaite, il la porte à Diego Rivera qui, selon Weston, s'exclame : « De toute ma vie, je n'ai vu une aussi belle photographie ».

En 1926, Weston et Modotti acceptent une commande d'Anita Brenner. Il s'agit de parcourir le pays afin de photographier des fresques, des objets de

he also realized he was avoiding something in California. "I simply packed my trunk and left before becoming once more too deeply involved in a mire of routine or imagined responsibilities," he wrote.

Weston's second Mexican stay – a little longer than fourteen months in duration – proved to be considerably harder than the first one. Political and anti-Catholic violence were on the increase, making everyday life strenuous at times and costing Weston at least one friend, Senator Manuel Hernández Galván, who was murdered by a fellow politician.

Ever aware of the maxim "form follows function," Weston began to see the possibilities of common, mass-produced functional objects, such as the ceramic toilet in his rented house. He struggled for more than a week to properly photograph what he referred to as a "glossy enameled receptacle of extraordinary beauty." His goal was to depict the toilet in a manner that would remove it from all connotations of meaning – humorous, scatological, obscene, or otherwise – and to convey an "absolute aesthetic response to form." When he finally had the print he wanted, he took it to Diego Rivera, who, according to Weston, exclaimed: "In all my life I have not seen such a beautiful photograph."

In 1926, Weston and Modotti accepted from Anita Brenner a commission to travel around the country and make photographs of murals, folk art, and traditional decorative arts for Brenner's book *Idols Behind Altars*. Tired of city life, Weston was thrilled at the idea of seeing parts of Mexico well beyond the capital city and having some new adventures. But the commission quickly turned into an ordeal that seemed as if it would never end. Flea-ridden accommodations, a thoroughly inefficient train system, and difficult conditions for photographing proved very frustrating. For four months, Weston, Modotti, and Brett struggled to fulfill the herculean task of

Fast acht Monate des Jahres 1925 verbrachte er in Kalifornien, die meiste Zeit davon in San Francisco und in Carmel bei Monterey. Er war überglücklich, seine Söhne und viele seiner alten Freunde wiederzusehen. Im August jedoch schiffte er sich wieder nach Mexiko ein, diesmal in Begleitung seines Sohnes Brett. Er war sich nicht sicher, ob er damit das Richtige tat. Einerseits war Mexiko damals für ihn immer noch »eine nicht abgeschlossene Arbeits- und Lebensperiode«. Aber es war ihm auch bewußt, daß er Kalifornien nicht nur deshalb den Rücken kehrte. »Ich packte einfach meinen Schrankkoffer und reiste ab, bevor ich mich erneut zu tief in einen Morast der Routine oder angeblicher Verpflichtungen hineinziehen ließ.« Westons zweiter Aufenthalt in Mexiko – er dauerte gut vierzehn Monate – stellte sich als beträchtlich schwieriger heraus als der erste. Die zunehmende politische und antikatholische Gewalt wirkte sich auf das tägliche Leben aus und kostete mindestens einem Freund Westons das Leben: Der Senator Manuel Hernández Galván wurde von einem politischen Gegner ermordet.

Weston hielt sich stets an die Maxime »form follows function«, und so war es nur folgerichtig, daß er das ästhetische Potential alltäglicher, funktionaler Massenartikel wie etwa der Keramikklosettschüssel in dem von ihm gemieteten Haus entdeckte. Länger als eine Woche rang er darum, das Objekt, das er als »ein glänzendes glasiertes Gefäß von außerordentlicher Schönheit« bezeichnete, angemessen zu photographieren. Er wollte die Klosettschüssel so darstellen, daß sie von allen Konnotationen – komischen, skatologischen, obszönen oder anderen – befreit war, und eine »absolut ästhetische Reaktion auf Form« übermitteln. Als er schließlich das Photo gemacht hatte, das seinen Vorstellungen entsprach, zeigte er es Diego Rivera, der, Weston zufolge, ausrief: »In meinem ganzen Leben habe ich noch keine so schöne Photographie gesehen.«

1926 nahmen Weston und Modotti von Anita Brenner den Auftrag an, durch Mexiko zu reisen und für ihr Buch *Idols Behind Altars* Wandgemälde,

l'art populaire et décoratif pour le livre qu'elle prépare, *Idols Behind Altars*. Fatigué de vivre en ville, le photographe est ravi à l'idée de visiter des régions du Mexique éloignées de la capitale et de connaître quelques nouvelles aventures. Mais le voyage se transforme rapidement en un cauchemar qui semble ne jamais devoir finir. Auberges envahies de puces, chemins de fer totalement désorganisés et conditions de travail difficiles forment un contexte de frustrations multiples. Pendant quatre mois, Weston, Modotti et Brett se battent pour atteindre l'objectif « herculéen » de 400 négatifs de qualité sur le thème demandé. A leur retour à Mexico, Weston est épuisé. Qu'il en soit conscient ou pas, il est maintenant prêt à quitter le Mexique. « Le Mexique est un crève-cœur », écrit-il alors. Il éprouve envers ce pays des sentiments contradictoires d'amour et d'amertume.

En novembre 1926, Weston et son fils repartent pour la Californie, mais sans Tina Modotti. Il est prêt à assumer une nouvelle carrière et une nouvelle vie aux Etats-Unis. Son nouveau style réaliste célèbre la forme, la lumière, la vie et la simplicité. Le temps est maintenant venu d'épurer sa propre vie et de se concentrer sur sa photographie.

En dehors de son bref séjour en Californie, Weston vient donc de traverser trois années qui sont pour lui d'une immense importance. Il a appris à réduire son sujet à l'essentiel et à trouver le point de vue le plus expressif à partir duquel l'objet pourra s'exprimer lui-même. Il crédite de cette avancée moins les artistes et amis qu'il a rencontrés là-bas que les paysans mexicains : « J'ai été régénéré par leur expression élémentaire – J'ai senti la terre ». Cependant, il note clairement que tout artiste moderne qui voudrait essayer « de rappeler le passé, les sentiments et les techniques de gens simples et sans préjugés artistiques… échouerait absolument ». Il se rend compte que « la route va vers l'avant, et non vers l'arrière, aussi riche le passé soit-il ».

Peu après son retour aux Etats-Unis, il modifie également sa technique de tirage et abandonne les papiers photographiques au platine et au palladium

producing four hundred first-rate negatives of appropriate subjects. By the time they had returned to Mexico City, Weston was exhausted, and whether he knew it or not, ready to quit Mexico. "Mexico breaks one's heart," he wrote. He had come to feel both love for and bitterness toward Mexico.

In November 1926, he and Brett returned to California without Modotti. Weston was ready to take on the responsibility of a career and a life in the United States. His new realist style celebrated form, light, life, and simplicity. It was now time to simplify his own life so that he could concentrate on his photography.

Weston's three-year stay in Mexico [interrupted only by the nearly eight-month visit to California] was immensely important. There he had learned to reduce his subject to its essence and to locate the most expressive vantage point from which the subject could speak for itself. He credited this not so much to his friendships with other artists there but to his exposure to the peasants of Mexico. "I have been refreshed by their elemental expression, – I have felt the soil." However, Weston made it clear that any modern artist who tried "to recall the past, the feeling and technique of simple, artless people" would "fail absolutely." He realized that "the way is ahead, not back, no matter how great the past may be."

Shortly after his return to the United States, he also transformed his printing technique by abandoning the lush, warm-toned platinum and palladium photographic papers that he had used almost exclusively for nearly two decades. Visiting an exhibition of pictorialist photography in Los Angeles, he came to the conclusion that most of the photographers had resorted to "artistic printing" to hide their own weaknesses. "Unable to feel Life … they produce only fogs and 'light effects'." Accordingly, he soon switched to black-and-white printing paper.

Volkskunst und traditionelle dekorative Kunst zu photographieren. Des Stadtlebens müde, war Weston begeistert von der Idee, ins Landesinnere zu reisen und neue Abenteuer zu erleben. Doch die Reise wurde schnell zu einer Tortur, die kein Ende zu nehmen schien. Unterkünfte voller Flöhe, ein völlig ineffizientes Eisenbahnsystem und schwierige Bedingungen zum Photographieren erwiesen sich als äußerst frustrierend. Vier Monate lang mühten Weston, Modotti und Brett sich ab, 400 erstklassige Negative von geeigneten Sujets aufzunehmen. Als sie nach Mexiko-Stadt zurückkehrten, war Weston ausgelaugt, und es war für ihn an der Zeit, Mexiko den Rücken zu kehren. »Mexiko bricht einem das Herz«, schrieb er. Seine Gefühle für Mexiko schwankten mittlerweile zwischen Liebe und Bitterkeit.

Im November 1926 kehrten er und Brett ohne Tina Modotti nach Kalifornien zurück. Weston hatte sich auf eine Laufbahn und ein Leben in den Vereinigten Staaten eingestellt. Sein neuer realistischer Stil pries die Form, das Licht, das Leben und die Einfachheit. Es war jetzt an der Zeit, ein ruhigeres und geregelteres Leben zu führen, damit er sich auf seine Photographie konzentrieren konnte.

Westons dreijähriger Aufenthalt in Mexiko [unterbrochen nur durch den fast achtmonatigen Besuch in Kalifornien] war ungeheuer wichtig. Dort hatte er gelernt, sein Sujet auf die Essenz zu reduzieren und den expressivsten Punkt zu finden, von dem aus das Sujet für sich selbst sprechen konnte. Er führte das nicht auf seine Freundschaften mit anderen Künstlern zurück, sondern auf die Begegnung mit den mexikanischen Bauern. »Ihre elementare Ausdrucksweise hat mich erquickt – ich habe den Erdboden gespürt.« Weston ließ jedoch keinen Zweifel daran, daß jeder »Versuch, die Vergangenheit, die Empfindungen und Techniken schlichter, natürlicher Menschen wiederaufleben zu lassen, ohne Wenn und Aber zum Scheitern verurteilt« sei. Der moderne Künstler habe »nach vorn zu gehen, nicht zurück, so großartig die Vergangenheit auch sein möge«.

à tons chauds qu'il utilisait presque exclusivement depuis deux décennies. En visitant une exposition pictorialiste à Los Angeles, il en arrive à la conclusion que la plupart des photographes adoptent le « tirage artistique » pour masquer leurs faiblesses. « Incapables de sentir la vie, ils ne produisent que des effets de brouillard et de lumière ». Il passe ainsi bientôt au papier de tirage noir et blanc.

De nouveau installé dans son studio de Glendale et partageant la responsabilité de l'éducation de ses fils avec Flora – ils sont toujours légalement mariés –, il se replonge dans la routine familière des portraits commerciaux pour gagner sa vie, et réalise des nus pour lui-même. Ses commandes commencent à l'irriter, en particulier le long travail de retouche qu'exige chaque tirage. Les modèles veulent que leurs petits défauts soient corrigés, certains lui demandent même de les rajeunir par un lourd travail de retouche… Weston semble souvent au sommet de sa créativité et de sa liberté lorsqu'il photographie des nus. En faisant danser son modèle, plutôt que poser, il doit réagir instinctivement à la fluidité des lignes et à l'infinie combinaison de formes que le corps humain peut créer. Il ressent le besoin d'une réponse formelle aussi spontanée que les mouvements de ses modèles. « Essayer d'enregistrer chaque mouvement et chaque expression », écrit-il, « tout dépend de la clarté de ma vision, de mon intuition à cet instant important qui, s'il est perdu, ne se répétera jamais ».

Au même moment, il commence à rechercher de nouveaux sujets qui correspondent à son nouveau style. Les portraits et les études de nus joueront longtemps un rôle essentiel dans sa carrière, mais il recherche autre chose que le corps et le visage humains. Très intéressé par les formes de la nature, il se tourne vers les légumes et les fruits, qu'il peut apporter à son studio et photographier comme il l'entend, ainsi qu'il l'avait fait au Mexique avec des objets d'art populaire. Son amie, le peintre Henrietta Shore, le sensibilise aux coquillages, qu'il commence également à photographier.

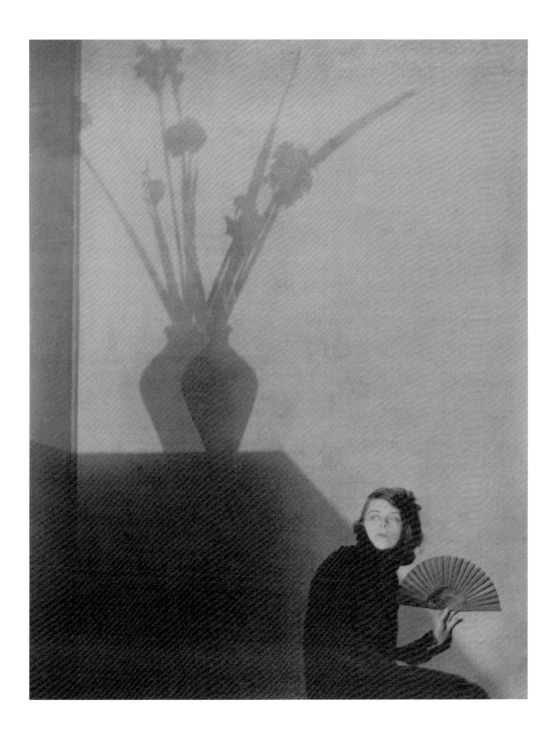

Epilogue
Epilog
Epilogue
1919

Settled back in his old Glendale studio and sharing responsibility for his sons with Flora [they were still married], Weston began the familiar routine of making commercial portraits for a living and concentrating on nude studies for himself. The portrait commissions soon became irritating, especially the labor-intensive retouching that was inevitably required for every print. Sitters wanted blemishes retouched away; some even wanted Weston to make them look younger through extensive retouching.

Weston often seemed freest and most creative when photographing nude models. By having the model dance rather than pose for him, he had to respond intuitively to the fluid lines and infinite combinations of form that the human body could create. Weston needed his own response to form to be as spontaneous as the model's movements. "Trying to record ever changing movement and expression," he wrote, "everything depends on my clear vision, my intuition at the important instant, which if lost can never be repeated."

At the same time, Weston also began searching for new subjects that would be equally appropriate for his new style. Portraits and nude studies continued to be mainstays of his work almost the whole of his career, but he wanted something besides the human body and the human face to photograph. Deeply interested in the forms of nature, Weston turned to vegetables and fruits, which he took into the studio and photographed under tight control as he had done in Mexico with craft and folk art objects. Within months his friend Henrietta Shore, a painter, introduced him to the shells, which he began arranging and photographing.

By isolating and somewhat enlarging the size of a shell or green pepper, or by slicing vegetables and shells in half, Weston allowed the forms of nature to reveal themselves as containing both significant pattern and splendid irregularity. He used light and shadow to articulate what he felt to be the ideal expression of the subject.

Bald nach seiner Rückkehr in die Vereinigten Staaten ging er auch zu einer neuen Abzugstechnik über. Er nahm Abstand von den satten, warm getönten Platin- und Palladiumphotopapieren, die er fast zwei Jahrzehnte lang nahezu ausschließlich verwendet hatte. Als er eine Ausstellung piktoralistischer Photographien in Los Angeles besuchte, kam er zu dem Schluß, daß die meisten Photographen auf »künstlerische Abzugsverfahren« zurückgegriffen hatten, um ihre eigenen Schwächen zu verbergen. »Da sie das Leben nicht nachempfinden können … bringen sie nur Nebelschleier und Lichteffekte hervor.« Und folgerichtig wechselte er zu Schwarzweiß-Druckpapier über. Weston richtete sich wieder in seinem alten Studio in Glendale ein und sorgte zusammen mit Flora [sie waren noch immer verheiratet] für seine Söhne. Er arbeitete erneut als Porträtphotograph, um Geld zu verdienen, und nahm nebenher für sich selbst Aktstudien auf. Die Porträtaufträge wurden ihm bald zu einer Last.

Am ungezwungensten und kreativsten schien Weston oft zu sein, wenn er Aktmodelle photographierte. Indem er seine Modelle nicht stehen oder sitzen, sondern tanzen ließ, mußte er intuitiv und spontan auf die fließenden Linien und unendlich vielen Formkombinationen des sich bewegenden menschlichen Körpers reagieren: »Wenn ich versuche, eine sich ständig ändernde Bewegung und den damit einhergehenden Ausdruck festzuhalten, hängt alles von meiner klaren Vision, meiner Intuition im wichtigen Augenblick ab, der nie wiederholt werden kann, wenn er verlorengeht.«

Zur gleichen Zeit begann Weston auch nach neuen Sujets zu suchen, die seinem neuen Stil gleichermaßen angemessen waren. Bis zum Ende seiner Laufbahn blieben Porträts und Aktstudien Eckpfeiler seines Schaffens, doch er wollte sich nicht auf den menschlichen Körper und das menschliche Gesicht beschränken. Weston interessierte sich sehr für die Formen der Natur und wandte sich Gemüsepflanzen und Früchten zu, die er in seinem Studio genauso sorgsam arrangierte, wie er es in Mexiko mit Kunst-

En isolant et parfois en agrandissant les dimensions d'un coquillage ou d'un poivron vert, ou en coupant en deux des coquilles ou des légumes, il permet à la forme naturelle de révéler sa construction et la splendeur de sa complexité. Il se sert avec prudence de l'ombre et de la lumière pour arriver à ce qu'il juge être l'expression idéale de l'objet. De 1927 à 1930, il réalise un grand nombre des photographies qui sont aujourd'hui considérées parmi ses plus importantes : photos de nautiles nacrés sur fond sombre et équivoque, couples de coquillages imbriqués les uns dans les autres et poivrons sensuels.

Les coquillages, en particulier, semblent rencontrer un grand succès. Lorsqu'il en envoie quelques tirages à Modotti restée au Mexique, elle lui répond immédiatement : « Je suis sans voix devant eux. Quelle pureté de vision ! Lorsque j'ai ouvert le paquet, je n'ai pu les regarder très longtemps… tant ils touchent à mes sentiments les plus intimes que j'en ai presque ressenti une peine physique » . Pour elle, ces coquillages étaient en même temps, « si purs et si pervers » . Rivera et plusieurs autres amis de Modotti, étaient d'avis que ces images étaient érotiques et mystiques, et se posèrent des questions sur l'état d'esprit du photographe au moment où il les avait prises. Rivera ira même jusqu'à demander à Modotti : « Weston est-il malade ? »

Ce dernier trouve ces réactions surprenantes et loin du sujet. « Pourquoi tous ces gens sont-ils aussi profondément affectés par l'aspect de ces images ? Tout ce que je peux dire, avec une honnêteté absolue, c'est que pas une fois en travaillant sur ces coquillages je n'ai éprouvé de réaction physique ou émotionnelle » . Il explique qu'au contraire, il a créé ces images avec seulement en tête une « vision purement esthétique et formelle ».

Le retour en Californie n'a en rien réglé ses soucis d'argent. Il vend quelques tirages et portraits mais dépend toujours de petits cadeaux ou prêts de Flora et d'amis pour échapper à ses créanciers. Il en rend responsable en grande partie le manque d'intérêt et de soutien pour les arts dans la culture améri-

Between 1927 and 1930, Weston made many of the photographs that are now recognized as among his most important: photographs of a gleaming white chambered nautilus shell set in a dark, ambiguous space; pairs of shells tucked into each other; and sensuous bell peppers.

The shells, in particular, gained the most response. When Weston mailed several to Modotti in Mexico, she immediately wrote back: "I felt speechless in front of them. What purity of vision. When I opened the package I couldn't look at them very long, they stirred up all my innermost feelings so that I felt a physical pain." Modotti went on to say that the shells were at the same time "so pure and so perverse." The consensus of opinion among Rivera and several of Modotti's other friends was that the shell photographs were erotic and mystical, and they wondered about Weston's state of mind as he made them. Rivera asked Modotti: "Is Weston sick at present?" Weston found all of these responses surprising and wide of the mark. "Why were all these persons so profoundly affected on the physical side? For I can say with absolute honesty that not once while working with the shells did I have any physical reaction to them." Instead, Weston explained, he had created those images with only a "vision of sheer aesthetic form" in mind.

The return to California had done nothing to lessen his worries about money. He sold a few prints and some portraits, but was still dependent on small gifts and loans from Flora and friends to keep him out of debt. He blamed his financial situation on the lack of appreciation and support for the arts in American culture. "The American public wants noise, steam-roller methods, – they must be forced to buy." But even more seriously, he worried about the effects all of this was having on his outlook. "I am deeply concerned about the return of my old bitterness," he wrote. "It will distort or destroy all that is creatively fine within … I am being gradually undermined again."

gewerbe- und Volkskunstobjekten getan hatte. Und nach einiger Zeit machte seine Freundin Henrietta Shore, eine Malerin, ihn auf Muschelschalen und Schneckengehäuse aufmerksam. Indem er eine Muschelschale oder eine grüne Paprikaschote isolierte und vergrößerte oder Gemüsepflanzen und Muschelschalen durchschnitt, enthüllte Weston sowohl die signifikanten Muster als auch die wunderbare Unregelmäßigkeit der Formen der Natur. Mit Hilfe von Licht und Schatten artikulierte er den Ausdruck des Sujets, der seinen Idealvorstellungen entsprach. Zwischen 1927 und 1930 schuf Weston viele der Photographien, die man heute zu seinen wichtigsten zählt: Photographien einer schimmernden, weißen, vielkammerigen Nautilusmuschelschale in einem dunklen, mehrdeutigen Raum, zwei ineinander gesteckte Muschelschalen und sinnliche Paprikaschoten.

Insbesondere die Photographien von Muschelschalen wurden begeistert aufgenommen. Als Weston einige davon an Modotti in Mexiko schickte, schrieb sie unverzüglich zurück: »Ich war sprachlos, als ich sie sah. Welche Reinheit der Vision. Als ich das Päckchen öffnete, mußte ich sie nach kurzer Zeit beiseite legen; sie wühlten mich im tiefsten Innern auf, so daß ich einen körperlichen Schmerz spürte.« Ferner schrieb Modotti, die Muschelschalen seien gleichzeitig »so rein und so pervers«. Auch Rivera und verschiedene andere Freunde Modottis waren sich einig in der Meinung, die Muschelschalen-Photographien seien erotisch und mystisch, und sie fragten sich, in welcher geistigen Verfassung Weston sich wohl befunden habe, als er sie schuf. Rivera fragte Modotti: »Geht es Weston zur Zeit nicht gut?«

Weston war überrascht. »Warum waren alle diese Leute emotional so tief berührt? Es ist die reine Wahrheit, wenn ich sage, daß ich kein einziges Mal emotional oder körperlich auf die Muschelschalen reagiert habe, als ich mit ihnen arbeitete.« Es sei ihm vielmehr um nichts anderes gegangen als um eine »rein ästhetische Formvision«.

caine. « Le public américain veut du bruit, des méthodes de rouleau compresseur… il veut être forcé à acheter » . Mais plus sérieusement encore, il s'inquiète de l'effet de tous ces problèmes sur sa santé psychologique: « Je me sens profondément concerné par le retour de mon ancienne amertume… Elle va déformer ou détruire tout ce qui est créativement intéressant en moi… je me sens de nouveau peu à peu miné ».

En mai 1928, il effectue un voyage bref mais important dans le désert Mojave où pour la première fois il s'efforce vraiment de photographier un paysage. Mal préparé à la violence géologique et aux formes oppressantes des rochers qu'il découvre, il admet que « c'est un des moments les plus impressionnants de ma vie ». Il photographie des rocs, des arbres et des panoramas désertiques, révélant dans chaque image ce que le désert lui offre. « On pourrait prendre un millier de négatifs et rester encore des semaines sans en épuiser toutes les possibilités ».

De la même façon que sa photographie pictorialiste lui a valu une réputation internationale dix ans plus tôt, ses nouvelles recherches lui attirent vite un nouveau public d'admirateurs aux Etats-Unis et en Europe. Depuis son retour en Californie, ses tirages sont de plus en plus exposés dans des galeries, des musées d'université et d'importants musées d'art de grandes villes. Lentement mais sûrement se constitue autour de lui un petit cercle de collectionneurs et de défenseurs comme Merle Armitage et Walter Arensberg. A la fin de l'été, il se rend avec Brett à San Francisco dans l'intention d'y séjourner quelques mois. Son ami de longue date Johan Hagemeyer, qui vit temporairement à Carmel, l'a invité à s'installer dans son atelier inoccupé de San Francisco. Bien qu'il ait désespérément envie de vivre « dans une petite bicoque, quelque part dans le désert ou la nature sauvage, sans aucune possession », pour se consacrer à la photographie sans être distrait, San Francisco lui apporte au moins un changement nécessaire. Tout va d'abord comme il l'a espéré. Il reçoit de nombreuses commandes et mène une vie

In May 1928, Weston made a brief, but important trip to the Mojave Desert where he made his first truly concentrated effort to photograph a landscape. Unprepared for the geological violence and the haunting forms of the rocks there, he admitted that this "was one of the most impressive moments of my life." He photographed rocks, trees, and desert vistas, reveling in everything that the landscape presented him. "One could expose a thousand negatives and be there weeks without exhausting possibilities."

In the same way that his pictorialist photography had gained an international reputation a decade earlier, so his new photography was beginning to reach a new, admiring audience across the United States and in Europe. Since his return to the United States, his prints had been appearing more and more frequently in commercial galleries, university museums, and important art museums in major cities. Slowly but surely he developed a small circle of collectors and supporters, such as Merle Armitage and Walter Arensberg.

At the end of the summer, Weston and Brett went to San Francisco intending to stay only a few months. His long-time friend Johan Hagemeyer, who was temporarily living in Carmel, had invited him to live and work in his empty San Francisco studio. Although he longed desperately to live in "a little shack somewhere in the desert or wilderness, with no possessions," where he could concentrate on his photography without distractions, San Francisco at least promised change. At first, everything went as he had hoped. There were many commissions, a busy social life with friends old and new, and several brief romances.

But as the months grew into a half-year, Weston predictably found himself frustrated with city life. He was working hard – very hard – at portraits, but wasn't managing to save much money. Just before Christmas he estimated his net worth at $ 150 in the bank, $ 50 in cash, and $ 515 owed him. Hagemeyer's San Francisco studio,

Auch nach seiner Rückkehr nach Kalifornien war er stets von Geldsorgen geplagt. Er verkaufte einige wenige Abzüge und einige Porträts, war aber immer noch auf kleine Zuwendungen und Darlehen von Flora und von Freunden angewiesen. Er lastete seine finanzielle Lage der fehlenden Würdigung und Unterstützung der Künste in der amerikanischen Kultur an. »Das amerikanische Publikum will Lärm, man muß ihm mit der Dampfwalze kommen – man muß die Leute zum Kaufen zwingen.« Und er fürchtete, daß diese Umstände ihn auf längere Sicht zermürben könnten: »Ich habe große Angst, daß meine alte Bitterkeit zurückkehrt und meine schöpferischen Kräfte beeinträchtigt oder zerstört. Allmählich wird mir wieder der Boden unter den Füßen weggezogen.«
Im Mai 1928 machte Weston einen kurzen, aber wichtigen Ausflug in die Mojave-Wüste, wo er sich zum ersten Mal konzentriert mit der Landschaftsphotographie auseinandersetzte. Der gewaltige Anblick der Landschaft mit ihren beängstigenden Felsformationen traf ihn völlig unvorbereitet als »einer der beeindruckendsten Augenblicke meines Lebens«. Er photographierte Felsen, Bäume und Wüstenansichten und schwelgte in allem, was die Landschaft zu bieten hatte. »Man konnte sich wochenlang dort aufhalten und tausend Negative belichten, ohne die Möglichkeiten zu erschöpfen.«
So, wie er sich ein Jahrzehnt zuvor mit seiner piktorialistischen Photographie einen internationalen Ruf erworben hatte, so erreichte jetzt auch seine neue Photographie ein neues, bewunderndes Publikum überall in den Vereinigten Staaten und in Europa. Seit seiner Rückkehr in die Vereinigten Staaten wurden seine Photographien immer häufiger in Galerien, Universitätsmuseen und wichtigen Kunstmuseen in großen Städten ausgestellt. Langsam, aber sicher entstand ein kleiner Kreis von Sammlern und Förderern, dem zum Beispiel Merle Armitage und Walter Arensberg angehörten. Mit der Absicht, nur einige Monate dort zu bleiben, gingen Weston und Brett gegen Ende des Sommers nach San Francisco. Sein alter Freund Johan

sociale animée en compagnie de ses amis, anciens ou nouveaux ; il connaît même quelques liaisons amoureuses.
Mais au fur et à mesure que les mois passent, il se trouve une fois de plus frustré par la vie urbaine. Il travaille dur – très dur – pour réaliser des portraits, mais ne peut guère mettre d'argent de côté. Juste avant Noël, il estime son capital net à 150 dollars en banque, 50 en argent liquide et 515 que l'on lui doit. L'atelier d'Hagemeyer est petit pour deux personnes et la salle de bain sert également de cuisine et de chambre noire. Il n'arrive pas à travailler pour lui-même en dehors de quelques portraits.
Bien que la vie artistique soit plus intéressante à San Francisco qu'à Los Angeles, et qu'il commence à être apprécié et même célèbre, il en a assez des villes. « Je veux pouvoir travailler, contempler mon travail, réfléchir sur moi-même, m'améliorer, accomplir ce pour quoi j'existe ». Inspiré par la vie d'Hagemeyer à Carmel, il décide de s'y installer aussi vite que possible. Au début de 1929, lorsque son ami décide de rentrer à San Francisco, Weston reprend sa petite maison de Carmel, village de bord de mer alors isolé qui jouit d'une réputation de colonie d'artistes. Là, il pourra vivre simplement et à peu de frais, à proximité de quelques-uns des plus spectaculaires paysages de l'Ouest américain. A Point Lobos, tout près, il découvre des plages, des formations rocheuses, des retenues d'eau laissées par les marées et des cyprès qui seront le sujet d'innombrables photographies pendant les deux décennies qui suivront. A quelques heures de voiture, il peut voir et photographier les merveilles du Yosemite, les vues impressionnantes de la Death Valley, les riches terres agricoles de la Vallée centrale et l'étonnante côte du nord de la Californie. Mais tout aussi important pour lui est qu'il sent que Carmel lui permet de se reposer et d'être seul : « Un plongeon dans l'océan, de longues promenades dans les collines et le long de la plage ». Il travaille de nouveau à un rythme frénétique. Ses nombreux amis de Carmel comptent des artistes, des écrivains et des célébrités qui vivent ici ou visitent la région, comme le

whose bathroom served as kitchen and darkroom, was small for himself and his son. And Weston hadn't managed to do much photography for himself besides a few portraits.

Although the artistic life was far better in San Francisco than in Los Angeles and Weston found himself the object of praise and devotion there, he wanted no more of cities. "I want a chance to work, to contemplate that work, search myself, improve myself, fulfill the very reason for my existence." Inspired by Hagemeyer's life in Carmel, Edward resolved to move there as soon as he could. So, early in 1929, when Hagemeyer decided to return to San Francisco, Weston rented Hagemeyer's cottage in Carmel, an isolated seaside village in northern California with a history of being an artist's colony. There he lived simply and inexpensively, close to some of the most spectacular landscapes in the American West. At nearby Point Lobos he discovered beaches, rock formations, tide pools, and cypress groves that became the subject of countless photographs over the next two decades. And within a few hours' drive were the wonders of Yosemite, the stark vistas of Death Valley, the lush farmlands of the Central Valley, and the stunning coastline of northern California, all of which he visited and photographed.

Perhaps equally important, Weston felt that Carmel allowed for recreation and some solitude: "a dip in the ocean, long walks through the hills, and along the beach." Before long, he was working at a frenzied pace. Among his many Carmel portraits were artists, writers, and dignitaries living in or visiting the Carmel area, including poet Robinson Jeffers, pianist Walter Gieseking, dancer Harald Kreutzberg, and an acquaintance from Mexico, painter Jose Clemente Orozco. He also started doing still-lifes again – bones, mushrooms, peppers, pieces of kelp – and continued to make nude studies.

Hagemeyer, der vorübergehend in Carmel lebte, hatte ihm für diese Zeit sein Studio in San Francisco angeboten. Zwar hätte Weston am liebsten in »einer kleinen Hütte irgendwo in der Wüste oder Wildnis, ohne Habe« gelebt, um sich ganz auf seine Photographie konzentrieren zu können, doch San Francisco versprach zumindest eine Abwechslung. Zunächst lief dort alles so, wie er es sich erhofft hatte. Es gab zahlreiche Aufträge, ein reges gesellschaftliches Leben und mehrere kurze Romanzen.

Doch als aus einigen Monaten fast ein halbes Jahr geworden war, war Weston des Stadtlebens wieder einmal überdrüssig. Er arbeitete hart – sehr hart – als Porträtphotograph, doch es gelang ihm nicht, genügend Geld zurückzulegen. Als er unmittelbar vor Weihnachten seine finanzielle Lage überschlug, hatte er 150 Dollar auf der Bank, 50 Dollar in bar und Außenstände in Höhe von 515 Dollar. Hagemeyers Studio in San Francisco war zu klein für ihn und seinen Sohn. Und abgesehen von einigen Porträtaufnahmen war Weston kaum dazu gekommen, für sich selbst zu photographieren.

Obwohl San Francisco für Künstler ein viel besseres Pflaster war als Los Angeles und Weston hier auf Bewunderung stieß, hatte er vom Leben in der Stadt genug. »Ich möchte arbeiten können, über meine Arbeit nachdenken können, mich selbst erforschen, mich verbessern, den Grund für mein Dasein erfüllen.« Weston beschloß, Hagemeyers Beispiel zu folgen und so bald wie möglich nach Carmel zu ziehen.

Als Hagemeyer Anfang 1929 nach San Francisco zurückkehrte, mietete Weston dessen Häuschen in Carmel, einem einsam gelegenen Dorf an der nordkalifornischen Küste, das auf eine Geschichte als Künstlerkolonie zurückblicken konnte. Dort lebte er einfach und bescheiden, nicht weit entfernt von einigen der spektakulärsten Landschaften im amerikanischen Westen. Im nahe gelegenen Point Lobos entdeckte er Strände, Felsformationen, Fluttteiche und Zypressenhaine, die im Laufe der folgenden zwei Jahrzehnte zum Thema zahlloser Photographien wurden. Und in nur

poète Robinson Jeffers, le pianiste Walter Gieseking, le danseur Harald Kreutzberg et une connaissance de Mexico, le peintre José Clemente Orozco. Il se remet aux natures mortes – os, champignons, poivrons, varechs – et poursuit ses études de nu.

Mais c'est lorsqu'il travaille sur le paysage local qu'il connaît les moments les plus stimulants. A Big Sur, il se retrouve « muet » face aux séquoias géants et aux montagnes vertigineuses qui forment une somptueuse ligne de côte. Confronté à un paysage aussi varié et monumental, sans comparaison avec ce qu'il a photographié jusqu'alors, il reste d'abord prudent. Quelques jours après avoir réalisé ses premiers négatifs à Big Sur, il s'aperçoit au tirage qu'il a échoué. C'est « un problème d'émotion plutôt que de révélation de l'essentiel ». Il faudra des mois avant qu'il n'ait le sentiment d'avoir compris le moyen de photographier ce type de paysage nouveau pour lui. Au même moment, il s'attache à saisir des détails de rochers et de cyprès à Point Lobos et dans des endroits voisins. Le plus difficile est parfois de trouver quelqu'un qui puisse l'amener sur place, puisqu'il n'a jamais appris à conduire. Un peu plus tard, son ami Richard Neutra, architecte émigré autrichien formé au Bauhaus, l'invite à sélectionner les envois des photographes de la côte Ouest pour l'exposition historique « Film und Foto » organisée à Stuttgart cette année-là. Il lui demande également de rédiger un court texte pour le catalogue. Weston y insiste sur le fait que cette sélection est dominée par les photographes californiens : « La Californie, non empêtrée dans les traditions, moins liée par les conventions, plus ouverte, libre, jeune – physiquement et spirituellement – offre un terreau encore vierge d'où sortiront un nouveau sentiment de la vie et de nouvelles manifestations de celle-ci. [Le paragraphe qui contient cette phrase a été rayé de la version publiée du texte de Weston.]

Finalement, Weston en vient à considérer 1929 – l'année de la catastrophe boursière – comme une année de travail exubérant qui voit son installation

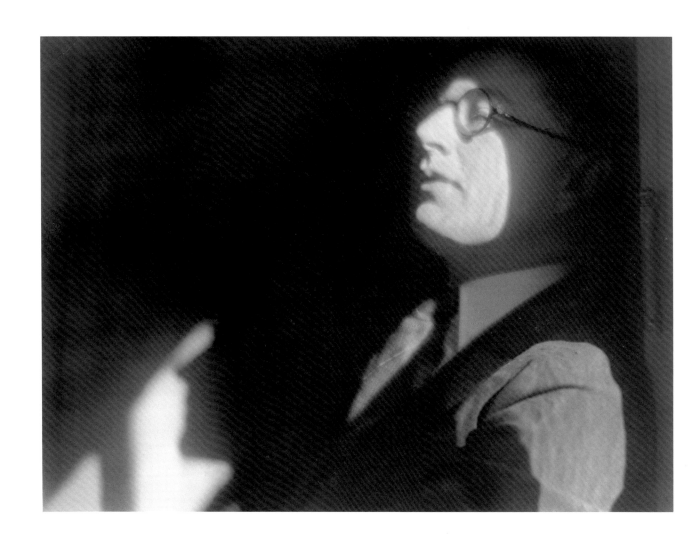

Sun Mask
Sonnenmaske
Masque solaire
1919

But the truly exciting times came when he photographed the local landscape. At Big Sur Weston found himself "inarticulate," surrounded as he was by giant redwood trees and the great mountains that came right down to the stunning coastline. Faced with such a varied landscape and a monumental scale unlike anything he had photographed before, Weston was, at first, cautious.

A few days after making his first negatives of the California coastline at Big Sur, he looked at his first print and realized he had not succeeded. It was "a thing of emotional mood, rather than a revelation of essentials," and it would be months before Weston felt he had figured out how to photograph this new type of landscape. In the meantime, he stuck to photographing details of rocks and cypresses at Point Lobos and nearby spots. At times the hardest part of his landscape photography was finding someone to drive him, since Weston never learned to drive.

Later that year his friend Richard Neutra invited him to select the West Coast entries to the landmark exhibition "Film und Foto" which was to be organized in Stuttgart that year. Neutra, a Bauhaus-trained German émigré architect also asked Weston to write a short text for the catalog. In his brief text he commented on the fact that his selection was dominated by Californian photographers: "California, unhampered by tradition, less bound by convention, more open, free, youthful, – physically and psychically, affords untilled soil from which will appear a new feeling for, and manifestation of, life." [The paragraph that included this statement was excerpted from the published version of Weston's text.]

In the end, Weston came to regard 1929, the year of the great stock market crash, as a year of exuberant work and settled down into the place that would be his home until his death. He fell in love with Sonya

wenigen Stunden waren die Naturwunder des Yosemite-Nationalparks zu erreichen, die kahlen Ausblicke über das Death Valley, die üppigen Weiden und Felder des Central Valley und die atemberaubende nordkalifornische Küste, Gegenden, die er alle besuchte und photographierte.

Nicht weniger wichtig dürfte es gewesen sein, daß Weston im abgeschiedenen Carmel Ruhe und Erholung fand: »ein Bad im Ozean, lange Spaziergänge über die Hügel und am Strand entlang«. Bald schon arbeitete er in rasendem Tempo. Viele Porträtaufnahmen entstanden in Carmel, darunter Porträts von Künstlern, Schriftstellern und Berühmtheiten wie dem Dichter Robinson Jeffers, dem Pianisten Walter Gieseking, dem Tänzer Harald Kreutzberg und dem Maler José Clemente Orozco, einem Bekannten aus Mexiko. Außerdem wandte er sich wieder dem Stilleben zu – Knochen, Pilze, Paprikaschoten, Seetang – und setzte seine Aktstudien fort.

Wirklich aufregend wurde es jedoch für ihn, als er die örtliche Landschaft zu photographieren begann. Bei Big Sur stand Weston »sprachlos« vor den gigantischen Redwood-Bäumen und der atemberaubenden Steilküste. Angesichts einer derart vielgestaltigen Landschaft von einer für ihn völlig neuen Monumentalität ging Weston zunächst mit Bedacht vor. Einige Tage nachdem er seine ersten Negative von der kalifornischen Küste bei Big Sur aufgenommen hatte, sah er sich seinen ersten Abzug an und erkannte, daß er seinen Vorstellungen nicht entsprach. Statt »Essentielles zu offenbaren« gab er »eine emotionale Stimmung« wieder, und es sollten Monate ins Land ziehen, bis Weston zu wissen glaubte, wie diese Landschaft photographiert werden mußte. In der Zwischenzeit machte er Detailaufnahmen von Felsen und Zypressen bei Point Lobos und anderen Orten in der näheren Umgebung von Carmel. Sein größtes Problem war oft, jemanden zu finden, der ihn fuhr, denn Weston lernte nie Auto fahren.

In diesem Jahr wurde er von seinem Freund Richard Neutra gebeten, für die bahnbrechende Ausstellung »Film und Foto«, die noch im selben Jahr in

dans ce qui sera son foyer jusqu'à la fin de sa vie. Il s'éprend de Sonya Noskowiak qui emménage avec lui et ses fils [qui vivent en alternance auprès de leur père]. Même sa situation financière s'améliore. Il note fièrement qu'il a pu acheter un nouveau phonographe, un appareil photo pour Brett, subvenir aux besoins de ses fils et aider Flora qui traverse des moments difficiles. Il réussit malgré tout à augmenter ses économies jusqu'à 800 dollars. Sa vie et sa carrière commencent à changer. Dans son journal, il note qu'il ne peut trouver le temps d'y écrire qu'une fois toutes les deux semaines. Le reste du temps, il photographie et entretient la correspondance toujours plus volumineuse que lui vaut sa réputation grandissante : « Demandes de tirages pour des expositions ou des publications, questions auxquelles il faut répondre, demandes de stages ».

Il commence à avoir davantage confiance en son travail. Déclarant toujours que sa dernière photo est la meilleure, il est enchanté. Le 8 mars 1930, par exemple, il note : « Hier, j'ai fait des photographies historiques ». Il vient juste de prendre deux négatifs de varech dont il est convaincu qu'ils seront « un jour considérés comme les exemples les plus raffinés de mon expression ». Se promenant seul le long de la plage après une tempête, il avait aperçu un tas de varechs « tordus, emmêlés, un chaos de rythmes convulsés ». Il « sélectionne une petite surface, arrange un peu ce labyrinthe apparemment inextricable, et le photographie avec une volonté d'intégration ». Il précise fièrement qu'il n'a rien eu à déplacer, si ce n'est son appareil. « Je tire beaucoup plus de joie des choses déjà composées que je découvre dans la nature que de mes meilleurs arrangements personnels ».

Disposant de plus de temps pour réfléchir à son travail, il commence à comprendre plus clairement ce qui se passe dans son esprit lorsqu'il expose un négatif dans son appareil. « Je commence sans idée préconçue – c'est la découverte qui m'excite – puis la redécouverte à travers l'objectif, sur le verre du viseur, le tirage fini prévu avant l'exposition dans sa totalité, dans chaque

Noskowiak, who moved in with him and the ever-changing combination of sons that lived with him in Carmel. And he even finished the year better off financially. He proudly recorded that he had bought himself a new record player and a camera for Brett, had supported his sons, and had helped Flora through some difficult times, and still increased his savings to $ 800.

Weston's life and career were beginning to change. In his daybooks he noted that he could only manage an entry every two weeks or so. The rest of the time he was busy photographing and handling the ever-increasing amount of correspondence that fame brought him: "requests for prints for exhibits and publication, questions to answer, would-be apprentices."

His confidence in own work also grew. Continually pronouncing his latest work to be his finest ever, he was ecstatic. On March 8, 1930, for example, Weston wrote: "Yesterday I made photographic history." He had just made two negatives of kelp that he was convinced would "someday be sought as examples of my finest expression and understanding." Walking along the beach after a storm, he had seen a pile of kelp that was "twisted, tangled, interwoven, a chaos of convulsed rhythms." He "selected a square foot, organized the apparently complex maze, and presented it, with powerful integration." He proudly noted that he had not had to move anything except his camera. "I get a greater joy from finding things in Nature, already composed, than I do from my finest personal arrangements."

With more time to reflect on his work, he began to realize with greater clarity what went on in his mind as he exposed a negative in his camera. "I start with no preconceived idea – discovery excites me to focus – then rediscovery through the lens – final form of presentation seen on ground glass, the finished print previsioned

Stuttgart eröffnet werden sollte, die Beiträge der an der amerikanischen Westküste lebenden Photographen auszuwählen. Neutra, ein aus Österreich stammender, vom Bauhaus beeinflußter Architekt, bat Weston auch um einen kurzen Text für den Katalog. In diesem Text ging Weston auf die Tatsache ein, daß seine Auswahl von kalifornischen Photographen dominiert wurde: »Physisch und psychisch bietet Kalifornien – unbelastet von Traditionen, weniger durch Konventionen eingeschränkt, offener, freier, jugendlicher – einen unbebauten Boden, aus dem ein neues Gefühl für das Leben und eine neue Manifestation des Lebens auftauchen wird.«

Für Weston war 1929, das Jahr des großen Börsenzusammenbruchs, ein in künstlerischer und privater Hinsicht äußerst erfolgreiches Jahr. Es war das Jahr, in dem er sich an dem Ort niederließ, der bis zu seinem Tod sein Zuhause bleiben sollte. Er verliebte sich in Sonya Noskowiak, die zu ihm in sein Haus zog, in dem in ständig wechselnden Konstellationen auch seine Söhne bei ihm wohnten. Und sogar in finanzieller Hinsicht war es ein ertragreiches Jahr. Stolz notierte er, er habe sich selbst einen neuen Plattenspieler und Brett eine Kamera gekauft, seine Söhne unterstützt und Flora in schwierigen Zeiten geholfen, und dennoch sei es ihm zum ersten Mal gelungen, seine Ersparnisse auf 800 Dollar zu erhöhen.

Westons Leben und seine Karriere begannen sich zu verändern. In seinen Tagebüchern notierte er, daß er nur noch etwa alle zwei Wochen die Zeit finde, Eintragungen zu machen. Er war voll und ganz damit beschäftigt, zu photographieren und die ständig anwachsende Korrespondenz zu erledigen, die der Ruhm mit sich brachte: »Bitten um Abzüge für Ausstellungen und Veröffentlichungen, Antworten auf Fragen, Anfragen von Leuten, die meine Schüler werden wollen.« Auch sein künstlerisches Selbstvertrauen wuchs. Begeistert verkündete er ständig, sein letztes Werk sei sein schönstes überhaupt. Am 8. März 1930 schrieb er zum Beispiel: »Gestern habe ich Photographiegeschichte geschrieben.« Er hatte zwei Negative von Seetang

détail de texture, de mouvement, de proportion » . Le concept westonien de prévisualisation, d'anticipation exacte du tirage final avant même qu'il n'expose le négatif, a influencé d'innombrables photographes ; parmi eux Ansel Adams, qui met au point son *Zone System* pour prévoir avec précision la manière dont les négatifs couleurs seront transposés dans un tirage en noir et blanc.

Au Mexique, Weston s'était déjà demandé à quoi ressembleraient ses tirages sur papier noir et blanc brillant. A son retour aux Etats-Unis, il abandonne les papiers au platine et au palladium, bien que ceux qu'il utilise juste après soient encore de tonalité assez chaude et de surface pas tout à fait lisse. En mars 1930, tout en développant quelques images pour un magazine imprimé sur papier brillant, il décide de passer au papier d'épreuve brillant. Il se rend compte qu'il sera peut être obligé de retirer toute son œuvre, mais il est convaincu que c'est une étape logique dans sa recherche de la « beauté photographique ». Il ne désire « aucune émotion au second degré due à des papiers, des couleurs ou à des surfaces recherchées : seuls le rythme, la forme et la perfection du détail sont à considérer ».

L'augmentation du prix de ses tirages – d'habitude 15 dollars chacun – lui permet d'envisager de se libérer de ce qui l'ennuie le plus : au milieu de l'année 1930, il annonce qu'il ne retouchera plus ses portraits, conscient qu'il perdra ainsi nombre de ses clients. Bien qu'il lui faille un certain temps pour décourager ceux qui lui demandent d'atténuer l'œuvre des années sur leur visage, il est très soulagé de devoir passer beaucoup moins de temps à la retouche et au travail fastidieux sur les tirages et les négatifs.

Au cours de l'été, la Delphic Studio Gallery d'Alma Reed lui propose sa première exposition personnelle à New York. Reed, qui vient de décider de se séparer de tous ses artistes pour se consacrer à Orozco, change d'avis lorsqu'elle lui rend visite en compagnie du peintre et découvre ses tirages récents. La promesse d'une exposition à New York met Weston en joie. « Le

complete in every detail of texture, movement, proportion, before exposure …" Weston's concept of previsualization, of anticipating exactly how the final print will look even before he exposes the negative, has influenced countless photographers since, including Ansel Adams, who developed his *Zone System* to accurately predict the manner in which colored negatives would turn out in a black-and-white print.

In Mexico, Weston had wondered what his prints would look like on truly glossy black-and-white paper, and once back in the United States he had dropped platinum and palladium papers altogether. But the papers that he first adopted were still fairly warm in tone and had a moderately soft surface. In March 1930, while making some prints for reproduction in a magazine using glossy paper, he immediately made up his mind to switch to a truly glossy paper. Although he realized this would eventually mean having to reprint his entire portfolio, he considered this a logical step in his quest for "photographic beauty." He wanted "no secondhand emotion from exquisite paper surfaces or color: only rhythm, form and perfect detail to consider."

Rising print sales – usually at $ 15 apiece – finally allowed Weston to contemplate ridding himself of his greatest annoyance; in mid-1930, knowing he would forfeit some sittings, he announced he would no longer retouch any portrait. Although it took some time to turn away every client who demanded their blemishes or years be removed from their portrait, Weston was greatly relieved to be able to reduce the hours spent tediously spotting prints and negatives.

In the summer of 1930 he was offered his first one-man exhibition in New York, at Alma Reed's Delphic Studio gallery. Reed, who had just decided to drop all her artists and represent only Orozco, changed her mind when she and Orozco visited Weston and saw his recent prints. The promise of a New York show exhilarated

aufgenommen und war davon überzeugt, daß sie »eines Tages als beste Beispiele meiner Ausdruckskraft und meines künstlerischen Verständnisses begehrt« sein würden. Als er nach einem Sturm am Strand entlanggelaufen war, hatte er einen »verwickelten, verhedderten, ineinandergeschlungenen« Seetanghaufen entdeckt«, ein Chaos verzerrter Rhythmen«. Er »organisierte das scheinbar verwickelte Wirrwarr und präsentierte es mit ausdrucksstarker Integration«. Stolz notierte er, daß er außer seiner Kamera nichts bewegen mußte. »Die bereits komponierten Dinge, die ich in der Natur entdecke, machen mir größere Freude als meine schönsten Arrangements.«

Es begann ihm jetzt mit größerer Klarheit bewußt zu werden, was in ihm vorging, wenn er ein Negativ in seiner Kamera belichtete. »Ich fange ohne eine vorgefaßte Idee an – die Entdeckung löst in mir die Fokussierung aus –, dann folgt die erneute Entdeckung durch die Linse – die endgültige Präsentationsform sehe ich auf der Mattscheibe, in allen Details der Textur, der Bewegung, der Proportion steht der fertige Abzug vollständig vor meinem inneren Auge, vor der Belichtung …«. Westons Konzept der Prävisualisierung, der genauen Vorwegnahme des endgültigen Abzugs noch bevor das Negativ belichtet wird, hat seither zahllose Photographen beeinflußt, zum Beispiel Ansel Adams, der sein »Zone System« entwickelte, um das Ergebnis eines Farbnegativs auf einem Schwarzweißabzug vorhersagen zu können.

In Mexiko hatte Weston sich gefragt, wie seine Abzüge auf wirklich glänzendem Schwarzweißpapier aussehen würden, und nach seiner Rückkehr in die Vereinigten Staaten hatte er sich von Platin- und Palladiumpapieren völlig abgewandt. Die Papiere, die er darauf zunächst verwendet hatte, hatten jedoch immer noch einen recht warmen Ton und eine einigermaßen sanfte Oberfläche. Als er im März 1930 für die Reproduktion in einer Zeitschrift einige Abzüge auf glänzendem Papier machte, entschloß er sich auf der Stelle, zu wirklich glänzendem Papier überzuwechseln. Er betrachtete diese Umstellung als einen logischen Schritt in seinem Wunsch nach »photographischer

futur se déployait en un instant, tout était justifié par le passé ». L'exposition approchant, il rédige des dizaines de lettres personnelles et envoie lui-même plus de deux cents invitations. Mais un jour avant le vernissage, un désastre se profile : les tirages ne sont pas arrivés à la galerie. Après de multiples échanges de télégrammes, ils sont finalement retrouvés et livrés. Orozco lui-même procède à l'accrochage. Bien que Weston ne se déplace pas pour l'exposition, il sent qu'elle remporte un grand succès. Plusieurs tirages sont vendus, dont l'un à Edward Steichen qui allait devenir responsable du département des photographies au Museum of Modern Art après la Seconde Guerre mondiale. A la fin de l'exposition new-yorkaise, Weston se voit proposer d'autres expositions à Chicago, Berkeley, Seattle, Denver, San Francisco et Carmel.

Plus il réfléchit à son œuvre, plus il sent que le rythme en est l'élément central. « Je suis un aventurier dans un voyage d'exploration, ouvert aux impressions fraîches, assoiffé d'horizons neufs, non pas comme un conquérant qui voudrait s'imposer, lui-même ou ses idées, mais pour m'identifier et m'unir à ce que je suis capable d'identifier comme m'appartenant: le « moi » des rythmes universels ».

Au même moment, il prend conscience que « l'art pour l'art est un échec ». L'artiste doit avoir un public et des échanges doivent se produire entre eux. « Je n'essaye pas de faire de l'artiste un propagandiste, un réformateur social, mais je dis que l'art doit offrir une qualité vivante qui le relie aux besoins présents ou aux espoirs futurs ». Weston qui a été pacifiste pendant la Première Guerre mondiale, critique tout autant le capitalisme et le communisme. Ardent défenseur de l'individu, il se rebelle contre tout ce qui rappelle la masse ou la pensée unique. « Je regarde les visages qui passent dans la rue ou se rassemblent en foules, et me sens sans espoir », écrit-il en 1932. Alors que la crise économique se poursuit et s'aggrave, il comprend que son existence à Carmel est un privilège. En avril 1932, il note : « Devant nous

Weston. "The future unfolded in a flash, all justified by the past." As the exhibition approached, he wrote dozens of personal letters and sent out more than two hundred announcements himself. But the day before the opening, disaster loomed; his prints had still not arrived at the gallery. After frantic transcontinental telegrams, the prints were eventually found and delivered. Orozco himself hung the exhibition. Although Weston didn't attend the exhibition himself, he felt it was a critical success. Several prints were sold, including one to Edward Steichen, the photographer who would eventually head the Department of Photographs at the Museum of Modern Art. By the end of the New York exhibition, Weston found himself with other exhibition offers in Chicago, Berkeley, Seattle, Denver, San Francisco, and Carmel.

The more Weston mused over his work, the more he felt that rhythm was the central element. "I am the adventurer on a voyage of discovery, ready to receive fresh impressions, eager for fresh horizons, not in the spirit of a military conqueror to impose myself or my ideas, but to identify myself in, and unify with, whatever I am able to recognize as significantly part of me: the 'me' of universal rhythms."

At the same time, Weston realized that "art for art's sake" is a failure. The artist must have an audience, and there must be some give and take between the two. "I am not trying to turn the artist into a propagandist, a social reformer, but I say that art must have a living quality which relates it to present needs, or to future hopes …" Weston had been a pacifist during World War I, and he was as critical of capitalism as he was of communism. An ardent believer in the individual, he rebelled against anything that reeked of mobs or mass-thinking. "I look into faces that pass in the street, or gather in crowds, – and feel hopeless," he wrote in 1932.

Schönheit«, obwohl ihm bewußt war, daß dieser Schritt in letzter Konsequenz bedeutete, sein gesamtes bisheriges Schaffen neu abziehen zu müssen. An die Stelle »aus exquisiten Papieroberflächen oder -tönen herrührender Emotionen aus zweiter Hand« sollte »die alleinige Betrachtung des Rhythmus, der Form und des vollkommenen Details« treten.

Die steigenden Preise für Abzüge – im Durchschnitt 15 Dollar pro Stück – ließen es schließlich möglich werden, daß Weston sich von seinem größten Ärgernis befreien konnte; wohl wissend, daß er damit manchen Auftrag einbüßen würde, gab er Mitte der 30er Jahre bekannt, er werde von nun an keine Porträtphotographien mehr retuschieren. Es kostete ihn zwar einige Zeit, jeden Kunden abzuweisen, der auf einem geglätteten oder »verjüngten« Porträt bestand, doch es war eine große Erleichterung für ihn, nicht mehr stundenlang Abzüge und Negative angeödet bearbeiten zu müssen.

Im Sommer 1930 wurde ihm seine erste Einzelausstellung in New York angeboten: in Alma Reeds Galerie »Delphic Studio«, die auch José Clemente Orozco vertrat. Die Aussicht auf eine Ausstellung in New York versetzte Weston in Hochstimmung. »Blitzartig entfaltete sich die Zukunft, ganz durch die Vergangenheit gerechtfertigt.« Als die Ausstellung näher rückte, schrieb er Dutzende persönliche Briefe und verschickte selbst mehr als 200 Ankündigungen. Doch am Tag vor der Eröffnung drohte das Desaster; seine Abzüge waren noch nicht in der Galerie angekommen. Verzweifelt wurden Telegramme quer über den Kontinent gejagt, bis sie schließlich gefunden und angeliefert wurden. Die Ausstellung erwies sich als ein durchschlagender Erfolg für Weston, der selbst nicht nach New York reiste. Mehrere Abzüge wurden verkauft, einer davon an Edward Steichen, den Photographen, der nach dem Zweiten Weltkrieg Direktor des Department of Photographs des Museum of Modern Art in New York werden sollte. Als die New Yorker Ausstellung zu Ende ging, lagen Weston weitere Ausstellungsangebote aus Chicago, Berkeley, Seattle, Denver, San Francisco und Carmel vor.

s'étend une moisson couleur moutarde, parsemée de pourpre, un refuge pour les alouettes. Dans le lointain, les collines et les vallons, Point Lobos et l'écume de la mer, à l'est une grange protégée par un cyprès sombre et solitaire, des mouettes qui s'aventurent au-dessus des terres, des bouffées d'embruns, ou des nuages de pluie – le tout plein de vie. Et pas très loin, des « soupes populaires », la faim, les foules, le meurtre, la mort ».

La même année voit également la publication de son premier livre de photographies et l'organisation de ce qui sera considéré plus tard comme une exposition collective d'importance historique. Le livre intitulé *The Art of Edward Weston* est conçu par le flamboyant agent et défenseur de l'art moderne, Merle Armitage. Weston est extrêmement fier de la maquette de son ouvrage et de la qualité des reproductions.

L'exposition qui se tient au M.H. de Young Museum de San Francisco annonce la formation du Group «f/64», et manifeste l'irruption de la photographie moderniste sur la côte Ouest. Le groupe commence sous forme d'une association amicale fondée lors d'une soirée chez Willard Van Dyke. Six des photographes présents – Weston, Noskowiak, Van Dyke, Ansel Adams, Imogen Cunningham et John Paul Edwards – décident que ce serait une bonne idée de louer un espace à San Francisco et de monter une exposition pour stimuler l'intérêt pour la « vraie photographie » ainsi que pour encourager de nouveaux talents. Le lieu trouvé est finalement le M.H. de Young Museum – à la suggestion de son directeur – grand amateur de photographie – qui propose plusieurs salles [moins d'un an plus tôt Weston avait fait l'objet d'une grande exposition personnelle au même endroit]. Lors de l'ouverture, quatre autres photographes rejoignent le groupe : Preston Holder, Consuela Kanaga, Alma Lavenson et Brett Weston.

A partir de 1933, Weston se tourne de plus en plus vers le paysage. Au cours des quinze années suivantes, il photographie pratiquement toute la Californie, diverses régions du Nord-Ouest et du Sud-Ouest, et de

As the economic crisis of the Depression not only continued but worsened, Weston realized that his exist-ence in Carmel was privileged. In April, 1932 he wrote: "Before us is a meadow of yellow mustard, sprinkled with purple, a home for meadowlarks. The background of rounded hills, Point Lobos, foam-washed in the distance, east-ward a barn, protected by a lone black cypress, sea gulls soaring inland, wisps of swift-sailing fog, or banks of April shower clouds, – all rich in fulfillment, Life. And not so many miles away breadlines, hunger, mobs, murder, Death."

The same year also saw the publication of his first book of photographs and what would later turn out to be an historic group exhibition. The book was *The Art of Edward Weston*, edited by the flamboyant impresario and promoter of modern art, Merle Armitage. Weston was extremely proud of Armitage's design and the quality of the printing.

The exhibition, held at San Francisco's M.H. de Young Museum, announced the formation of Group f/64. This landmark exhibition served as a formal statement that the West Coast version of modernist photography had arrived. Group f/64 began as a friendly undertaking at a party one night at Willard Van Dyke's. Six of the photographers at the party – Edward Weston, Sonya Noskowiak, Willard Van Dyke, Ansel Adams, Imogen Cun-ningham, and John Paul Edwards – decided it would be a good idea to rent a room in San Francisco in order to mount exhibitions to stimulate interest in "real photography" and encourage new talent.

The site was eventually shifted to the M.H. de Young Museum at the suggestion of the director, who was very supportive of photography and who offered the group several galleries. [Less than a year earlier, Weston had had a large one-man exhibition at the de Young.] By the time the exhibition opened, four other photographers had been included: Preston Holder, Consuela Kanaga, Alma Lavenson, and Brett Weston.

Je mehr Weston über sein Werk nachdachte, desto deutlicher wurde ihm bewußt, daß das Zentralelement der Rhythmus war. »Ich bin ein Abenteurer auf Entdeckungsfahrt, empfangsbereit für neue Eindrücke, erpicht auf neue Horizonte, nicht im Geiste eines militärischen Eroberers, um mich oder meine Vorstellungen anderen aufzuzwängen, sondern um mich mit allem zu identifizieren und zu vereinen, was ich signifikant als Teil meines Ichs erken-nen kann: des Ichs universaler Rhythmen.« Zur selben Zeit erkannte Weston »L'art pour l'art« als einen Fehlschlag. Der Künstler braucht ein Publikum, und zwischen dem Künstler und seinem Publikum muß es ein Geben und Nehmen geben. »Es geht mir nicht darum, den Künstler zu einem Propagan-disten, einem Sozialreformer zu machen, aber ich sage, daß die Kunst etwas Lebendiges haben muß, das sich auf heutige Bedürfnisse oder künftige Hoffnungen bezieht …« Im Ersten Weltkrieg war Weston Pazifist gewesen, und er stand dem Kapitalismus genauso kritisch gegenüber wie dem Kommunismus. Als glühender Verfechter des Individualismus rebellierte er gegen alles, was nach Masse oder Mob roch. »Ich sehe in die Gesichter, die auf der Straße an mir vorbeilaufen oder sich zu Menschenmassen versam-meln – und verliere jede Hoffnung«, schrieb er 1932.

Als sich die Weltwirtschaftskrise fortsetzte, wurde Weston bewußt, daß er in Carmel ein privilegiertes Leben führte. Im April 1932 schrieb er: »Vor uns eine senfgelbe Wiese, durchsetzt mit Lila, ein Zuhause für die Lerchen. Hinter uns sanfte Hügel, Point Lobos meerumschäumt in der Ferne. Nach Osten eine Scheune im Schutz einer einsamen schwarzen Zypresse. Landeinwärts fliegende Seemöwen, schnell dahineilende Nebelwölkchen oder Regen-wolkenbänke im April – alles strotzt vor Leben. Und nur wenige Meilen von hier bitterste Not, Hunger, Mobs, Mord, der Tod.«

1932 war auch das Jahr, in dem seine Photographien zum ersten Mal in einem Buch veröffentlicht wurden und in dem er sich an einer Gruppenausstellung beteiligte, der später ein historischer Rang beigemessen werden sollte. Das

nombreux sites des Etats-Unis. Le paysage devient son sujet dominant au moment où, partout dans le pays, des artistes explorent en profondeur la réalité américaine. Les paysages de Weston suggèrent que l'essence du carac-tère américain tient directement à la relation entre ce peuple et sa terre. Il met fin à sa relation de cinq ans avec Sonya Noskowiak en avril 1934. Au cours des dernières années, il a entretenu diverses liaisons et a décidé qu'il ne pouvait plus « vivre dans le mensonge ». Déclarant que les autres femmes sont « aussi inévitables que les marées », il rompt avec Sonya, et cinq jours plus tard seulement, photographie Charis Wilson dont il s'éprend et affirme qu'elle sera « le grand amour de sa vie ».

Il avait remarqué Charis lors d'un concert et s'était fait présenter. Il la décrit comme « une grande fille superbe, au corps finement proportionné, au visage intelligent piqué de taches de rousseur, aux yeux bleus, aux cheveux bruns dorés tombant sur les épaules ». Cinq ans plus tard, il obtient enfin le divorce de Flora afin de pouvoir épouser Charis. Leur couple sera à de nombreux égards une réussite. Excellent écrivain, Charis est la seule de ses compagnes à ne pas pratiquer la photographie, mais ils réaliseront ensemble plusieurs livres.

Juste au moment où il rencontre Charis, son ami et soutien Merle Armitage lui donne un nouveau coup de main. Armitage est nommé responsable de la division de Californie du Sud du Public Works of Art Project, un programme fédéral conçu pour donner du travail aux artistes pendant la Grande Dépres-sion. Il engage immédiatement Weston bien que celui-ci vive en Californie du Nord. Pendant quelques mois, il perçoit un modeste salaire pour continuer à travailler. Les autres photographes du programme – dont son fils Brett et Sonya Noskowiak – sont employés à reproduire l'œuvre de peintres et de sculpteurs pour les archives du Gouvernement.

A la fin de 1934, Weston rédige la dernière des entrées régulières de son journal qu'il a fidèlement tenu depuis 1917 [en 1944, il écrira quelques pages

From 1933, Weston turned increasingly to landscape. During the next fifteen years, he photographed nearly every area of California and parts of the Northwest and Southwest, in addition to photographing his way across the United States. The landscape became his dominant subject at a time when artists across America were deeply involved in defining the American experience. Weston's landscapes suggest that the essence of the American character emerges directly from people's relationship to the land.

Weston ended a five-year relationship with Sonya Noskowiak in April 1934. Over the past few years he had found himself drawn into affairs with other women and had decided he could no longer "live a lie" with her. Declaring that other women were "as inevitable as the tides," he broke off with her and she moved out. Five days later, Weston photographed and immediately fell in love with Charis Wilson, whom he predicted would be "the great love of my life."

Weston had glimpsed Charis at a concert and had arranged an introduction to her. He described her as a "tall, beautiful girl, with finely proportioned body, intelligent face well-freckled, blue eyes, golden brown hair to shoulders." Five years later, Weston finally obtained a divorce from Flora so that he and Charis could marry. In many respects it was a great partnership. An excellent writer, Charis was the only one of Weston's serious loves who never practiced photography. Instead, they produced several books together as equals.

Just at the time that he met Charis, Weston's friend and supporter Merle Armitage was able to help him out once again. Armitage had gotten himself named as head of the Southern California division of the Public Works of Art Project [PWAP], a federal program created to employ artists during the Depression. He immediately signed on Weston, in spite of the fact that he lived in northern California, and for a few months Weston was

Buch war *The Art of Edward Weston*, herausgegeben von Merle Armitage, einem extravaganten Agenten und Förderer der modernen Kunst. Auf die Druckqualität und auf Armitages Gestaltung des Buches war Weston ungemein stolz. Die Ausstellung fand im M.H. de Young Museum in San Francisco statt und war der kurz zuvor gebildeten Gruppe »f/64« gewidmet. Sie war ein Meilenstein in der Geschichte der modernen Photographie, der den Vorstoß der Photographen der amerikanischen Westküste zur internationalen Avantgarde markierte.

Die Idee der Gruppe »f/64« wurde auf einer Party bei Willard Van Dyke geboren. Dort beschlossen sechs der anwesenden Photographen – Edward Weston, Sonya Noskowiak, Willard Van Dyke, Ansel Adams, Imogen Cunningham und John Paul Edwards – einen Raum für Ausstellungen in San Francisco anzumieten, um das Interesse an der »echten Photographie« und neue Talente zu fördern. Als der für Photographie engagierte Direktor des MH de Young Museum der Gruppe mehrere Galerieräume zur Verfügung stellte, wurde dieses Angebot dankbar angenommen. [Kaum ein Jahr zuvor hatte Weston eine Einzelausstellung in diesem Museum gehabt.] In der Ausstellung waren schließlich vier weitere Photographen vertreten: Preston Holder, Consuela Kanaga, Alma Lavenson und Brett Weston.

Seit 1933 wandte Weston sich mehr und mehr der Landschaft zu. In den folgenden 15 Jahren photographierte er nahezu alle Gegenden Kaliforniens und viele weitere Landschaften in allen Teilen der Vereinigten Staaten, insbesondere im Nord- und Südwesten. Die Landschaft wurde sein wichtigstes Thema in einer Zeit, als Künstler in ganz Amerika sich darum bemühten, das amerikanische Lebensgefühl zu definieren. Westons Landschaftsphotographien vermitteln den Eindruck, die spezifisch amerikanische Wesensart gehe unmittelbar aus der Beziehung der Menschen zum Land hervor.

Im April 1934 beendete Weston seine fünfjährige Beziehung mit Sonya Noskowiak. In den letzten Jahren hatte er immer wieder Affären mit anderen

pour résumer les dix années écoulées]. Ses *daybooks* lui ont servi en partie de journal et en partie à noter ses réflexions sur les défis que lui posaient sa vie ou son art. Il relit souvent ce qu'il a écrit et le commente, entretenant ainsi une sorte de dialogue avec lui-même à travers le temps. Plusieurs fois, il en détruit des parties entières – ce qu'il lui arrive de regretter – et prétendra que ce journal n'est guère plus « qu'un bon moyen d'évacuer, de nettoyer le cœur et l'esprit » avant de partir prendre des photographies. Vers les années 30, il pense à le publier [souvent quand il est à court d'argent], mais seuls quelques extraits paraîtront de son vivant dans des magazines. En 1961, le journal sera finalement édité dans une version légèrement revue par sa biographe et historienne de la photographie Nancy Newhall. Peu de photographes nous ont laissé une image aussi révélatrice de leur art, de leur vie et de leur époque.

Weston et Brett s'installent à Santa Monica en 1935, où Charis les rejoint quelques mois plus tard. Comme toutes ses relations précédentes – à l'exception de Flora –, Charis lui sert de modèle et il réalise avec elle certains de ses nus les plus célèbres. Il la photographie dans son studio mais aussi sur la plage d'Oceano, dans les dunes, en une suite de poses naturelles. Oceano est un de ces lieux inspirateurs qui lui permettent des avancées majeures. Il prend également un certain nombre de photos de dunes, étonnamment lyriques, presque totalement abstraites, qui captent les effets de la lumière et du vent sur le sable. En 1937, il reçoit la première bourse Guggenheim jamais accordée à un photographe. Charis et lui partent immédiatement pour une série de voyages en Californie. Grâce à ses deux bourses consécutives, ils accomplissent plus de 40 000 kilomètres en voiture et Weston prend environ 1500 clichés. Une petite partie de ces images, accompagnées d'un fascinant récit de voyage écrit par Charis, est incluse dans un livre, publié en 1940 sous le titre de *California and the West*. L'argent de cette bourse leur permet aussi de demander à Neil, le fils d'Edward, de construire la « bicoque » dont celui-ci rêvait depuis des années. Sur une parcelle de terrain des hautes terres de

actually paid a modest salary to continue being a photographer. All the other photographers on the program, including his son Brett and his old love, Sonya Noskowiak, were employed copying the works of painters and sculptors for government files.

As 1934 ended, Weston made the final regular entry in his daybooks, which he had kept faithfully since about 1917. [In 1944 he added a few pages summarizing the ten intervening years.] The daybooks had served as part diary and part meditation on the issues that faced him in his life and art. He often went back to read and comment on earlier entries, carrying on a dialogue with himself over the weeks and years. Several times he had destroyed entire sections of the daybooks [which he came to regret], and at one point he claimed the daybooks were little more than "a good place to evacuate, cleanse the heart and head" before going out to photograph. But Weston knew otherwise, and by the 1930s, he had begun to contemplate editing and publishing the daybooks [usually when he was short of money], although in the end only excerpts were published in magazines during his lifetime. In 1961, the daybooks were finally released in a version slightly edited by biographer and photographic historian Nancy Newhall. Few photographers have left behind such a revealing picture of their art, life, and times.

Weston and Brett moved to Santa Monica in 1935, with Charis following and moving in a few months later. Like all of his earlier loves [except Flora], Charis served as Weston's model, and he made many of his most famous nude studies with her. In addition to photographing her in the studio, they would drive up to the beach at Oceano, where he photographed her nude in the dunes in a series of strikingly informal, unposed positions. Oceano proved to be one of those inspiring locations that led to major breakthroughs for Weston. He also made

Frauen gehabt, und er entschied, daß er nicht mehr »in Lüge« mit ihr zusammenleben könne. Mit der Erklärung, Verhältnisse mit anderen Frauen seien in seinem Leben »so unausbleiblich wie die Gezeiten«, brach er die Beziehung ab, und sie zog aus. Als er nur fünf Tage später Charis Wilson photographierte, verliebte er sich sofort in sie und sah in ihr »die große Liebe meines Lebens«. Charis war Weston bei einem Konzert aufgefallen, und er ließ sich mit ihr bekannt machen. Er beschrieb sie als »ein hochgewachsenes, wunderschönes Mädchen mit einem schön proportionierten Körper, einem intelligenten, sommersprossigen Gesicht, blauen Augen und schulterlangem, goldbraunem Haar«. Fünf Jahre später erreichte Weston schließlich die Scheidung von Flora, so daß er und Charis heiraten konnten. In vieler Hinsicht war es eine großartige Partnerschaft. Charis, eine ausgezeichnete Autorin, war Westons einzige Lebensgefährtin, die sich nie als Photographin betätigte. Statt dessen veröffentlichten sie mehrere Bücher.

Genau zu der Zeit, als Weston Charis kennenlernte, konnte ihm sein Freund und Förderer Merle Armitage wieder einmal helfen. Armitage hatte sich zum Leiter des Public Works of Art Project [PWAP] für den Verwaltungsbezirk Südkalifornien ernennen lassen. Dieses Programm war von der amerikanischen Bundesregierung ins Leben gerufen worden, um Künstlern während der Depression Beschäftigungs- und Verdienstmöglichkeiten zu verschaffen. Unmittelbar nach seiner Ernennung ging er über die Tatsache hinweg, daß Weston in Nordkalifornien lebte, und nahm ihn unter Vertrag. Einige Monate lang bezog Weston ein bescheidenes Gehalt, um seine künstlerische Tätigkeit als Photograph fortsetzen zu können.

Ende 1934 machte Weston den letzten regulären Eintrag in seine Tagebücher, die er seit etwa 1917 regelmäßig geführt hatte. [1944 fügte er einige Seiten hinzu, die die seither vergangenen zehn Jahre rekapitulierten.] In seinen Tagebüchern hielt er nicht nur die Ereignisse des Tages fest, sondern auch seine Gedanken über das, was ihm in seinem Leben und in seiner Kunst

Carmel appartenant au père de Charis, ils construisent « Wildcat Hill », une confortable maison en bois constituée d'une seule pièce, mais équipée d'un petit laboratoire.

Lorsque l'argent Guggenheim est dépensé, Merle Armitage, une fois encore, fait participer Weston à son nouveau projet. Il a reçu commande de la maquette d'une nouvelle édition du recueil de poèmes de Walt Whitman, *Leaves of Grass*, de la part du Limited Editions Club, et a convaincu les éditeurs de demander à Weston de réaliser les photos. Bien que Weston ait fait savoir qu'il n'avait pas l'intention d'illustrer littéralement les poèmes, les éditeurs semblent penser autrement. Weston et Charis reprennent donc la route, cette fois en direction du Texas, jusqu'à la Nouvelle-Orléans, puis le Maine. Ils séjournent également plusieurs semaines à New York.

Ce voyage permet à Weston, pour la première fois de sa vie, de développer sa vision du paysage américain au-delà des limites de la côte Ouest. Lorsqu'en décembre 1941, les événements de Pearl Harbour les contraignent à rentrer en Californie, ils ont parcouru plus de la moitié des quarante-huit Etats et Weston a réuni plusieurs centaines de négatifs. Lorsque le livre est finalement publié, à la fin de 1942, Weston est furieux de la médiocre qualité des reproductions et de la maquette. Merle Armitage, merveilleux directeur artistique, a été remercié par le Limited Editions Club, et son remplaçant a placé un filet vert pâle autour des photos de Weston …

Au cours de la dernière décennie de sa carrière, son travail se fait encore plus subtil et ses centres d'intérêt se multiplient. Peu de photographies de cette période exercent le même impact que les poivrons, les coquillages, les dunes ou les nus de Tina et de Charis, mais on y trouve une remarquable maturité et une force de vision très sûre. Les compositions sont plus complexes, mais surtout ces dernières œuvres semblent inviter le spectateur à partager un univers, presque intimiste : la famille, les amis, des chats, des voyages en automobile et des pique-niques à Point Lobos en composent l'essentiel.

a number of photographs of the dunes themselves – stunningly lyrical, almost totally abstract images that captured the patterning effects of light and wind on the sand.

In 1937, Weston was awarded the first Guggenheim Fellowship ever given to a photographer. He and Charis immediately set out upon a series of driving tours through California. During the course of his two successive fellowships, they drove more than 25,000 miles and Weston made approximately 1,500 negatives. A small percentage of these images, along with Charis's fascinating account of their travels, were included in a book published in 1940, *California and the West*. The money from the Guggenheim Fellowships also allowed Charis and Weston to commission his son Neil to finally build the "shack" he had dreamed about years earlier. Using a plot of land in Carmel Highlands that was owned by Charis's father, they built Wildcat Hill, a comfortable one-bedroom, wooden house with a small darkroom.

Just as the Guggenheim money ran out, Merle Armitage once again pulled Weston into his latest project. Armitage had been asked to do the book design for a new edition of Walt Whitman's poem cycle *Leaves of Grass*, to be published by the Limited Editions Club. He convinced the publisher to let Weston make photographs for the project. Although Weston claimed he had no intention of literally "illustrating" Whitman's poems, the publisher seemed to think otherwise. Nevertheless, he and Charis traveled across the Southwest, through Texas and into the South as far as New Orleans, where they turned north and went all the way to Maine. They also spent several weeks in New York City.

This trip allowed Weston, for the first time, to extend his vision of the American landscape to areas beyond the West. By the time the December 1941 bombing of Pearl Harbor by the Japanese had sent them back

begegnete. Er griff oft auf frühere Einträge zurück, um über die Wochen und Jahre hinweg einen Dialog mit sich selbst zu führen. Mehrmals vernichtete er ganze Teile seiner Aufzeichnungen [was er später bereute], und einmal sagte er, die Tagebücher dienten ihm nur dazu, »Herz und Kopf zu reinigen und freizumachen«, bevor er die Kamera in die Hand nehme. Er wußte jedoch um ihre tatsächliche Bedeutung, und in den 30er Jahren kam ihm immer wieder der Gedanke, sie für die Veröffentlichung zu bearbeiten. Zu seinen Lebzeiten sollten allerdings nur Auszüge in Zeitschriften veröffentlicht werden. 1961 erschienen die Tagebücher schließlich in einer leicht bearbeiteten Fassung, die seine Biographin, die Photographiehistorikerin Nancy Newhall, herausgab. Nur wenige Photographen haben eine derart aufschlußreiche Schilderung ihrer Kunst, ihres Lebens und ihrer Zeit hinterlassen.

1935 zogen Weston und sein Sohn Brett nach Santa Monica, und Charis folgte ihnen wenige Monate später nach. Wie alle seine früheren Geliebten [außer Flora] diente auch Charis ihm als Modell, und auf einigen seiner bekanntesten Aktstudien ist sie zu sehen. Er nahm sie nicht nur im Studio auf, sondern auch am Strand bei Oceano, wo er sie in einer Folge verblüffend ungezwungener, natürlicher Posen nackt in den Dünen photographierte. Oceano erwies sich als einer der inspirierenden Orte, die zu einem wichtigen Durchbruch in Westons Schaffen führten. Er nahm auch mehrere Photographien von den Dünen selbst auf – erstaunlich lyrische, fast völlig abstrakte Bilder, auf denen die vom Licht und Wind in den Sand gezeichneten Muster eingefangen sind.

1937 wurde Weston als erster Photograph überhaupt mit einem Guggenheim Fellowship ausgezeichnet. Er und Charis nutzten dieses Stipendium unverzüglich für mehrere Autoreisen durch ganz Kalifornien. Im Laufe seiner zwei aufeinanderfolgenden Stipendien der Guggenheim-Stiftung nahm Weston ungefähr 1.500 Negative auf. Zusammen mit Charis' faszinierendem Bericht über diese Reisen wurde ein kleiner Teil dieser Bilder 1940 in dem

L'une des plus remarquables nouveautés à l'époque est l'apparition de l'humour dans l'œuvre de Weston. En 1939 et 1940, il visite deux grands studios hollywoodiens – MGM et Twentieth Century Fox – et recrée un monde artificiel, presque surréaliste, à partir de décors de films, de fausses façades, de mannequins de caoutchouc. D'autres photographies témoignent de son intérêt prononcé pour le kitsch et les exemples humoristiques de l'art populaire américain.

Il est également capable de s'attacher à des sujets que de nombreux photographes dédaignent encore : les ruines des villes-fantômes californiennes, un gant jeté par un ouvrier d'une cimenterie, un morceau de bois bizarre arrondi, rappelant une sculpture de Jean Arp, ou le cadavre d'un homme que Charis et lui trouvent dans la Death Valley. Mais le plus inattendu des sujets de ces dernières années est sans doute celui des chats. Au cours de la Seconde Guerre mondiale, ne pouvant aller photographier à Point Lobos et gêné par les restrictions sur l'essence, il reste chez lui et commence à photographier ses nombreux chats à « Wildcat Hill ». Il a le temps et la patience de les prendre dans de multiples poses. Charis réunit ces images dans un livre, *The Cats of Wildcat Hill*, publié peu après la guerre. 1945 annonce la fin de la carrière du photographe. Alors qu'il prépare une grande rétrospective pour le Museum of Modern Art de New York, Charis et lui se séparent et le divorce est prononcé dans l'année qui suit. De 1946 jusqu'à ce qu'il abandonne la photographie, il ne fera plus qu'une poignée d'images dont peu d'entre elles sont vraiment intéressantes. La perte de Charis et les premières attaques de la maladie de Parkinson semblent rendre toute création difficile bien que Weston continue à travailler dans sa chambre noire.

En 1947, après avoir un peu hésité, il réalise ses premières expériences photographiques en couleurs. Il produit plusieurs dizaines d'ektachromes sur la Death Valley et Point Lobos, des portraits et d'autres sujets qu'il a déjà

to California, Weston and Charis had visited more than half the forty-eight states within the United States and Weston had hundreds more negatives to work from. But when the book was finally published in late 1942, Weston was furious with the mediocre quality of the reproductions and with the book's design. Merle Armitage, a marvelous book designer, had been dropped by the Limited Editions Club, and his replacement had put a pale green border around Weston's photographs.

In the final decade of his career, his work became more subtle and the imagery more varied. While few photographs from this era carry with them the revolutionary impact of the peppers and shells, of the dunes, or of the nudes of Tina and Charis, there is a remarkable maturity and confidence of vision in them. Compositions became more complex. But more importantly, Weston's later work seems to create and invite the viewer into a highly personal, almost intimate world of family, friends, cats, automobile trips, picnics at Point Lobos.

One of the more notable new directions for Weston was the introduction of humor into images. In 1939 and 1940, he visited the lots of two of the major Hollywood movie studios – MGM and Twentieth Century Fox – where he almost playfully turned movie sets, false-front buildings, rubber dummies, and other props into a surreal, artificial universe. Other photographs attest to his long-standing attraction to kitsch and to humorous examples of American folk art.

He was also capable of pointing his camera at subjects few thought photographic at the time: the ruins in California ghost towns, a cement worker's stiff discarded glove, a whimsical piece of rounded wood reminiscent of a sculpture by Jean Arp, and the body of a dead man that he and Charis had come across in Death Valley. But of all the new subjects of the late years, perhaps the most unexpected were his household cats. During World

Buch *California and the West* veröffentlicht. Die Gelder aus den Guggenheim Fellowships gestatteten es Charis und Weston auch, seinem Sohn Neil den Auftrag zu geben, endlich die »Hütte« zu bauen, von der er schon vor Jahren geträumt hatte. Auf einem Grundstück in den Carmel Highlands, das Charis' Vater gehörte, bauten sie »Wildcat Hill«, ein komfortables Holzhaus mit einem Schlafzimmer und einer kleinen Dunkelkammer.

Als das Geld aus den Guggenheim-Stipendien fast verbraucht war, kam einmal mehr Merle Armitage zu Hilfe. Er war vom Limited Editions Club mit der Buchgestaltung für eine Neuausgabe von Walt Whitmans Gedichtzyklus *Leaves of Grass* [*Grashalme*] beauftragt worden und konnte den Verleger dazu überreden, Weston die Photographien für das Projekt machen zu lassen. Weston erklärte, er habe nicht die Absicht, Whitmans Gedichte im eigentlichen Sinne zu »illustrieren«. Obwohl er damit den Vorstellungen des Verlegers nicht zu entsprechen schien, reisten er und Charis quer durch den Südwesten und durch Texas. Im Süden kamen sie bis nach New Orleans. Von dort aus ging es in den Norden bis hinauf nach Maine. Auch in New York City verbrachten sie mehrere Wochen. Auf dieser Reise konnte Weston seine Vision von der amerikanischen Landschaft zum ersten Mal auf Gebiete außerhalb des Westens ausdehnen. Als sie im Dezember 1941 nach der Bombardierung Pearl Harbors nach Kalifornien zurückkehrten, hatten Weston und Charis mehr als die Hälfte der Bundesstaaten der USA besucht und brachten Hunderte von Negativen mit nach Hause. Als das Buch jedoch Ende 1942 veröffentlicht wurde, war Weston außer sich über die Buchgestaltung und die mittelmäßige Qualität der Reproduktionen.

Im letzten Jahrzehnt seiner Laufbahn wurde sein Werk subtiler und die Motivik vielgestaltiger. Zwar machen nur wenige Photographien aus dieser Zeit den revolutionären Eindruck der Paprikaschoten und Muschelschalen, der Dünen oder der Aktaufnahmen von Tina und Charis, doch sind sie von einer bemerkenswert reifen und selbstsicheren visionären Kraft. Die Kompo-

photographiés en noir et blanc. Kodak en utilise plusieurs pour une campagne publicitaire. Curieusement, Weston semble très satisfait des résultats de cette rapide incursion dans la couleur. Vers 1952, il a l'idée de demander à Brett et à ceux de ses assistants en lesquels il a le plus confiance de tirer en nombre limité certains de ses plus importants négatifs. « Le projet », comme il l'appelle, se composera d'environ une douzaine d'exemplaires de plus de 800 images. Ces tirages sont appelés par les collectionneurs les « Project Prints ».

Edward Weston meurt le jour du Nouvel An 1958. Il avait commencé à photographier à une période dominée par l'amateurisme et a contribué à faire de la photographie un art. Il a réussi à s'élever au sommet de la photographie pictorialiste – avec son imagerie symbolique et d'atmosphère et ses tirages très travaillés – puis à dégager sa création de ces excès et de ces archaïsmes pour créer un art nouveau, à la fois classique et familier. Il a su avec génie laisser s'exprimer au mieux les objets de l'univers.

Dans ce parcours qui va faire de lui l'un des plus grands photographes modernistes aux multiples talents, Weston s'intéresse tout autant aux formes qu'il trouve dans l'art populaire et les aciéries, qu'aux coquillages et au corps humain, aux flaques d'eaux et aux déserts. Son œuvre, qui peut être à la fois abstraite et complètement réaliste, reste toujours sensuelle.

L'étonnante réussite de Weston en tant que photographe de paysages a été de réaliser des images remarquables des multiples paysages de l'Amérique. Bien qu'il soit surtout connu pour des lieux bien précis, comme Point Lobos ou les dunes d'Oceano, il réalise également des œuvres puissantes dans des régions aussi variées que les déserts, les montagnes, les terres de culture, les bayous de Louisiane et même les grandes villes américaines. Il a élargi le vocabulaire de la photographie de paysage aux transformations apportées par l'homme – bâtiments, routes, panneaux, pylônes électriques, barrières – et même aux villes entières.

War II, prohibited from photographing on Point Lobos and limited by fuel rationing and travel restrictions, Weston stayed at home, and began to photograph the antics of his many cats. There were always numerous cats living at Wildcat Hill and Weston was assured enough to pose and photograph them with all serious intent. Charis assembled these photographs into a book, *The Cats of Wildcat Hill*, which was published shortly after the war.

The year 1945 marked the beginning of the end for Weston. While working on a large retrospective exhibition for the Museum of Modern Art, New York, he and Charis separated. Within a year they were divorced. From 1946 until he stopped photographing, he made only a handful of images, none of them memorable. The loss of Charis and the early onset of Parkinson's Disease made creative work difficult, although he continued to print in the darkroom. In 1947, after some resistance, Weston experimented with color photography for the first time. He made several dozen Ektachrome transparencies of Death Valley, Point Lobos, portraits, and other subjects he had previously photographed in black-and-white. Kodak used several in an advertising campaign and, surprisingly, Weston enjoyed the results of his brief foray into color.

Sometime around 1952, Weston conceived of the idea of having Brett and other trusted darkroom assistants print a limited edition of some of his most important negatives. By the time they had finished "the project," as it came to be called, approximately one dozen copies had been made of more than eight hundred images. Collectors still refer to these prints as Project Prints.

Edward Weston died on New Year's Day, 1958. He had begun photography in an era of amateurs and had helped lead it to the level of a well-respected art. He had succeeded in rising to the top of the world of pictorial photography, with its moody and symbolic imagery and its heavily worked prints, only to turn and strip from

sitionen wurden komplexer. Vor allem jedoch scheint Weston mit seinen Photographien von Familienmitgliedern, Freunden, Katzen, Autoausflügen und Picknicks am Point Lobos eine sehr persönliche, fast schon intime Welt hervorzubringen und den Betrachter in diese Welt einzuladen. Zu den bemerkenswerteren Neuerungen in dieser Schaffensphase gehörte die Einführung des humoristischen Elements.

1939 und 1940 besuchte Weston die Gelände zweier großer Hollywood-Filmstudios – MGM und Twentieth Century Fox –, wo er fast spielerisch Filmkulissen, Blendfassaden, Gummiattrappen und andere Requisiten zu einem surrealen, künstlichen Universum zusammensetzte. Auch andere Photographien bezeugen seine ausgeprägte Vorliebe für Kitsch und humorvolle Beispiele der amerikanischen Volkskunst. Er richtete seine Kamera auch auf Sujets, die damals kaum ein anderer Photograph beachtet hätte: die Ruinen kalifornischer Geisterstädte, den weggeworfenen steifen Handschuh eines Zementarbeiters, ein seltsames rundes Stück Holz, das an eine Skulptur von Hans Arp erinnert, und die Leiche eines Mannes, auf die er und Charis im Death Valley gestoßen waren.

Die überraschendsten Sujets der späten Jahre waren jedoch seine Hauskatzen. Während des Zweiten Weltkriegs, als es verboten war, am Point Lobos zu photographieren, und Benzinrationierungen und Reisebeschränkungen verhängt wurden, war Weston gezwungen, zu Hause zu bleiben, wo er das Possenspiel seiner zahlreichen Katzen zu photographieren begann. An Katzen hatte es nie Mangel in Wildcat Hill [»Wildkatzenhügel«], und Weston wußte sie genauso aufmerksam zu posieren und zu photographieren wie alle seine anderen Motive. Charis stellte seine Photographien von Katzen zu dem Buch *The Cats of Wildcat Hill* zusammen, das kurz nach dem Krieg veröffentlicht wurde.

Das Jahr 1945 markierte für Weston den Anfang vom Ende. Mitten in den Vorbereitungen für eine Retrospektive im New Yorker Museum of Modern

Bien qu'il ait photographié des objets industriels assez régulièrement à partir de 1922, il dissocie leurs formes modernes de leurs fonctions économiques et de leurs conséquences sur l'homme. Il n'apprécie pas les facilités de la vie moderne – il parla un jour de l'automobile comme « d'une diabolique, bruyante invention » et déteste les effets de l'industrialisation. Alors qu'il vit au Mexique, il note avec dégoût que « si Henry Ford avait été contemporain des pyramides, avec son efficacité, on n'aurait pas trouvé le temps de les construire ».

Weston a developpé une approche qui représente la quintessence de la photographie moderne américaine, et plus spécifiquement californienne. Sa vie et son art ne font qu'un : directs, passionnés, sans compromis, révélateurs et en harmonie avec les rythmes de la nature.

photography all the excess and archaism in order to create a new photography that was at once classical and colloquial. His genius was to know how best to let the things of this world speak for themselves.

In the course of becoming perhaps America's finest and most versatile modernist photographer, Weston responded equally to the forms he found in folk art and steel mills, in shells and the nude body, in tide pools and in deserts. His work could be both abstract and completely realistic, but it was always sensuous. Weston's stunning achievement as a landscape photographer was to have made remarkable images of every type of landscape in America, although he is best known for several places that he photographed, notably Point Lobos and the sand dunes at Oceano. Weston also made strong works in areas as diverse as the desert, the mountains, rolling farmlands, the bayous of Louisiana, and even America's major cities. He expanded the visual vocabulary of landscape photography to include the man-made world – buildings, roads, signs, utility poles, fences – and sometimes entire cities.

Although he photographed industrial subjects fairly regularly from 1922 on, he disassociated their modern forms from their economic functions and human consequences. Weston disliked modern conveniences; he once referred to automobiles as "evil, noisome contraptions," and he reviled the effects of modern manufacturing. While living in Mexico City he noted with disgust that "if Henry Ford had lived contemporary with the Pyramids, and had served that age with his efficiency, there would have been no time nor labor for the building of them."

Weston developed a quintessentially American, and specifically Californian, approach to modern photography. His life and his art were one – direct, passionate, uncompromising, reflective, and in harmony with nature's rhythms.

Art trennten sich Charis und er. Innerhalb eines Jahres wurden sie geschieden. Von 1946 bis 1948, dem Jahr, in dem er das Photographieren aufgeben mußte, schuf er nur noch eine Handvoll Bilder, von denen keines wirklich bedeutend ist. Die Trennung von Charis und der frühe Ausbruch der Parkinsonschen Krankheit hatten seine Kreativität beeinträchtigt, auch wenn er noch immer Abzüge seiner Negative machte. Nach einigem Zögern experimentierte Weston 1947 zum ersten Mal mit der Farbphotographie. Vom Death Valley, von Point Lobos, von Porträtmodellen und anderen Sujets, die er in früheren Jahren auf Schwarzweißphotographien festgehalten hatte, nahm er mehrere Dutzend Ektachrome auf. Kodak verwendete mehrere davon für eine Werbekampagne, und erstaunlicherweise fand Weston Gefallen an den Ergebnissen seines kurzen Ausflugs in die Farbphotographie.

Um das Jahr 1952 herum kam Weston auf den Gedanken, Brett und andere bewährte Dunkelkammerassistenten Abzüge einiger seiner wichtigsten Negative in einer limitierten Edition anfertigen zu lassen. Als das »Projekt«, wie es genannt wurde, abgeschlossen war, hatten sie von mehr als 800 Bildern jeweils ungefähr ein Dutzend Abzüge gemacht. Sammler bezeichnen diese Abzüge noch heute als »Project Prints«.

Edward Weston starb am Neujahrstag des Jahres 1958. Er hatte in einer Zeit der Amateure zu photographieren begonnen und dazu beigetragen, die Photographie zu einer respektierten Kunstgattung zu machen. Es war ihm gelungen, in die ersten Reihen der Welt der piktorialistischen Photographie mit ihrer stimmungsvollen und symbolischen Bildsprache und ihren stark retuschierten Abzügen aufzusteigen, nur um sich von ihr zu lösen und die Photographie von allem Übermaß und Archaismus zu befreien und eine neue, zugleich klassische und »umgangssprachliche« Photographie hervorzubringen. Er wußte, wie er die Dinge dieser Welt am besten für sich selbst sprechen lassen konnte. Darin lag seine Genialität.

Während er sich zum vielleicht besten und vielseitigsten amerikanischen Photographen der Moderne entwickelte, ließ Weston sich von Formen ansprechen, die er in der Volkskunst und in Stahlwerken fand, in Muschelschalen und im nackten Körper, in Flutteichen und in Wüsten. Seine Photographien konnten sowohl abstrakt wie auch völlig realistisch sein, immer aber waren sie sinnlich.

Mit bemerkenswerten Darstellungen amerikanischer Landschaften aller Art hat Weston als Landschaftsphotograph eine phantastische Leistung erbracht. Bekannt geworden ist er vor allem durch Aufnahmen einiger bestimmter Orte – insbesondere Point Lobos und die Sanddünen bei Oceano, doch auch in der Wüste, den Bergen, den wogenden Feldern des mittleren Westens, den Sümpfen Louisianas und selbst in den amerikanischen Großstädten gelangen ihm Bilder von bezwingender Kraft. Er erweiterte das Vokabular der Landschaftsphotographie um von Menschenhand geschaffene Elemente – Gebäude, Straßen, Schilder, Telegraphenmasten, Zäune – , selbst ganze Städte.

Seit 1922 photographierte Weston ziemlich regelmäßig industrielle Sujets. Dabei trennte er ihre modernen Formen von ihren ökonomischen Funktionen und ihren Konsequenzen für die Menschheit. Vielen Errungenschaften der modernen Technik stand er eher ablehnend gegenüber; Automobile bezeichnete er einmal als »üble, widerliche Kisten«, und er haßte die Auswirkungen der modernen Massenproduktion. Als er in Mexiko-Stadt lebte, bemerkte er voller Abscheu, »hätte Henry Ford zur Zeit der Pyramiden gelebt und dieser Epoche seine Effizienz beschert, hätte es weder die Zeit noch Arbeitskräfte gegeben, um sie zu errichten.«

Weston entwickelte einen durch und durch amerikanischen und spezifisch kalifornischen Zugang zur modernen Photographie. In seinem Leben war er wie in seiner Kunst – direkt, leidenschaftlich, kompromißlos, nachdenklich und in Harmonie mit den Rhythmen der Natur.

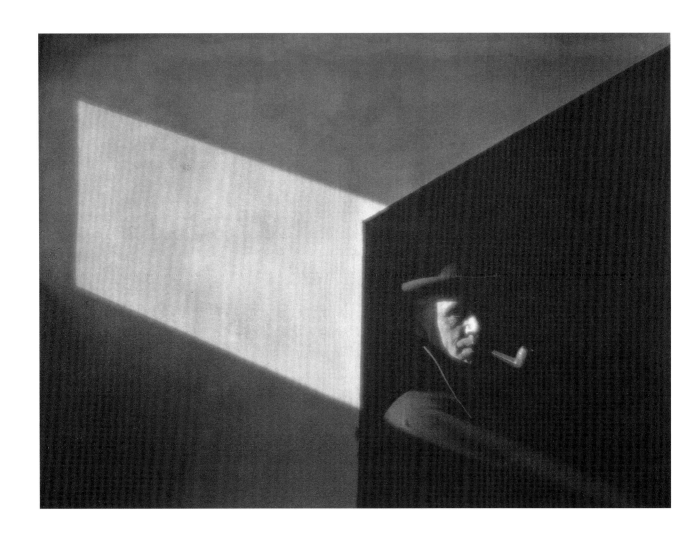

Sunny Corner in an Attic
Sonnige Ecke auf einem Dachboden
Coin ensoleillé dans une mansarde
1920

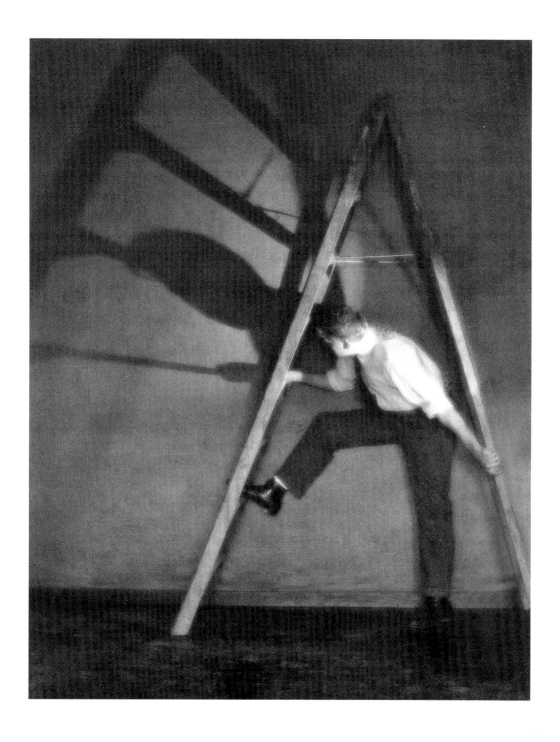

Scene Shifter
Kulissenschieber
Décor coulissant
1921

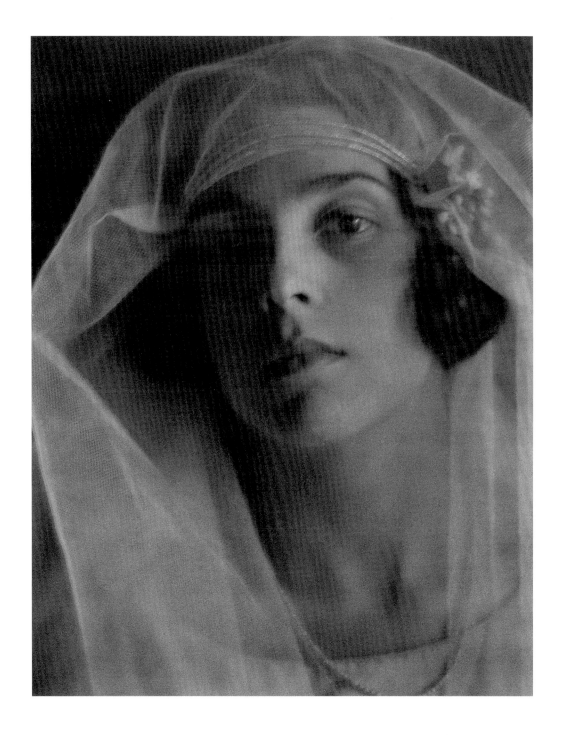

Bride
Braut
Fiancée
c. 1920

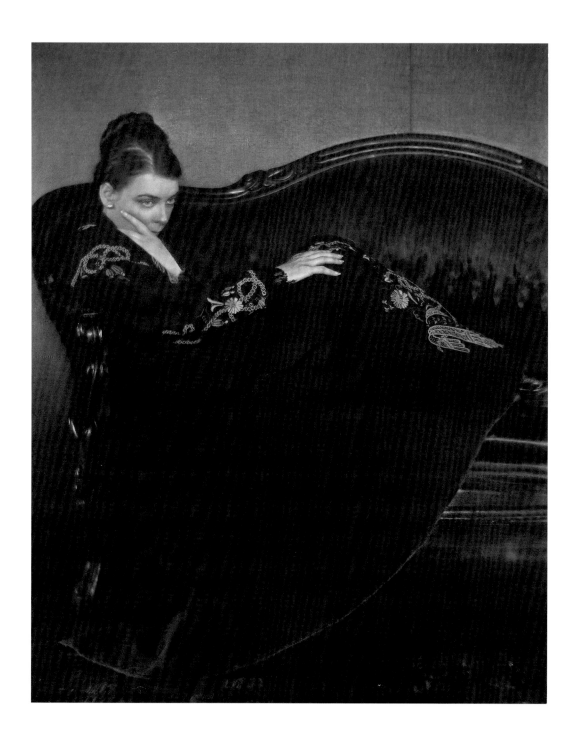

Margrethe Mather in my Studio
Margrethe Mather in meinem Studio
Margrethe Mather dans mon atelier
1921

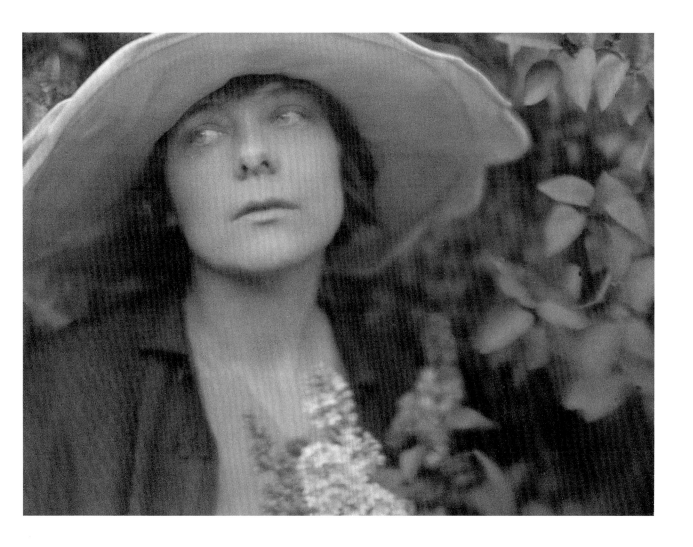

Margrethe with Phlox
Margrethe mit Phlox
Margrethe avec phlox
1921

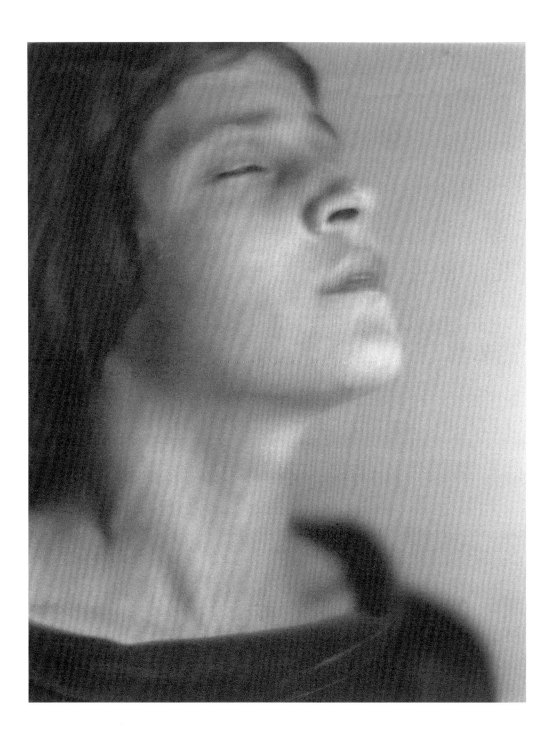

Head of an Italian Girl
Kopf eines italienischen Mädchens
Tête d'une jeune fille italienne
1921

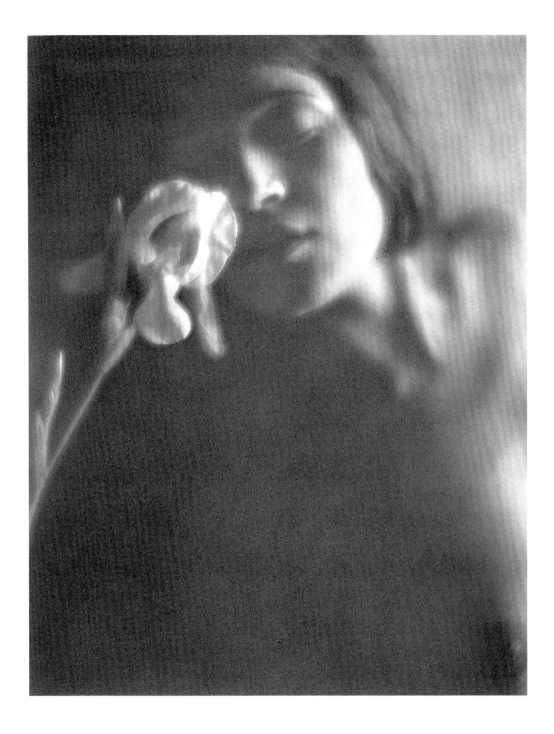

The White Iris
Die weiße Iris
L'iris blanc
1921

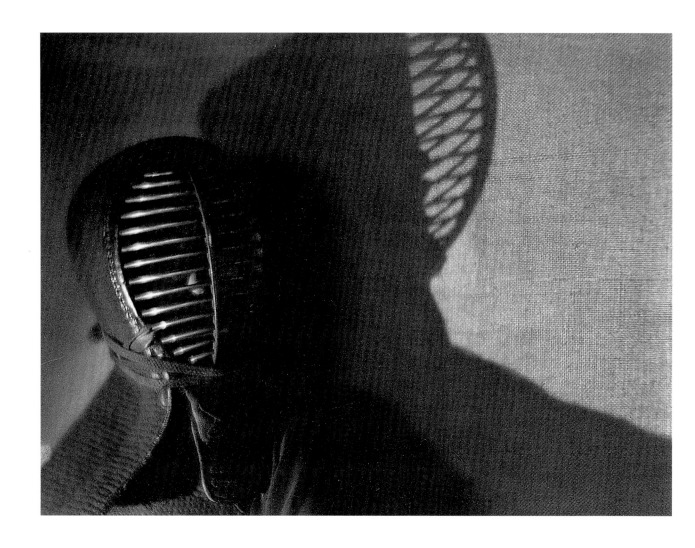

Japanese Fighting Mask
Japanische Kampfmaske
Masque de combat japonais
1921

Mein Werk ist dem, was ich darüber sage, immer um einige Sprünge voraus! Ich bin einfach nur ein Mittel zu einem Zweck: Halte ich die Kamera in der Hand, kann ich weder sagen, warum ich etwas auf eine bestimmte Art und Weise aufnehme, noch, warum ich es überhaupt aufnehme!

My work is always a few jumps ahead of what I say about it! I am simply a means to an end: I cannot, at the time, say why I record a thing in a certain way, nor why I record it at all!

Mon travail devance toujours de quelques pas de ce que je peux en dire! Je suis simplement un moyen pour arriver à une fin: je ne peux pas, sur le moment, dire pourquoi j'enregistre une chose d'une certaine façon, ni même pourquoi je l'enregistre!

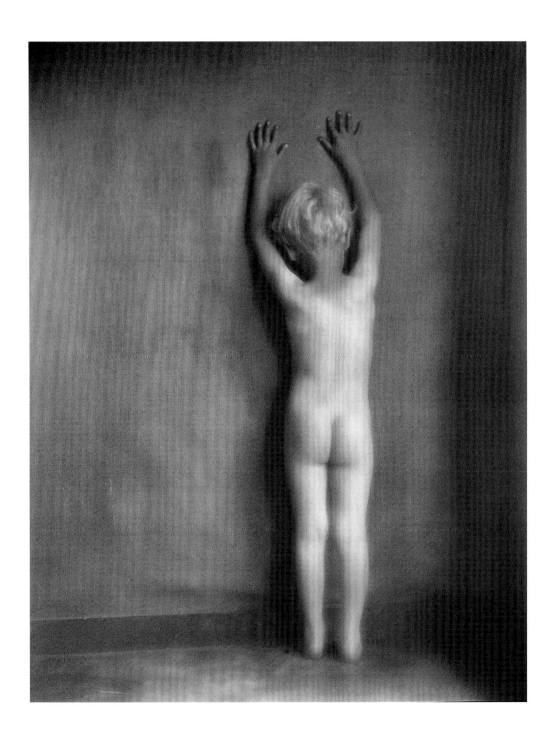

Neil
1922

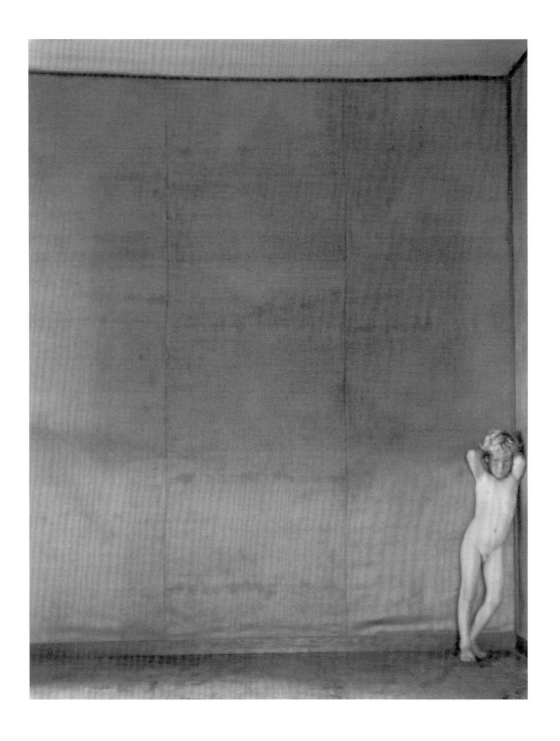

Neil
1922

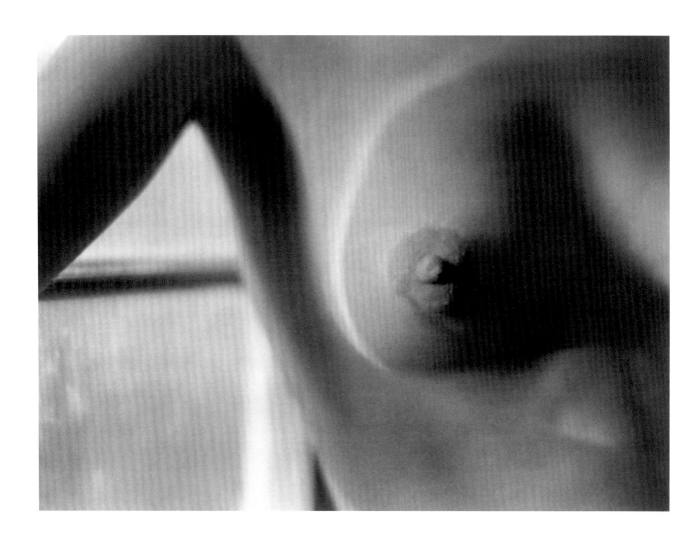

Breast
Brust
Sein
1922

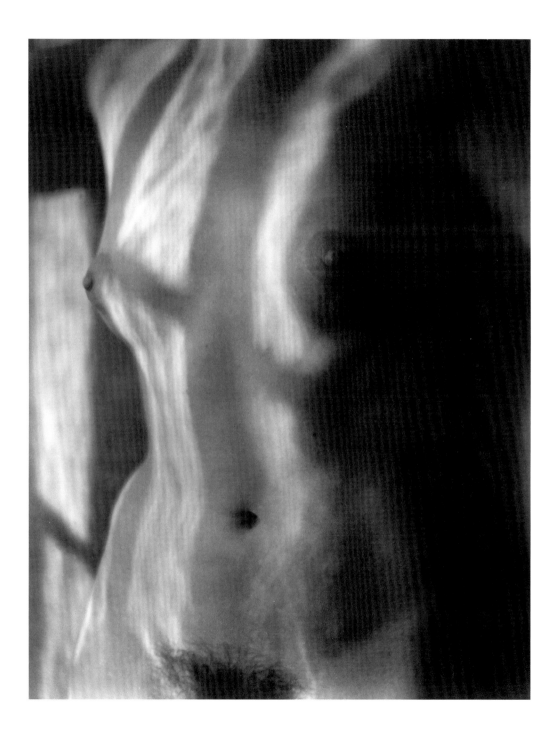

Refracted Sunlight on Torso
Gebrochenes Sonnenlicht auf Torso
Reflet de la lumière du soleil sur un torse
1922

The Ascent of Attic Angles
Der Anstieg der Dachbodenwinkel
Les angles mansardés d'un grenier
c. 1921

Ruth Shaw
1922

Karl Struss
1922

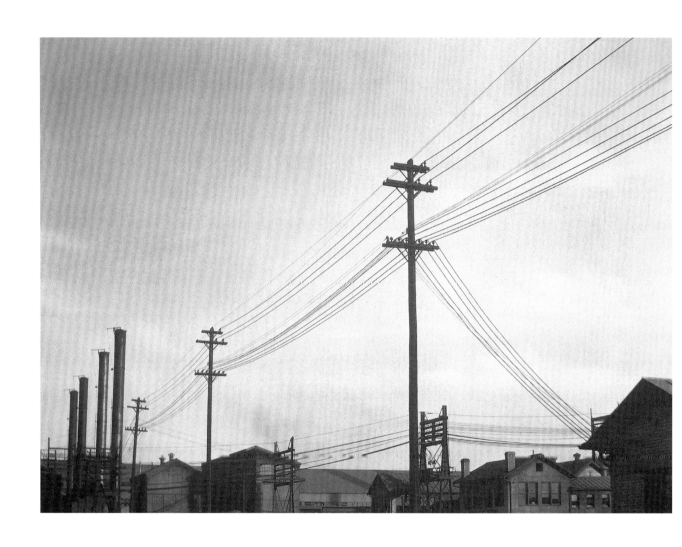

Telephone Lines. Middletown, Ohio
Telefonleitungen. Middletown, Ohio
Lignes téléphoniques. Middletown, Ohio
1922

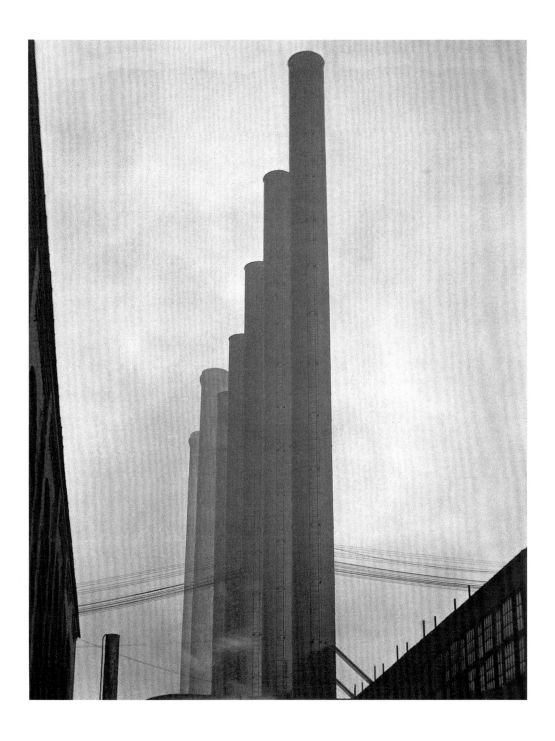

Armco Steel. Ohio
1922

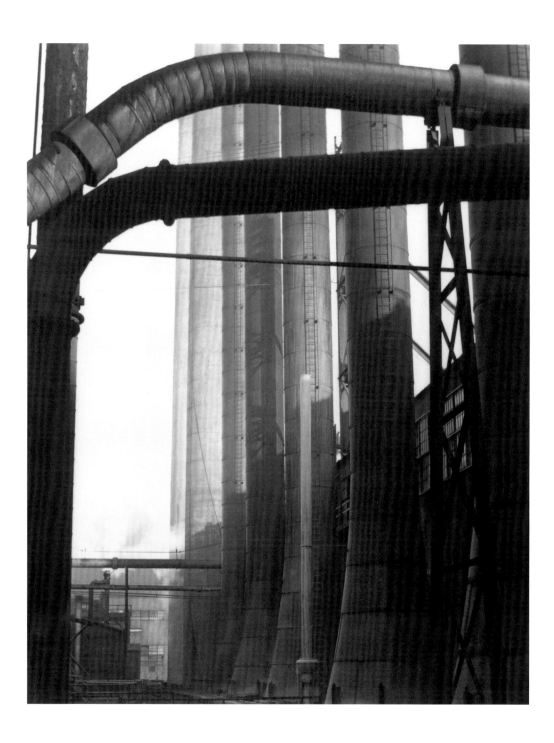

Armco Steel. Ohio
1922

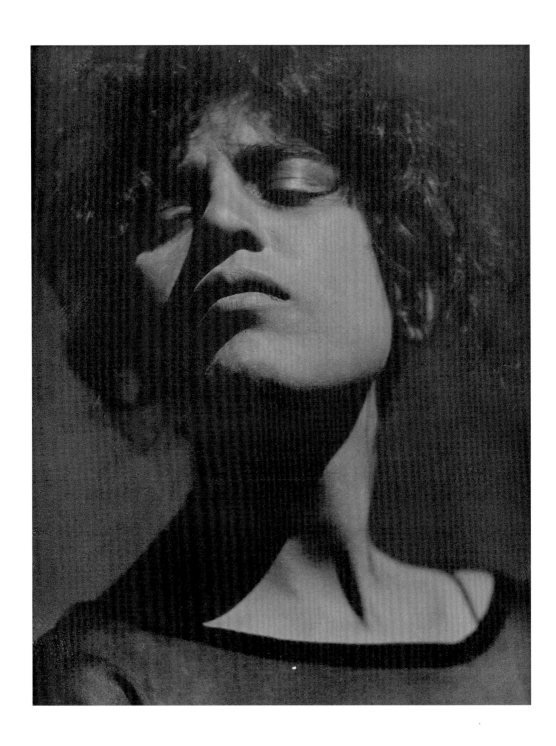

Guadalupe Marín de Rivera
1923

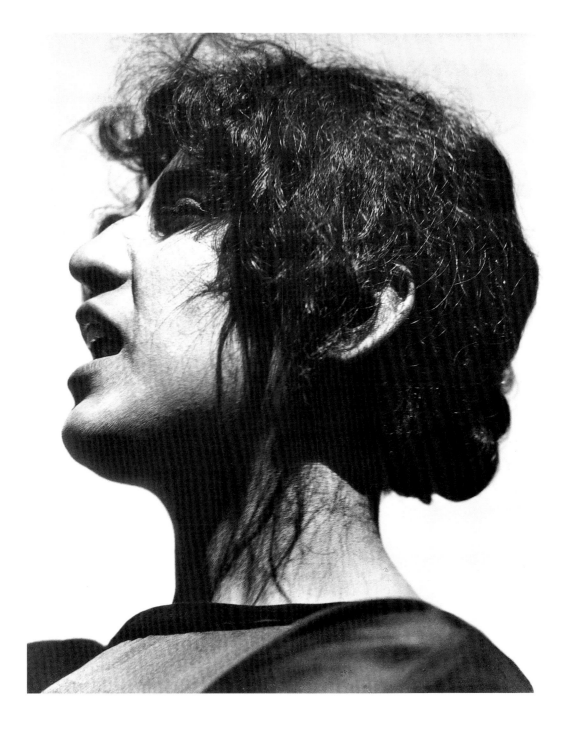

Guadalupe Marín de Rivera
1923

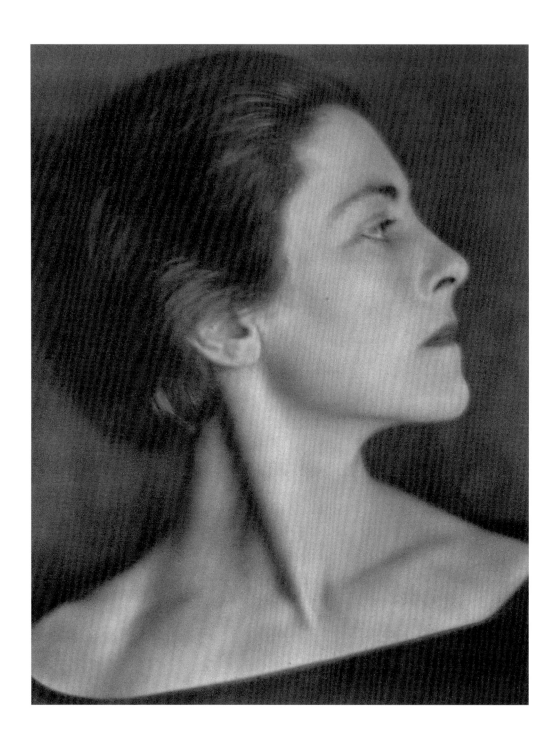

Lois Kellog
1923

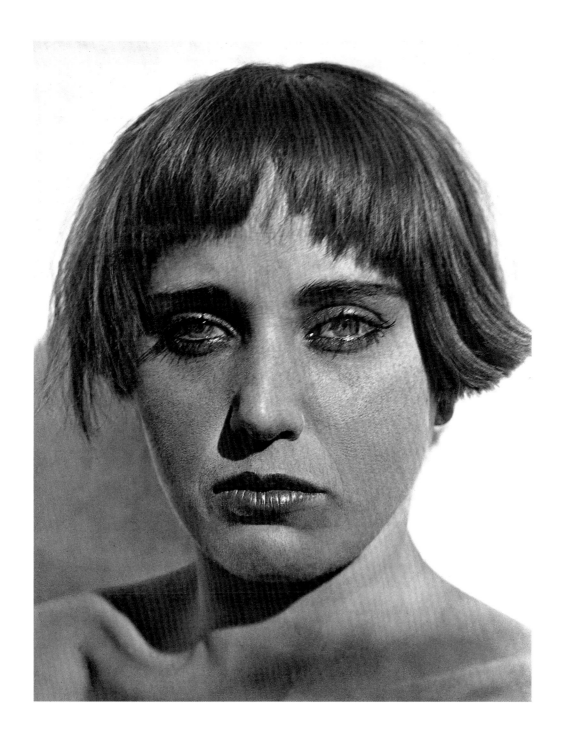

Nahui Olin
1923

Tina Reciting [Eyes only]
Tina rezitierend [nur ihre Augen]
Tina récitant [yeux seulement]
1924

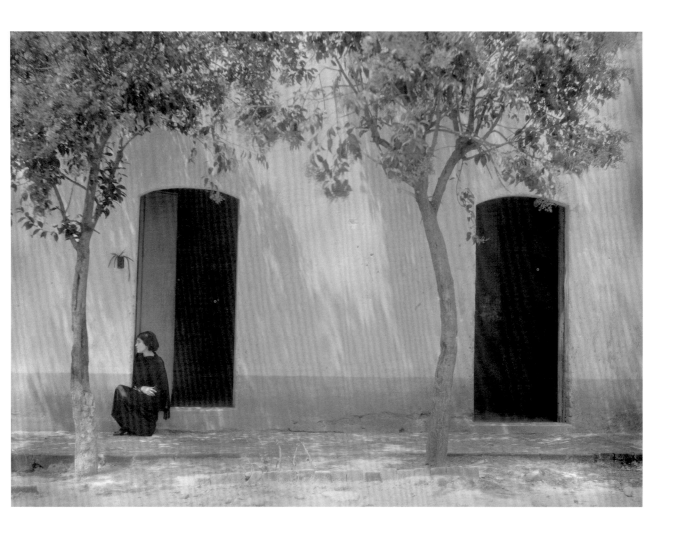

Tina
1923

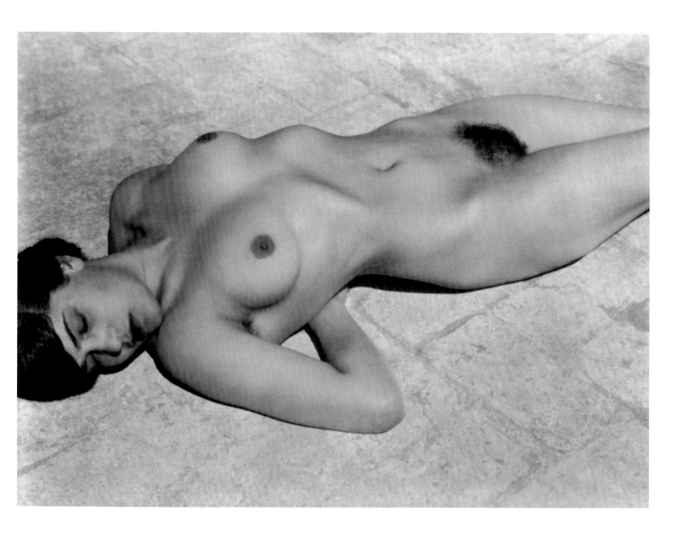

Nude
Akt
Nu
1923

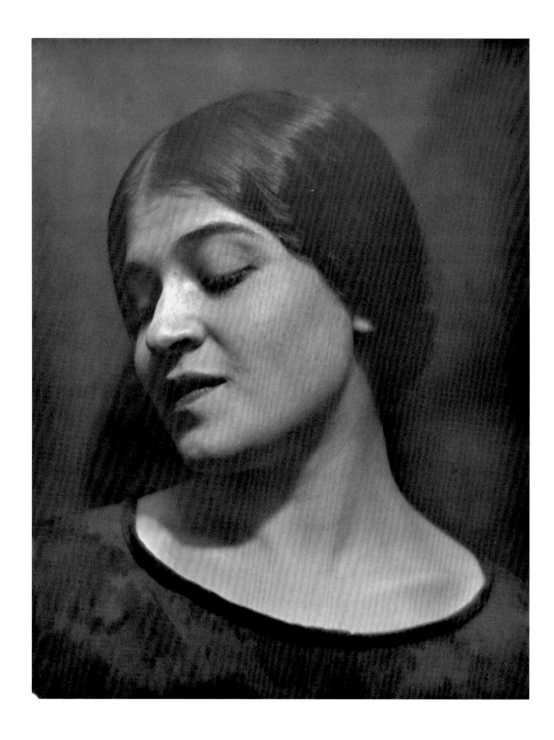

Tina Reciting
Tina rezitierend
Tina récitant
1924

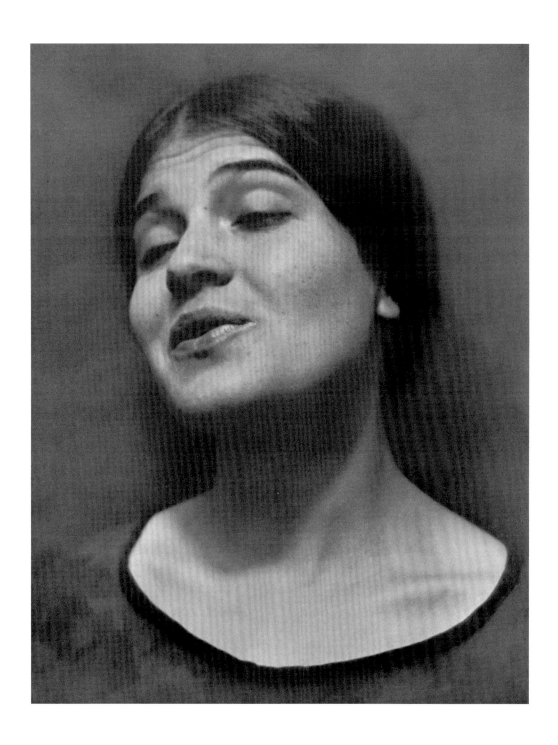

Tina Reciting
Tina rezitierend
Tina récitant
1924

Palma Cuernavaca
1924

Pirámide del Sol
1923

In der Photographie wird die allererste Empfindung, das spontane Gefühl für die Sache, gänzlich und für alle Zeit in genau dem Moment eingefangen, in dem die Sache gesehen und empfunden wird. Empfinden und Festhalten sind etwas Simultanes …

So in photography, the first fresh emotion, the feeling for the thing, is captured complete and for all time at the very moment it is seen and felt. Feeling and recording are simultaneous …

Ainsi en photographie, la première émotion fraîche, le sentiment de la chose, est captée dans son intégralité et pour toujours au moment même ou celle-ci est vue et ressentie. La sensation et son enregistrement sont simultanés …

Circus Tent
Zirkuszelt
Chapiteau de cirque
1924

Pirámide de Cuernavaca
Pyramide von Cuernavaca
Pyramide de Cuernavaca
1924

Aqueduct. Los Remedíos
Äquadukt. Los Remedíos
Aqueduc. Los Remedíos
1924

Hands. Mexico
Hände. Mexiko
Mains. Mexique
1924

Two Swan Gourds
Zwei Schwanen-Flaschenkürbisse
Deux gourdes en forme de cygnes
1924

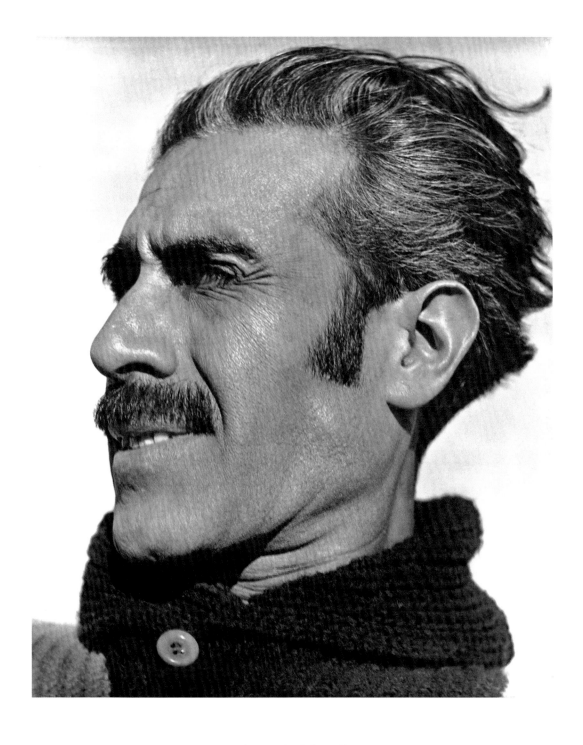

Manuel Hernández Galván - Shooting
Manuel Hernández Galván - schießend
Manuel Hernández Galván - visant
1924

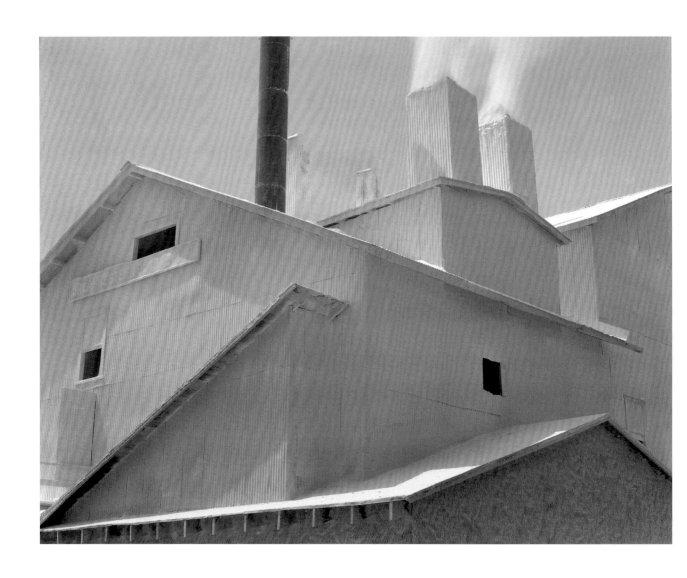

Plaster Works. Los Angeles
Gipswerke. Los Angeles
Ouvrages de plâtre. Los Angeles
1925

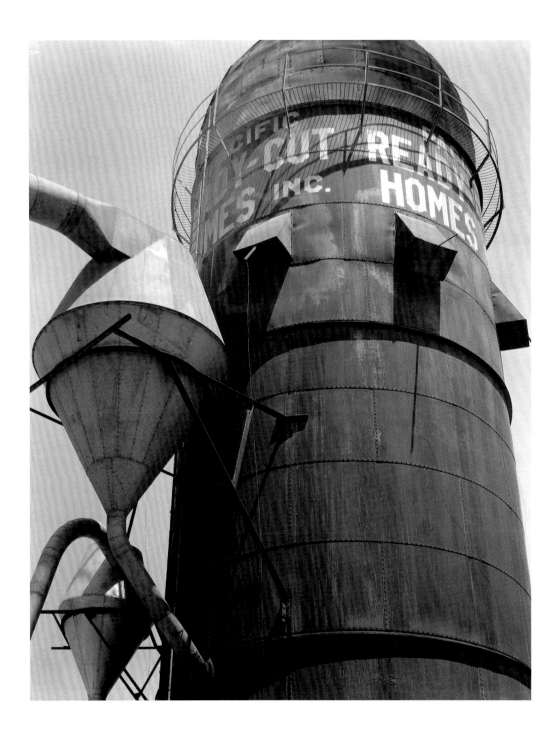

Factory. Los Angeles
Fabrik. Los Angeles
Usine. Los Angeles
1925

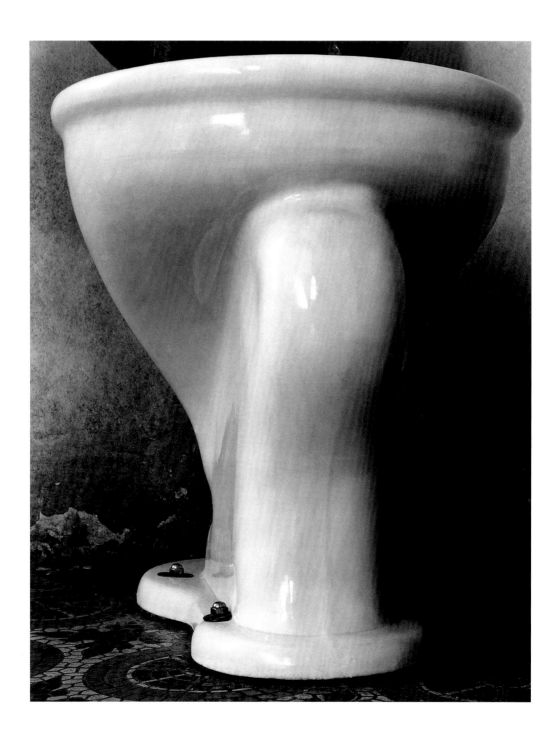

Excusado
Klosett
Cuvette
1925

Washbowl
Waschschüssel
Bassine
1925

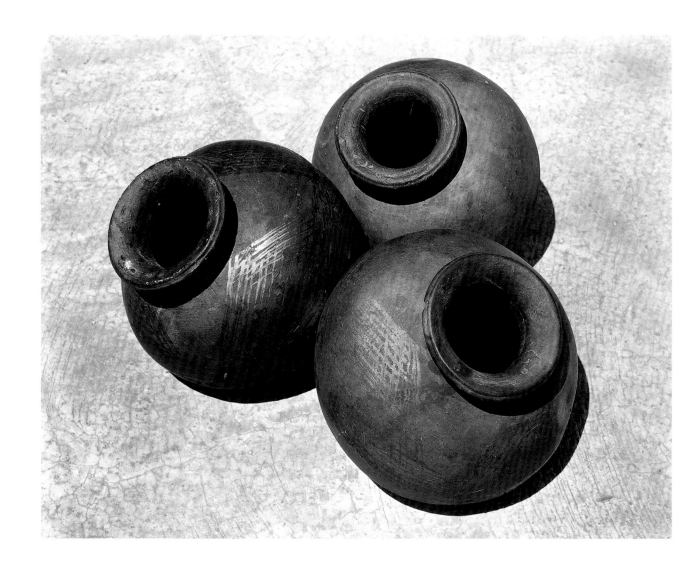

Tres Ollas de Oaxaca
Drei Töpfe aus Oaxaca
Trois pots de Oaxaca
1926

Pulquería, Mexico City
1926

Pulquería. Mexico City
1926

Pulquería Mural
1926

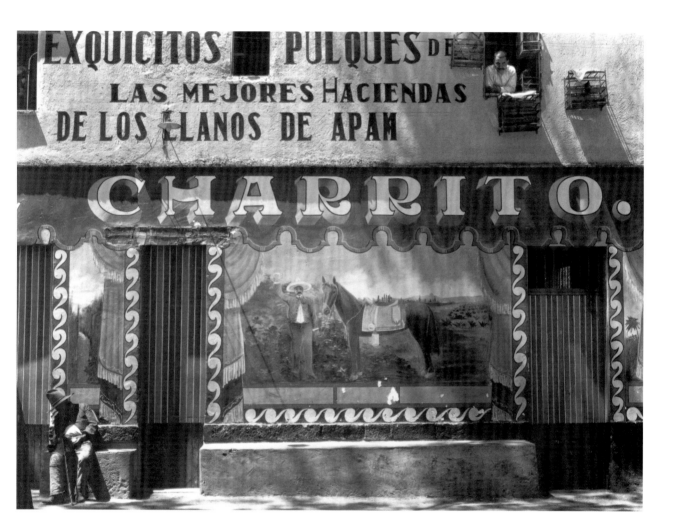

Charrito
1926

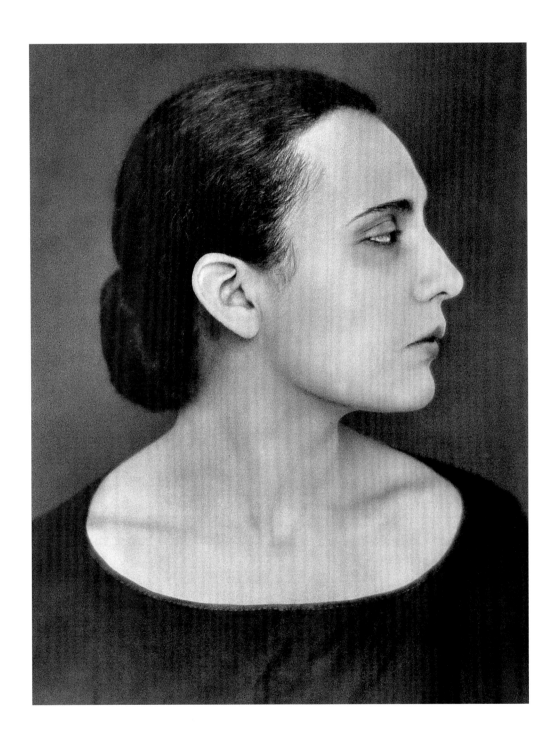

Victoria Marin
1926

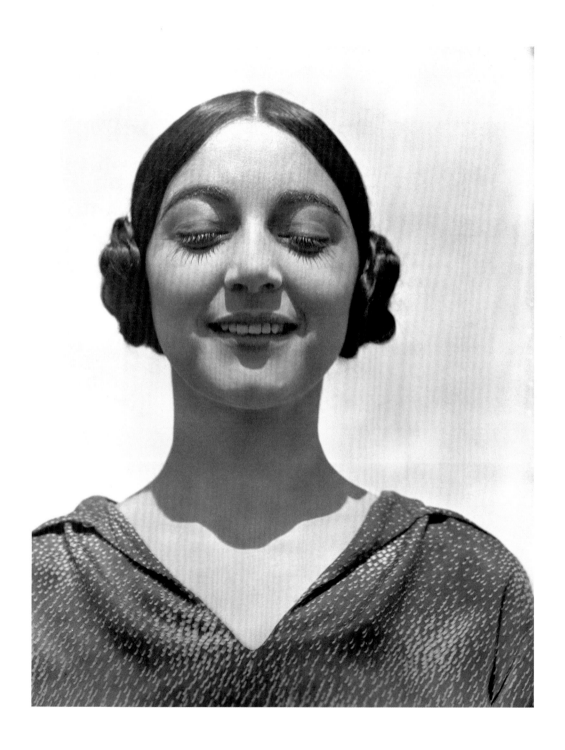

Rose Roland. Mexico
1926

Ich möchte die reine Schönheit, die eine Linse so exakt wiedergeben kann, ohne die Einwirkung eines »künstlerischen Effekts« präsentieren.

I want the stark beauty that a lens can so exactly render, presented without interference of "artistic effect".

Je veux la beauté nue qu'un objectif peut rendre avec tant d'exactitude, sans interférence « d'effet artistique ».

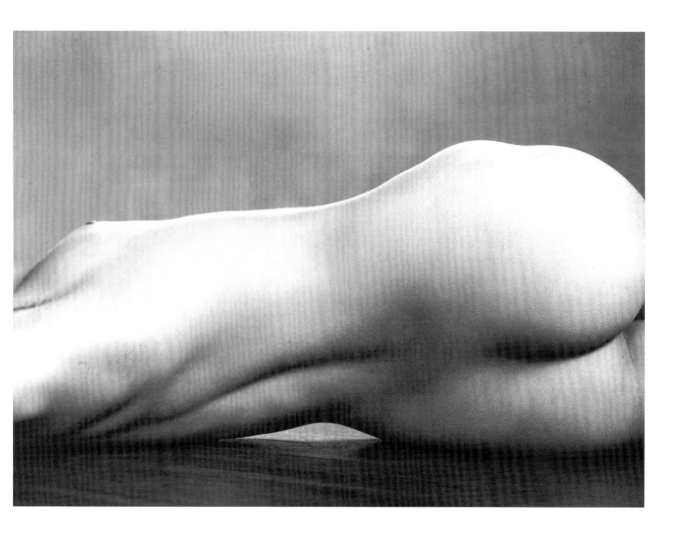

Nude
Akt
Nu
1925

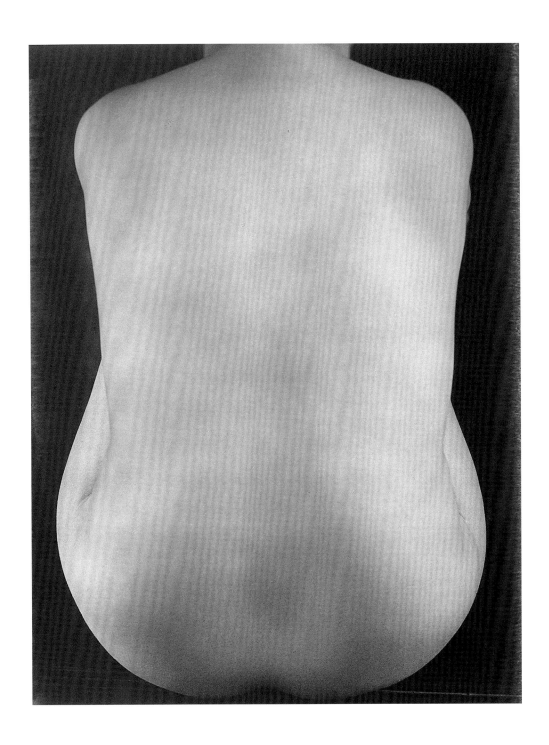

Nude
Akt
Nu
1925

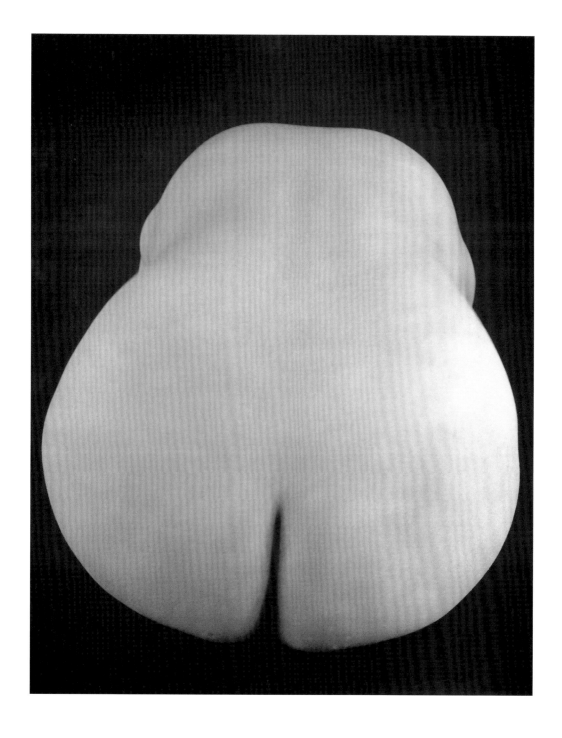

Nude
Akt
Nu
1925

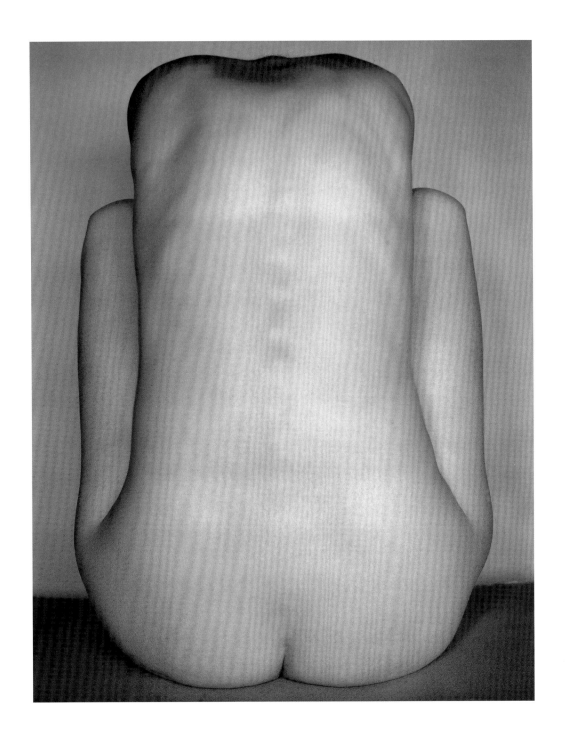

Nude
Akt
Nu
1927

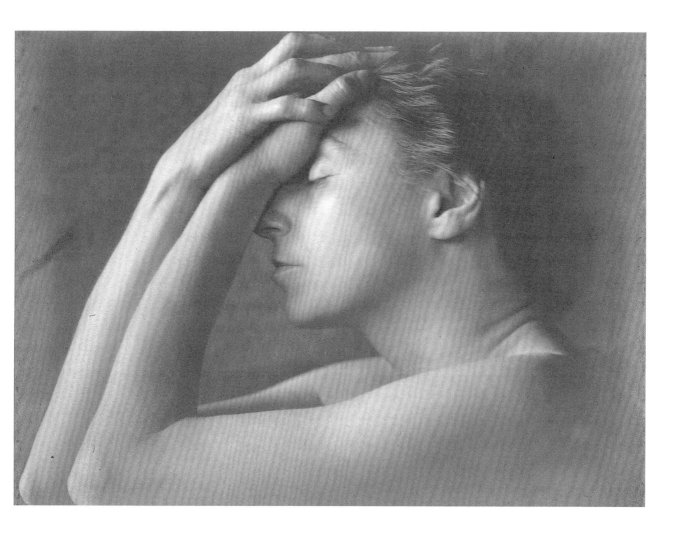

Portrait of Christel Gang
Portrait von Christel Gang
Portrait de Christel Gang
1927

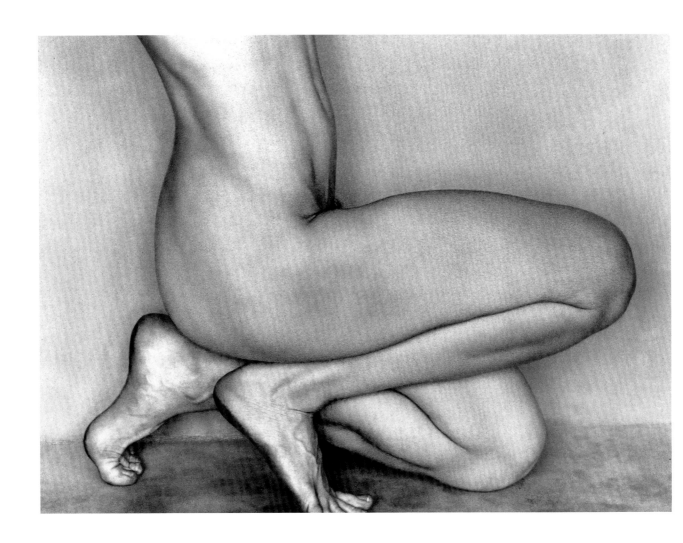

Nude
Akt
Nu
1927

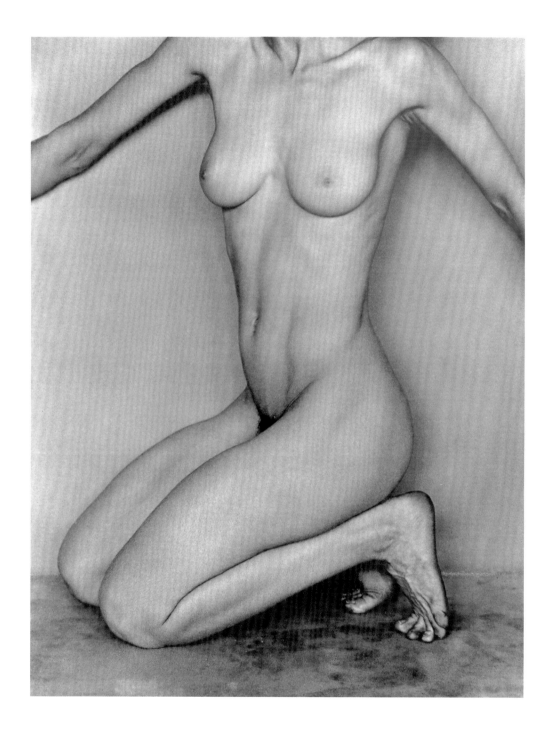

Nude
Akt
Nu
1927

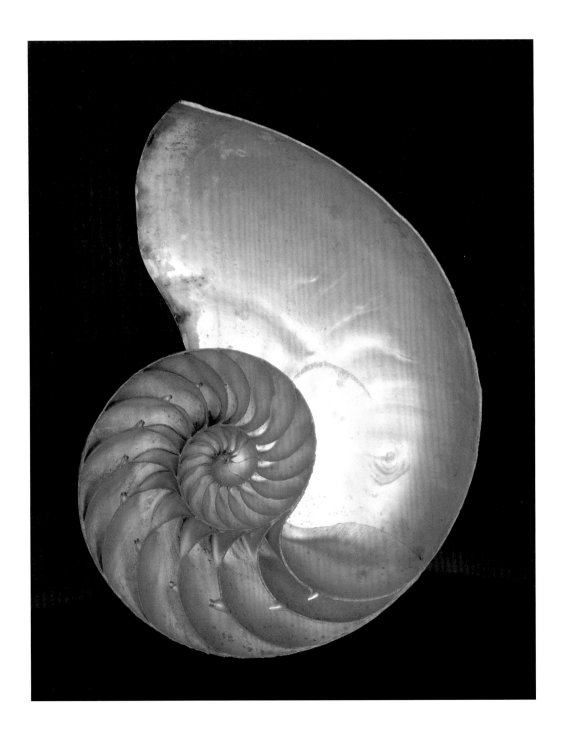

Shell
Muschel
Coquillage
1927

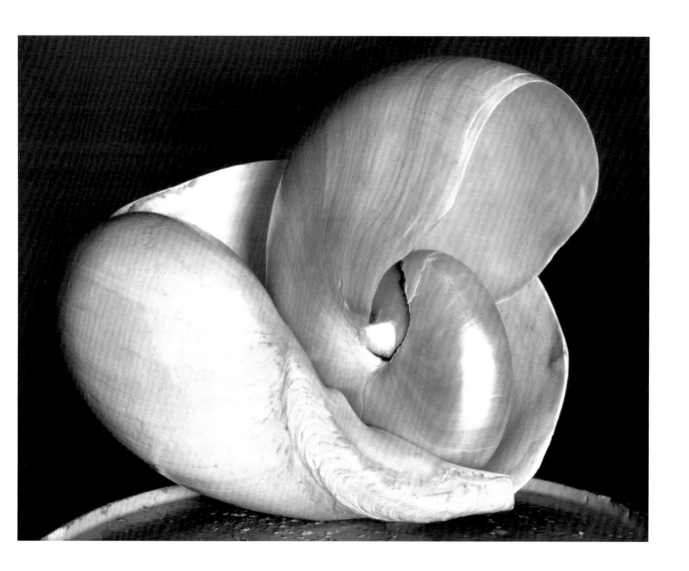

Shell
Muschel
Coquillage
1927

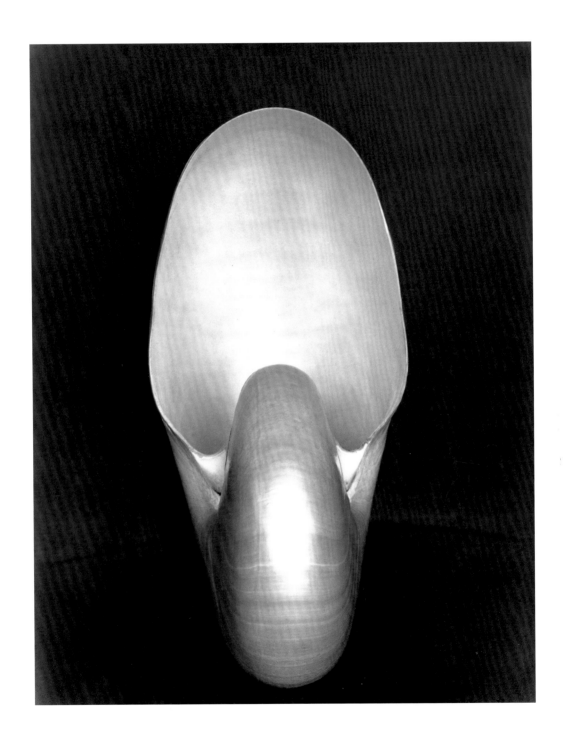

Nautilus Shell
Nautilusmuschel
Nautile
1927

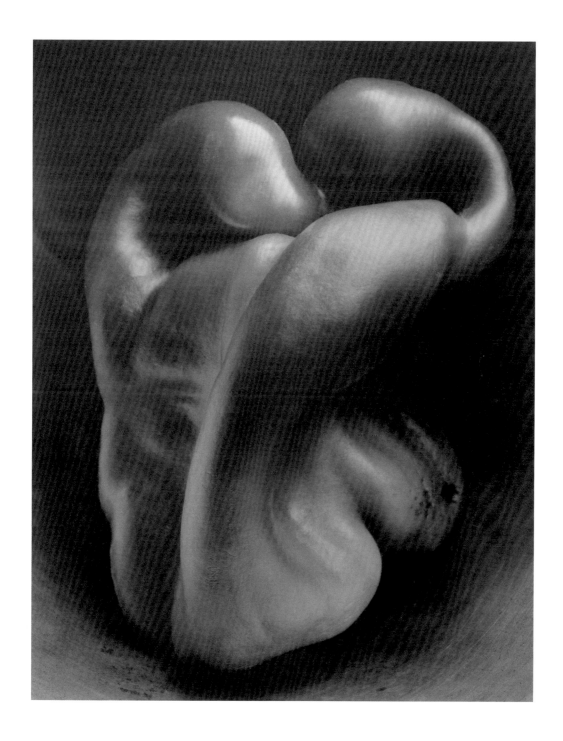

Pepper No. 30
Paprika Nr. 30
Poivron no 30
1930

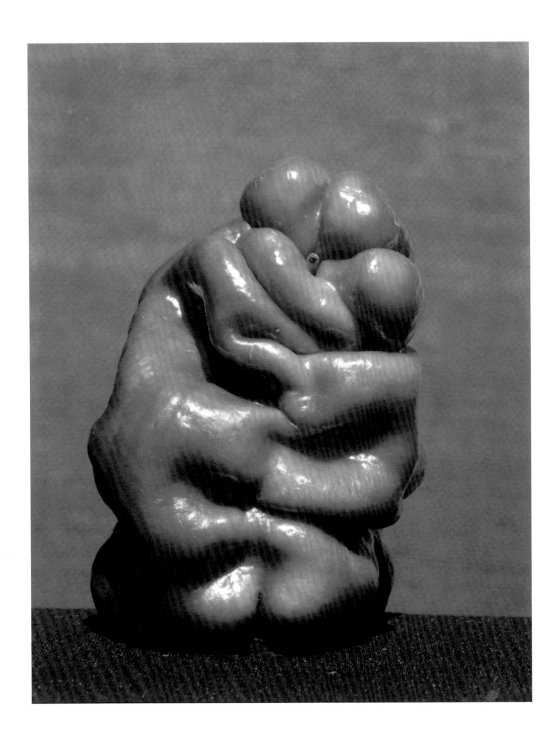

Pepper
Paprika
Poivron
1929

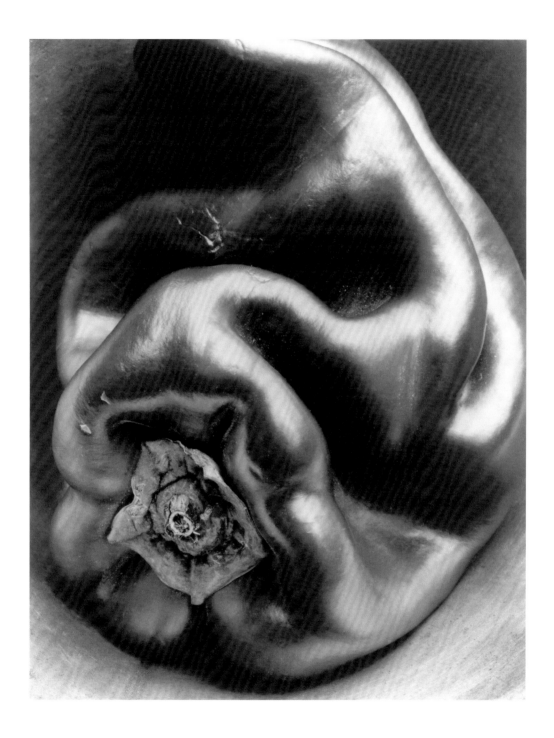

Pepper No. 35
Paprika Nr. 35
Poivron no 35
1930

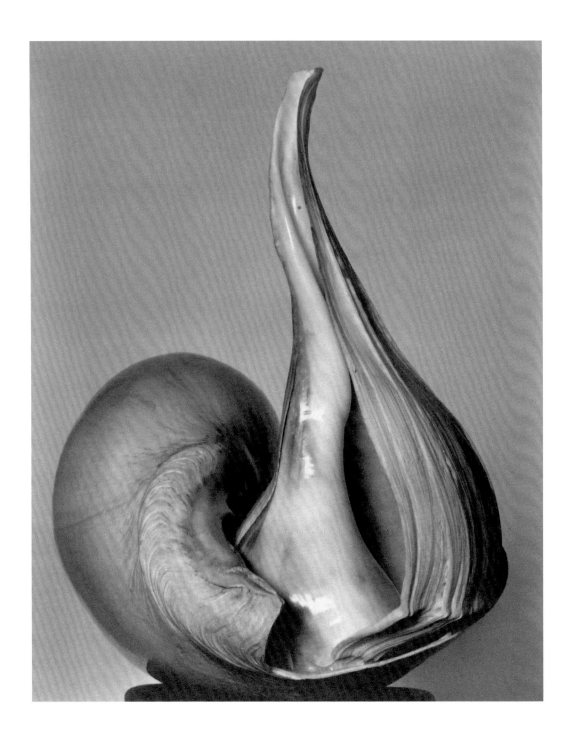

Shells
Muscheln
Coquillages
1927

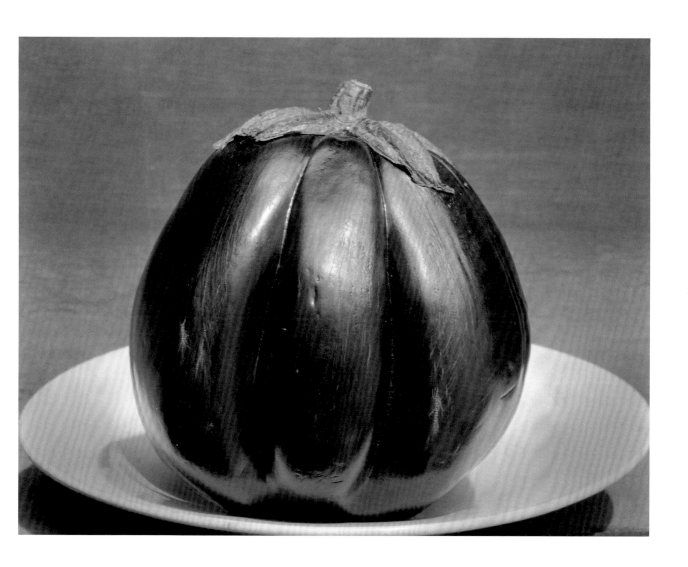

Eggplant
Aubergine
Aubergine
1929

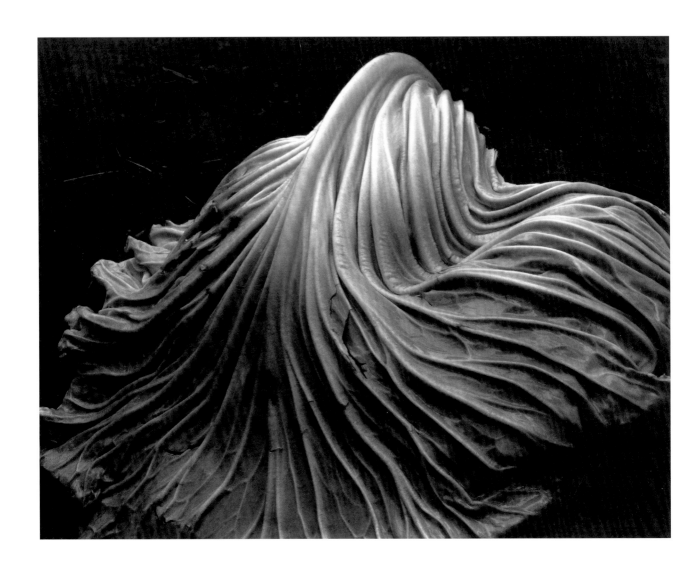

Cabbage Leaf
Kohlblatt
Feuille de chou
1931

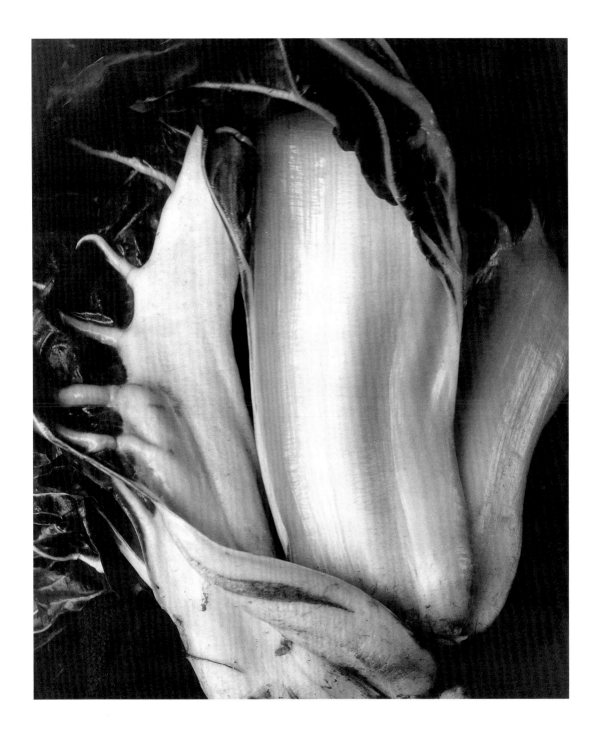

Chinese Cabbage
Chinakohl
Chou chinois
1931

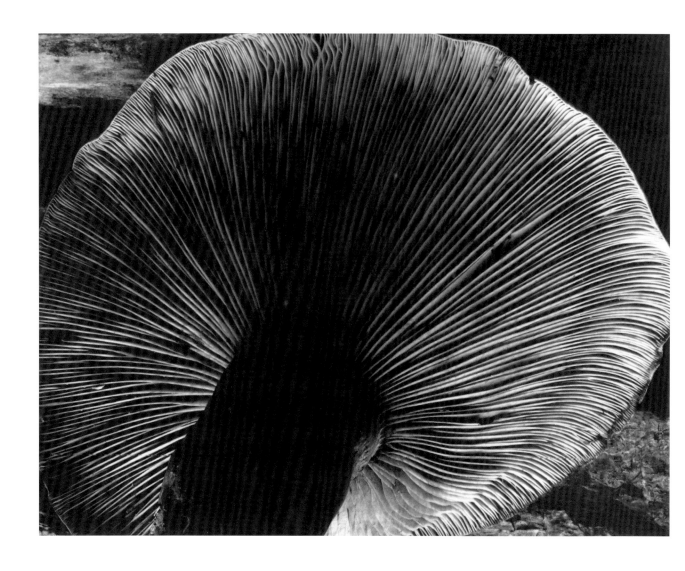

Toadstool
Pilz
Champignon
1931

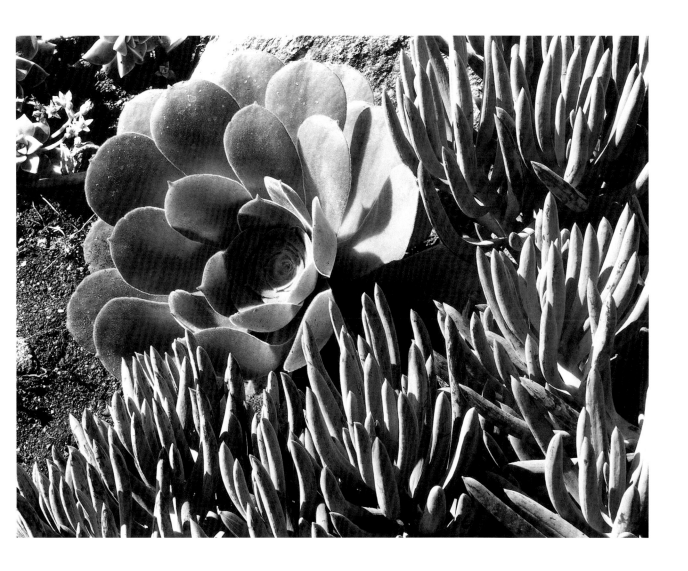

Succulent
Sukkulente
Plante succulente
1930

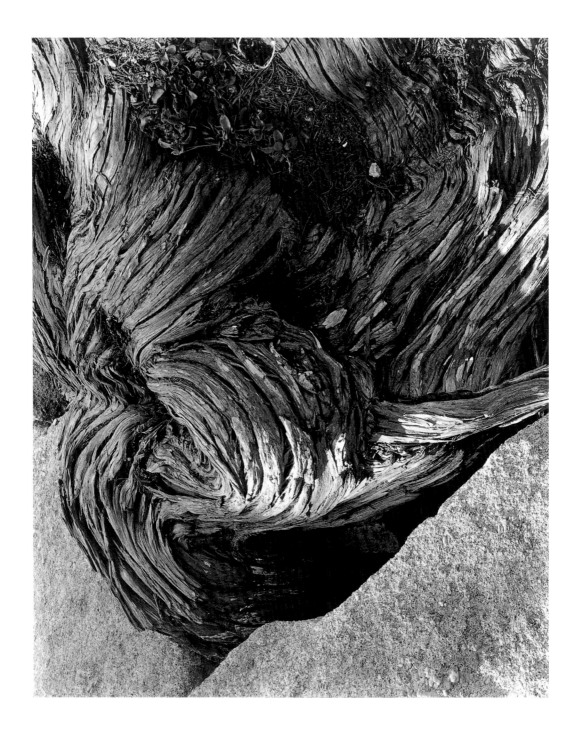

Cypress Root. Seventeen Mile Drive
Zypressenwurzel. Seventeen Mile Drive
Racine de cyprès. Seventeen Mile Drive
1929

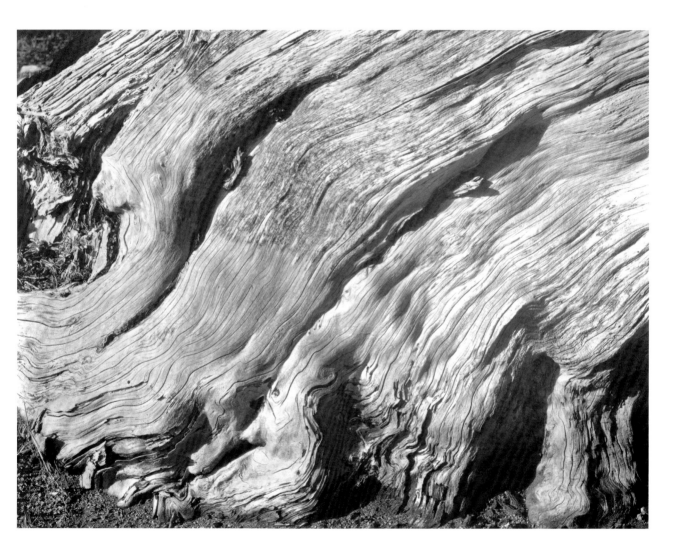

Cypress. Point Lobos
Zypresse. Point Lobos
Cyprès. Point Lobos
1929

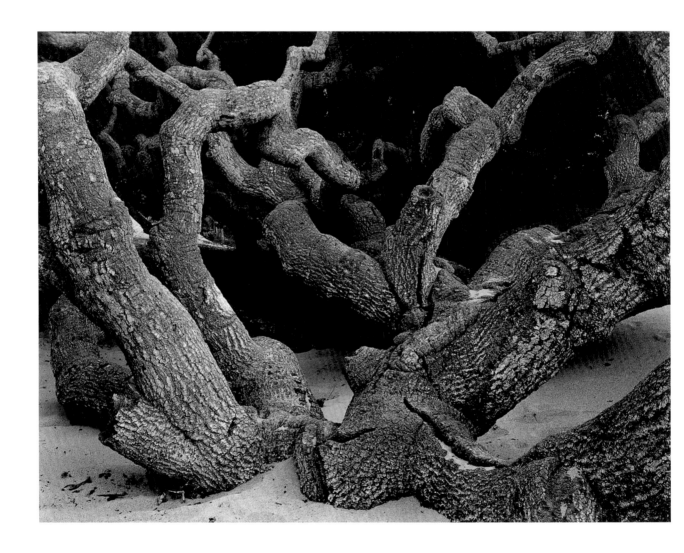

Oak. Monterey County
Eiche. Monterey County
Chine. Monterey County
1929

Cypress Root and Succulents. Point Lobos
Zypressenwurzel und Sukkulenten. Point Lobos
Racine de cyprès et plantes succulentes. Point Lobos
1930

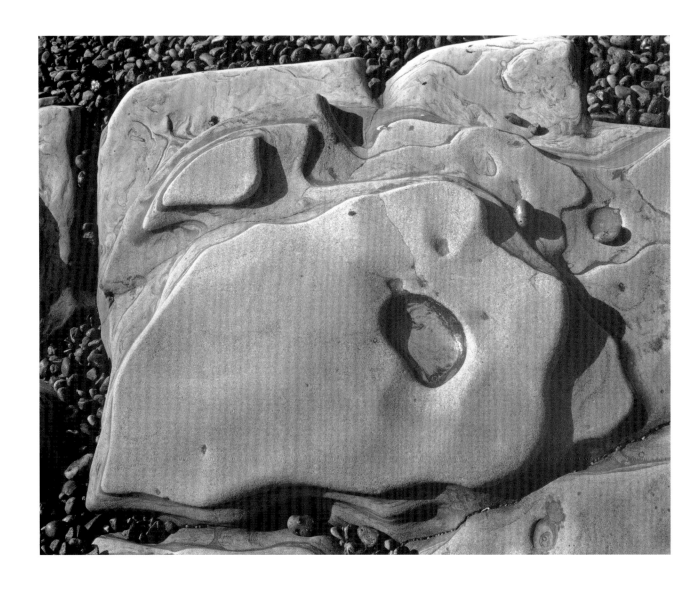

Eroded Rock No. 50
Erodierter Felsen Nr. 50
Rocher érodé no 50
1930

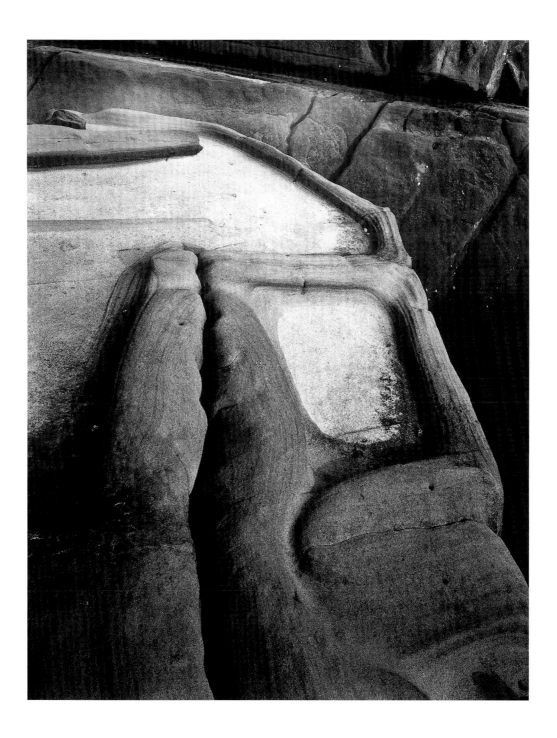

Point Lobos
1929

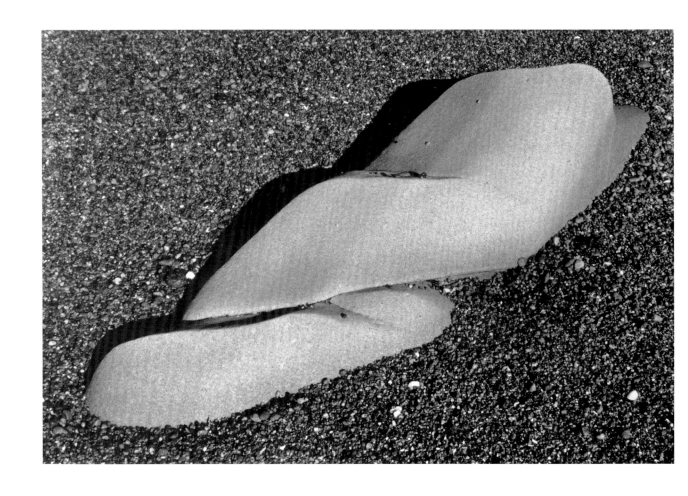

Eroded Rock No. 51
Erodierter Felsen Nr. 51
Rocher érodé no 51
1930

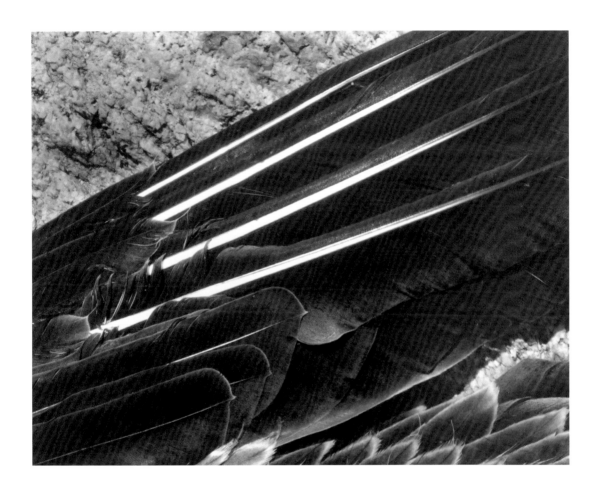

Pelican's Wing
Pelikanflügel
Aile de pélican
1931

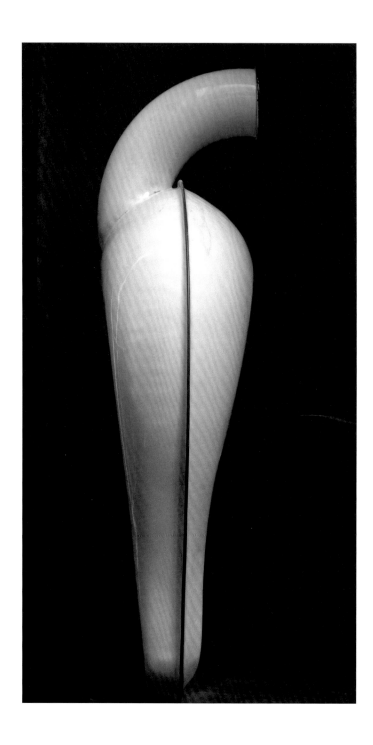

Bedpan
Bettpfanne
Bassin
1930

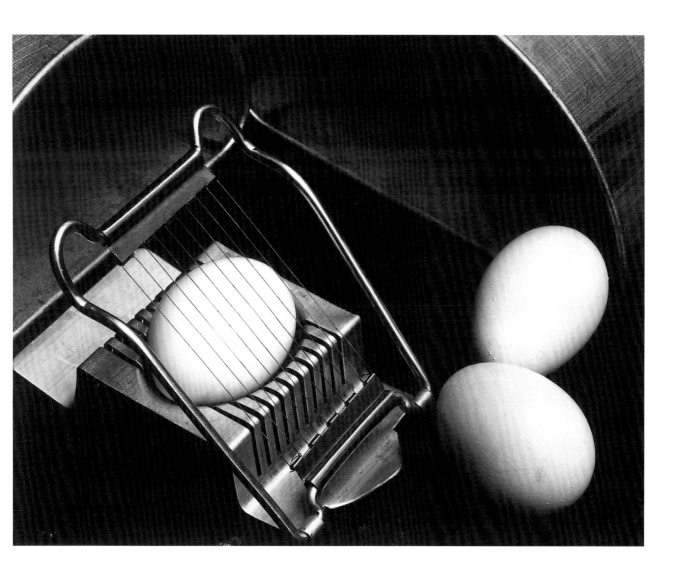

Eggs and Slicer
Eier und Eierschneider
Œufs et coupe-œuf
1930

Die bereits komponierten Dinge, die ich in der Natur entdecke, machen mir größere Freude als meine schönsten Arrangements. Eine Auswahl ist schließlich nichts anderes als eine andere Art der Anordnung …

I get a greater joy by finding things in Nature, already composed, than I do from my finest personal arrangements. After all, selection is another way of arranging …

Je tire beaucoup plus de joie des choses déjà composées que je découvre dans la nature, que de mes meilleurs arrangements personnels. Après tout, sélectionner est une autre façon de composer …

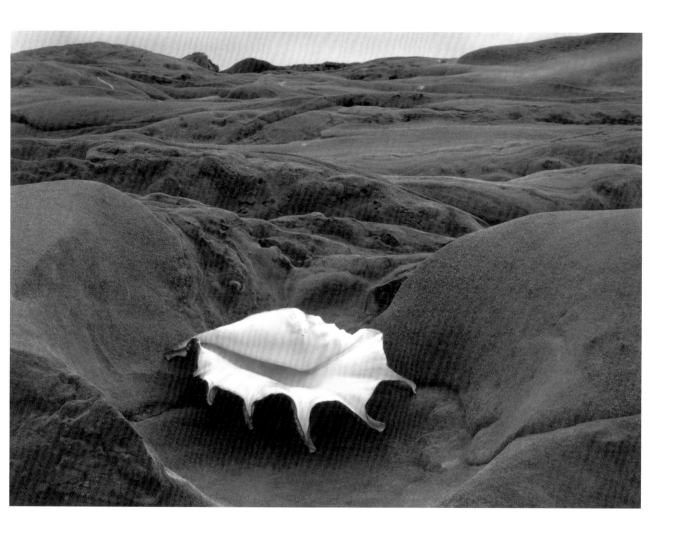

Shell and Rock Arrangement
Muschel und Felsenarrangement
Coquillage et arrangement rocailleux
1931

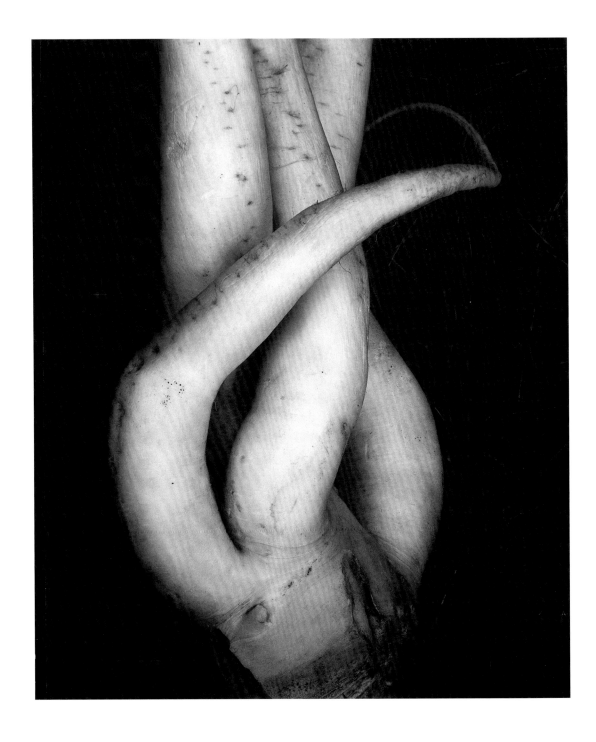

White Radish
Weißer Rettich
Radis blanc
1933

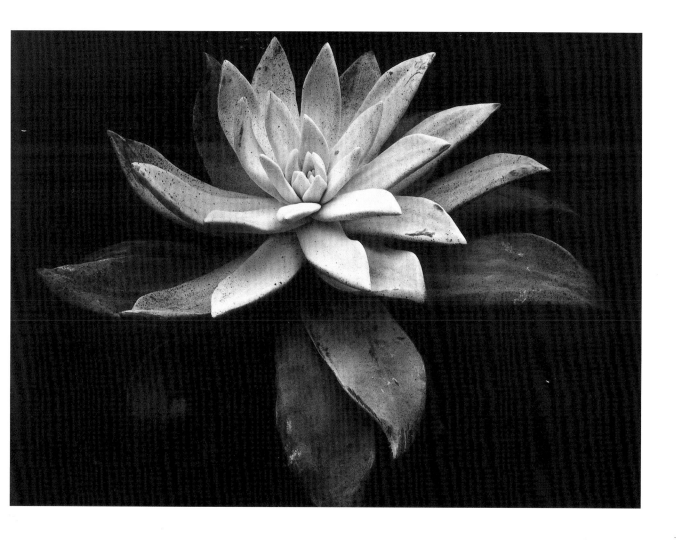

Succulent
Sukkulente
Plante succulente
1932

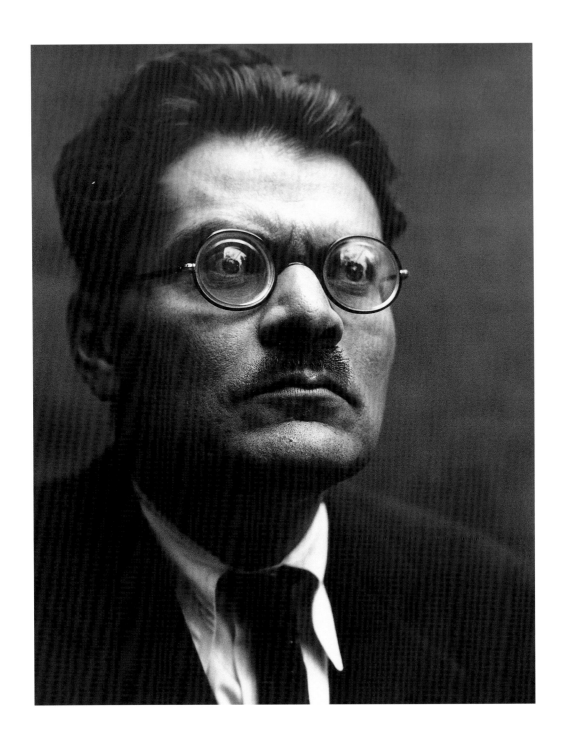

José Clemente Orozco
1930

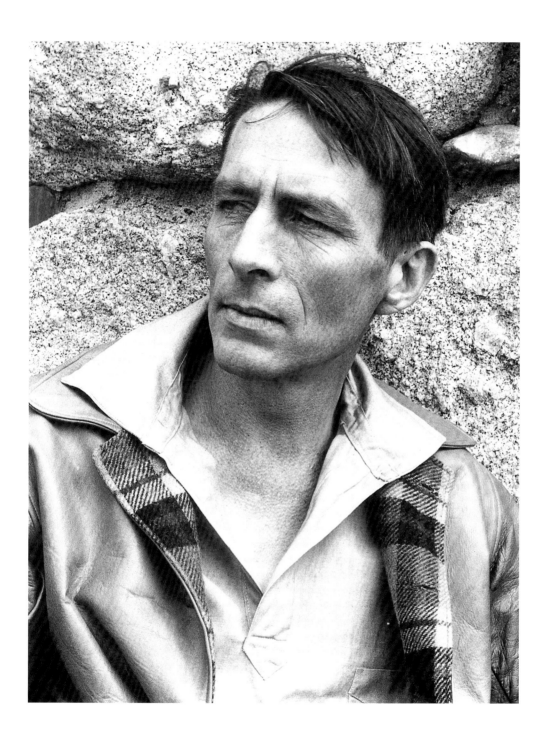

Robinson Jeffers
1929

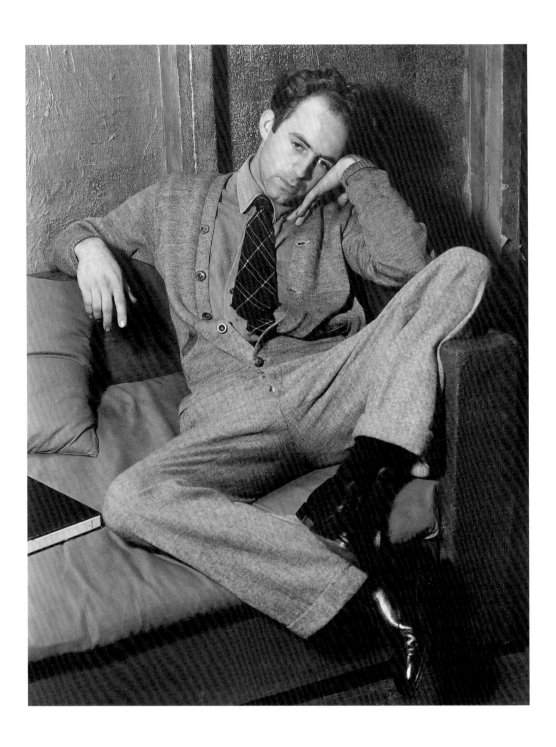

Willard Van Dyke. Oakland
1932

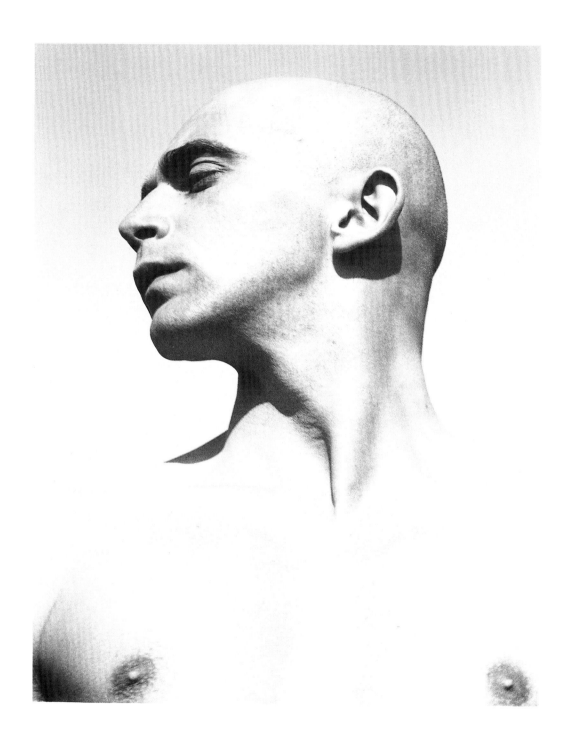

Harald Kreutzberg
1932

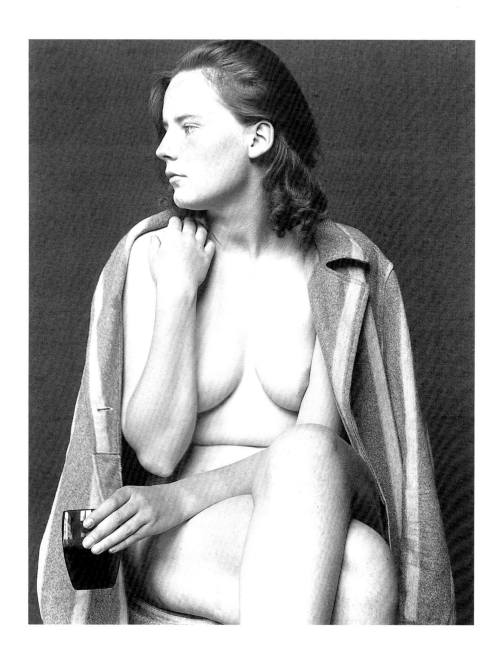

Charis
1934

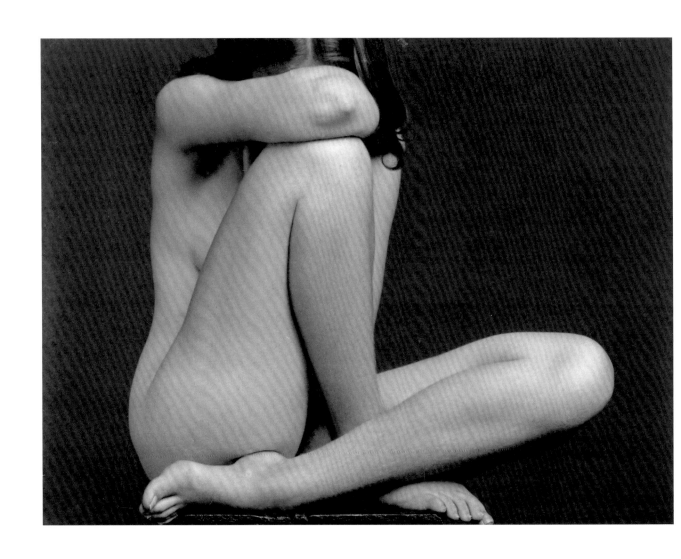

Nude
Akt
Nu
1934

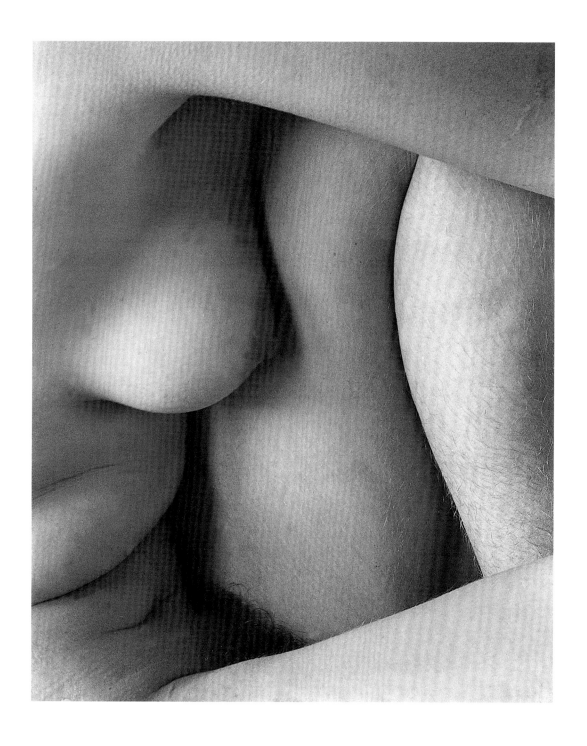

Nude
Akt
Nu
1934

Cloud. New Mexico
Wolke. New Mexico
Nuage. Nouveau-Mexique
1933

'E' Town. New Mexico
'E' Stadt. New Mexico
Ville 'E'. Nouveau-Mexique
1933

Whale Vertebrae. Point Lobos
Rückenwirbel eines Wals. Point Lobos
Vertèbres dorsales d'une baleine. Point Lobos
1934

Barn. Castroville
Scheune. Castroville
Grange. Castroville
1934

Old Adobe. Carmel Valley
Alter Adobe. Carmel Valley
Vieille adobe. Carmel Valley
1934

Wheels and Hill. San Juan
Räder und Hügel. San Juan
Roues et colline. San Juan
1934

Dunes. Oceano
Dünen. Oceano
Dunes. Oceano
1936

Dunes. Oceano
Dünen. Oceano
Dunes. Oceano
1936

Die Natur darf nicht von einem durch psychologisches Kopfweh oder Herzeleid gefärbten Gesichtspunkt aus aufgezeichnet werden …

Nature must not be recorded with a viewpoint colored by psychological headaches or heartaches …

La nature ne doit pas être enregistrée d'un point de vue entaché de problèmes psychologiques ou de peines de cœur …

Dunes. Oceano
Dünen. Oceano
Dunes. Oceano
1936

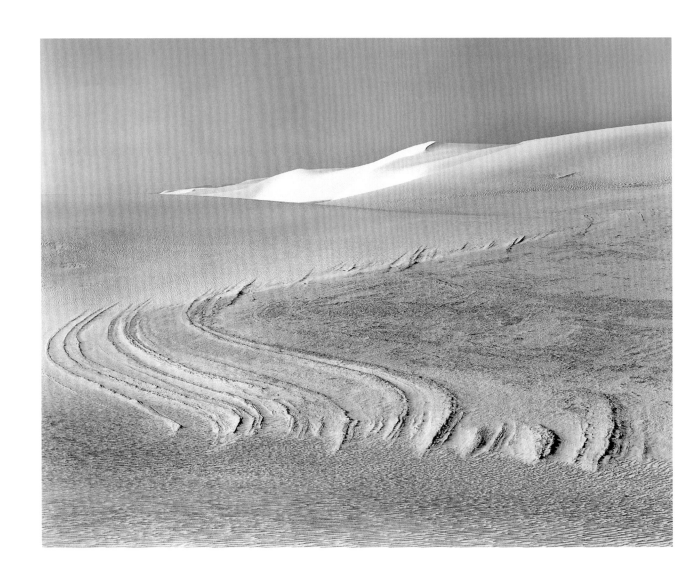

Dunes. Oceano
Dünen. Oceano
Dunes. Oceano
1936

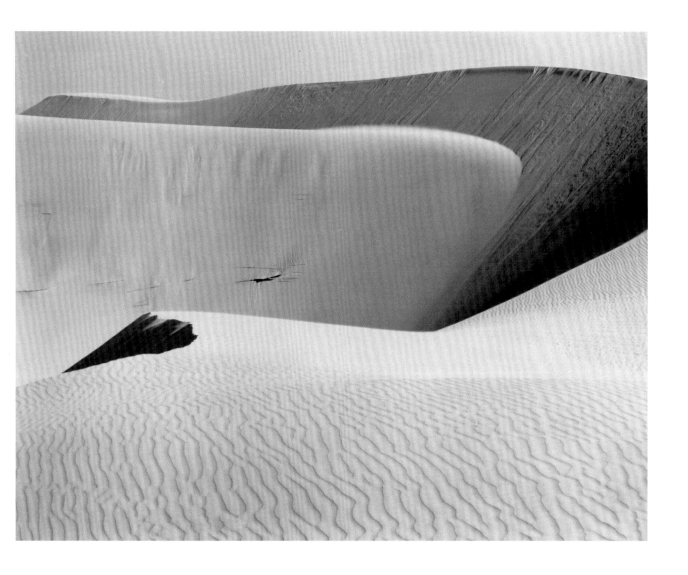

Dunes. Oceano
Dünen. Oceano
Dunes. Oceano
1936

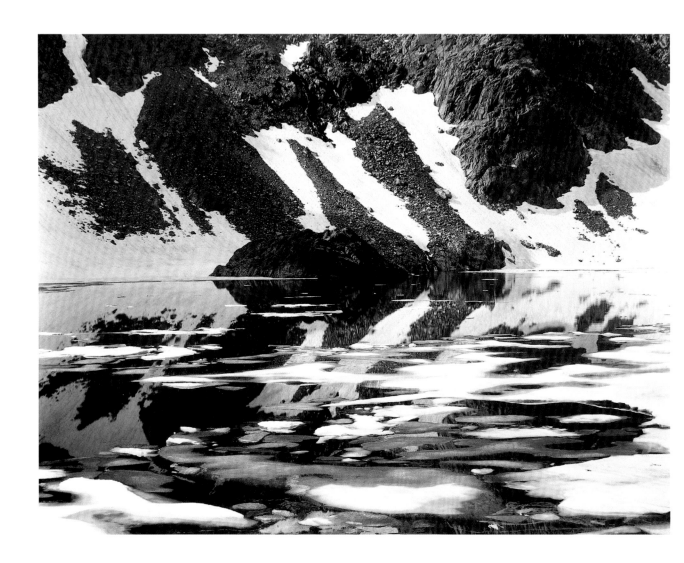

Iceberg Lake
1937

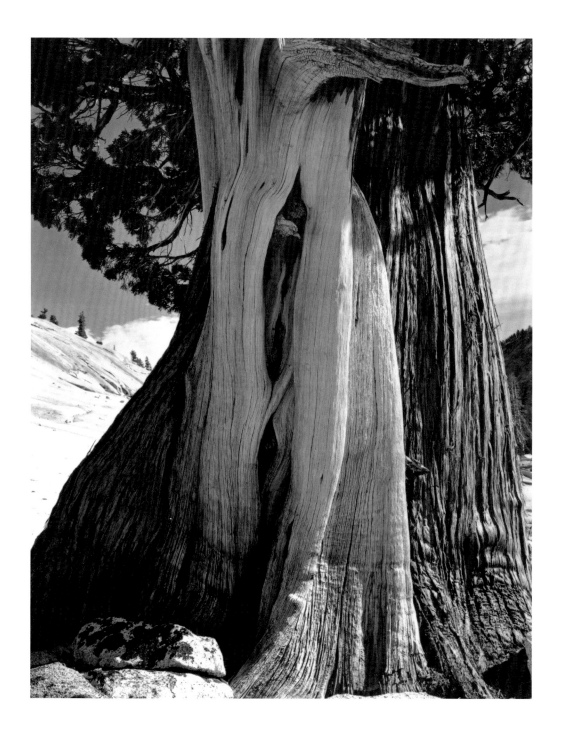

Juniper. Lake Tenaya
Wacholder. Lake Tenaya
Genévrier. Lake Tenaya
1937

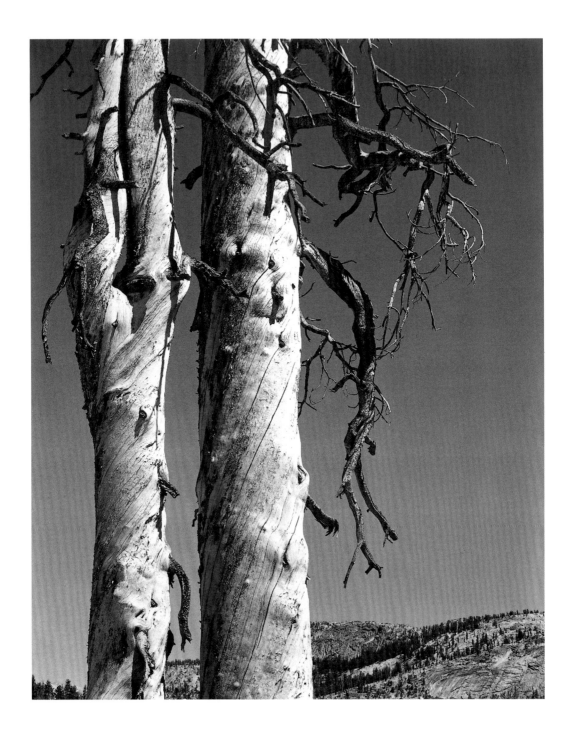

Trees. Lake Tenaya
Bäume. Lake Tenaya
Arbres. Lake Tenaya
1937

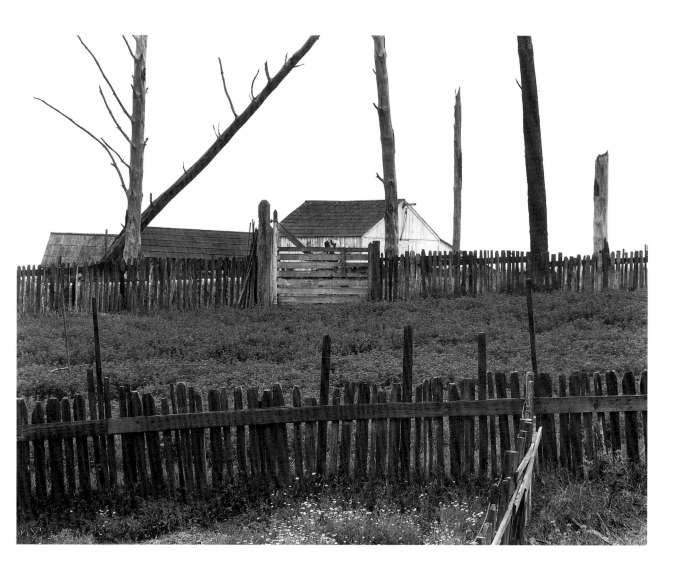

Stewart's Point. North Coast
Stewart's Point. Nordküste
Stewart's Point. Côte nord
1937

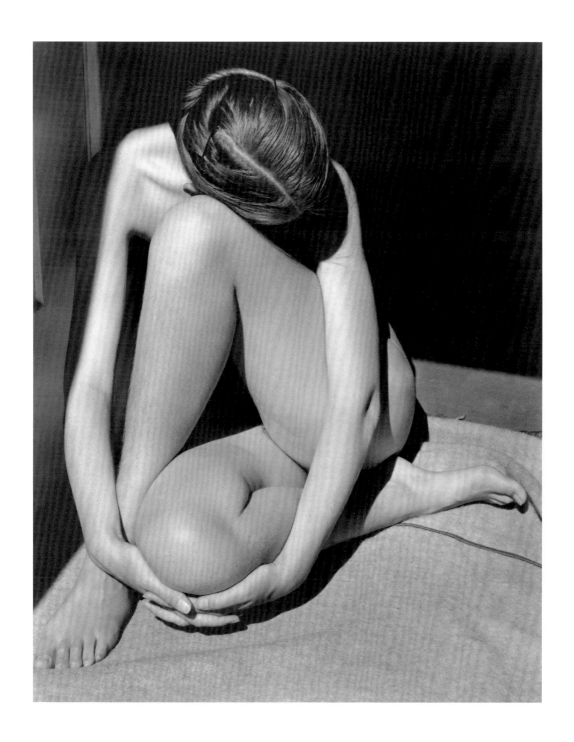

Nude
Akt
Nu
1936

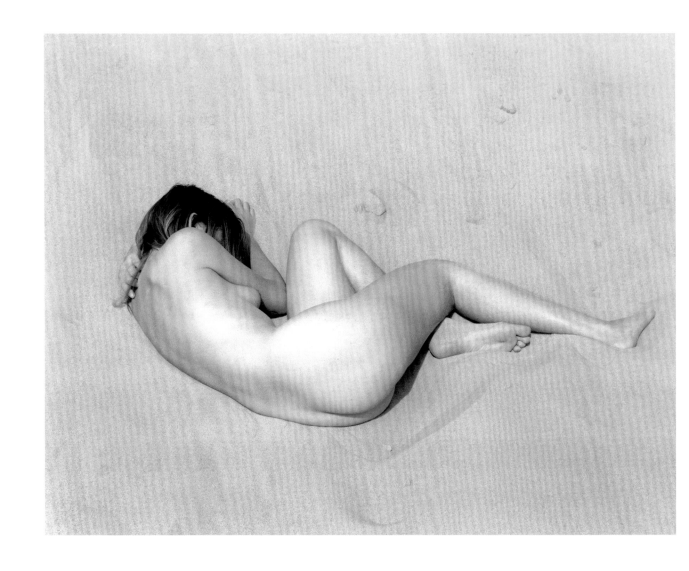

Nude. Oceano
Akt. Oceano
Nu. Oceano
1936

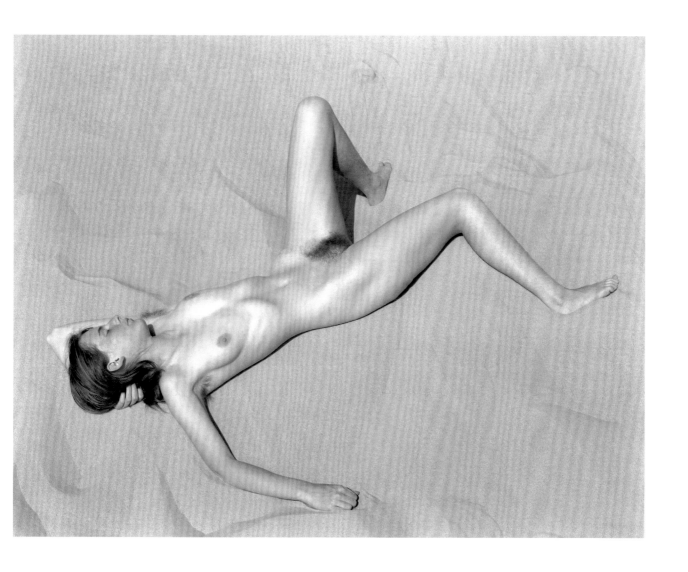

Nude. Oceano
Akt. Oceano
Nu. Oceano
1936

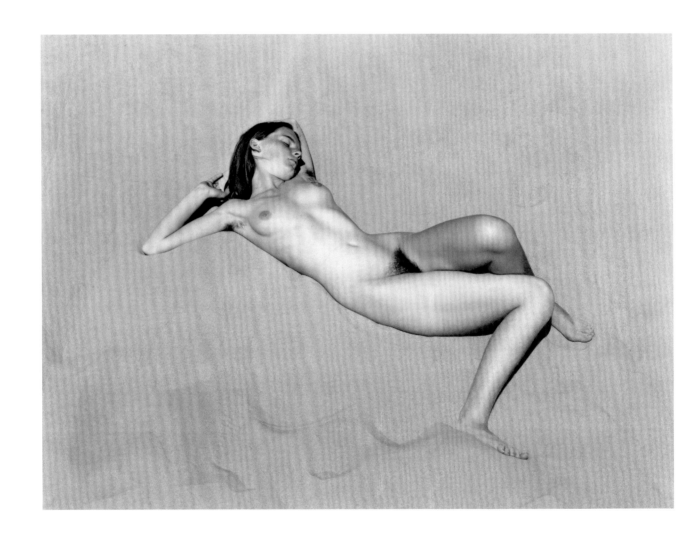

Nude. Oceano
Akt. Oceano
Nu. Oceano
1936

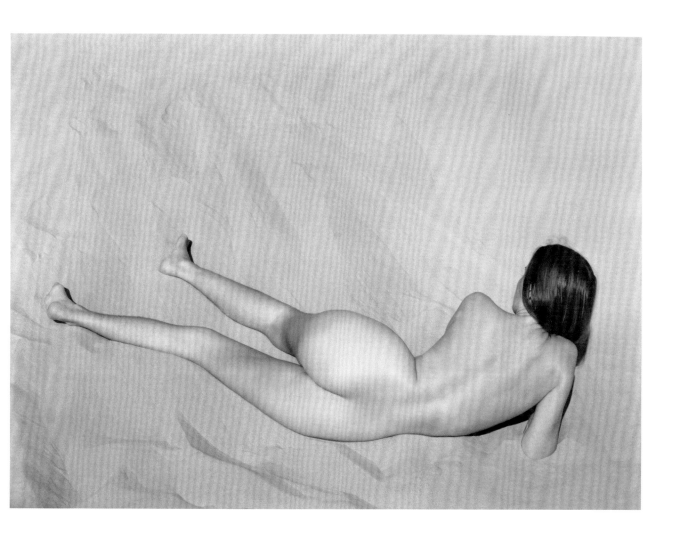

Nude. Oceano
Akt. Oceano
Nu. Oceano
1936

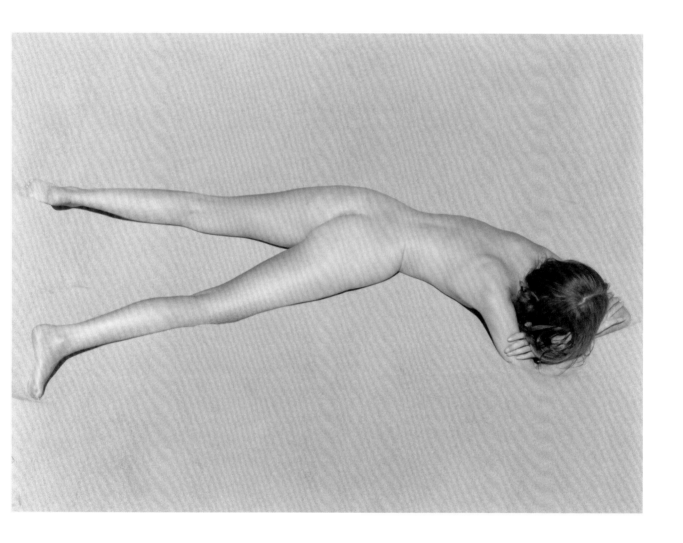

Nude. Oceano
Akt. Oceano
Nu. Oceano
1936

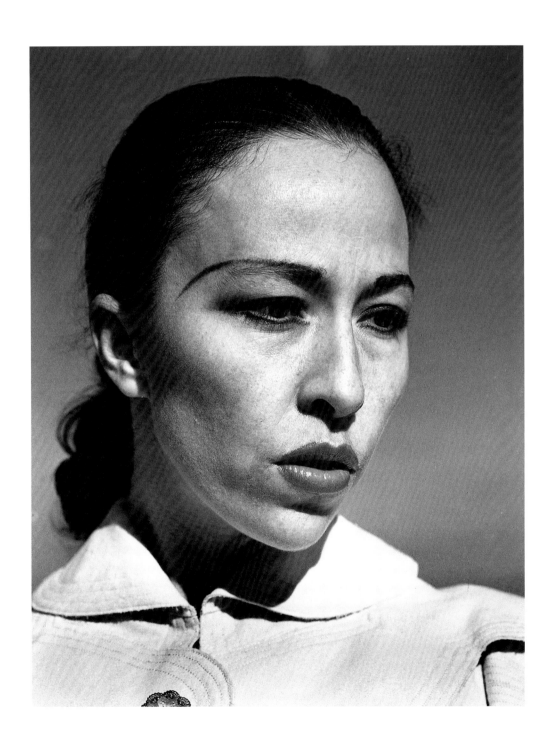

Carmelita Marraci
1937

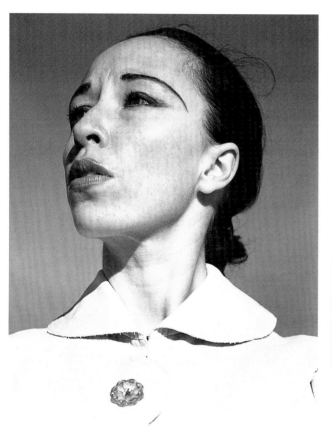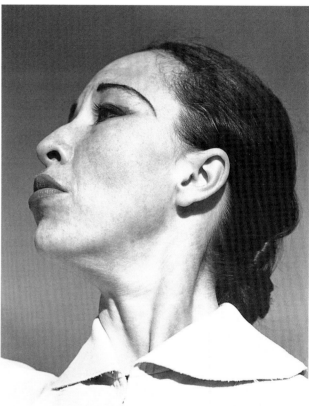

Carmelita Marraci
1937

Moonstone Beach
1937

Tesuque, New Mexico
1937

Wonderland of Rocks
Wunderland der Felsen
Pays merveilleux des rochers
1937

Hill and Telephone Poles
Hügel und Telefonmaste
Colline et pylônes téléphoniques
1937

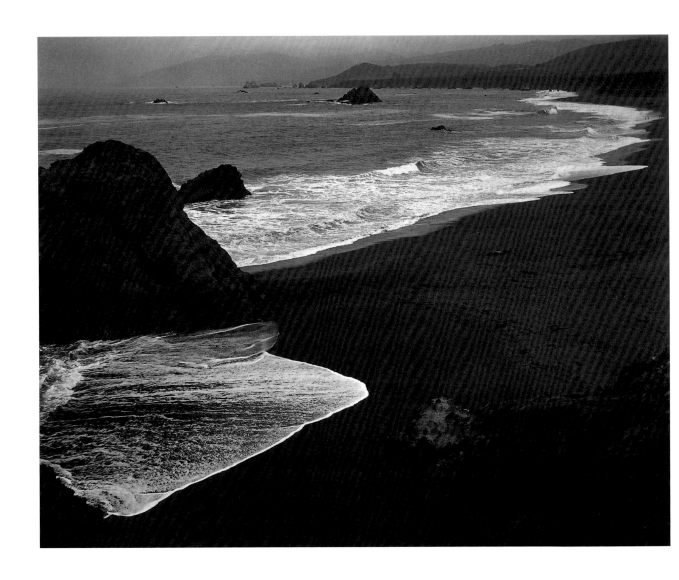

Bodega Coast
1937

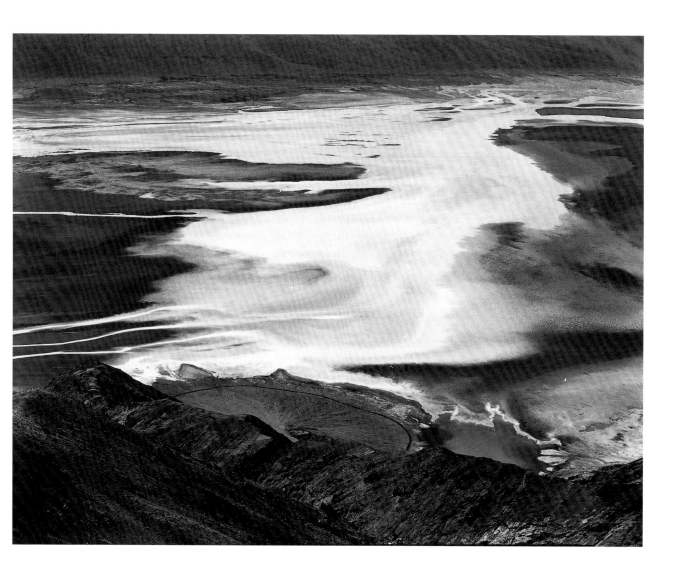

Dante's View. Death Valley
Dantes Aussicht. Death Valley
Vue de Dante. Death Valley
1937

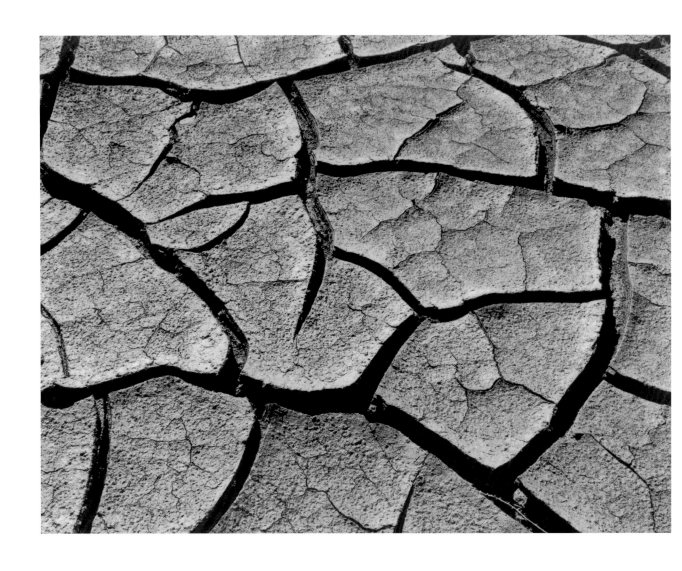

Cracked Earth. Borego Desert
Aufgebrochene Erde. Borego Desert
Terre craquelée. Borego Desert
1938

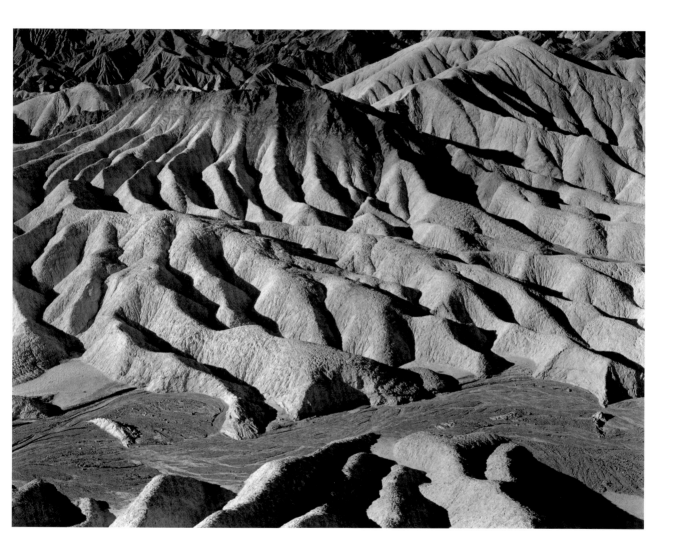

Zabriskie Point. Death Valley
1938

Die Kunst muß etwas Lebendiges haben, das sich auf heutige Bedürfnisse oder künftige Hoffnungen bezieht, denen, die zur Reise bereit sind, die reif sind, aber einen Anstoß brauchen, der ihnen die Augen öffnet, neue Wege eröffnet …

Art must have a living quality which relates it to present needs, or to future hopes, opens new roads for those ready to travel, those who were ripe but needed an awakening shock …

L'art doit avoir une qualité vivante qui le relie aux besoins du présent ou aux espoirs du futur, ouvre de nouvelles voies à ceux qui sont prêts à voyager, à ceux qui sont prêts mais ont besoin d'un choc qui les éveille …

Connecticut Barn
Scheune in Connecticut
Grange du Connecticut
1941

Twenty Mule Team Canyon. Death Valley
1938

Meyer's Ranch
1938

MGM Storage Lot
MGM Lagerplatz
Entrepôt MGM
1939

MGM Storage Lot
MGM Lagerplatz
Entrepôt MGM
1939

MGM Studios
1939

Judge Walker's Gallery. Elk
1939

Church Door. Hornitos, California
Kirchentür. Hornitos, Kalifornien
Porte d'église. Hornitos, Californie
1940

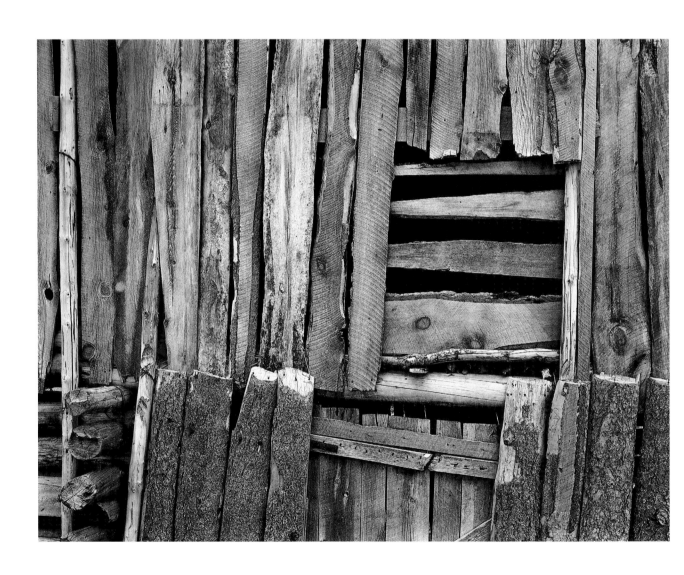

Broken Walls. Las Truchas, New Mexico
Gebrochene Wände. Las Truchas, New Mexico
Murs cassés. Las Truchas, Nouveau-Mexique
1941

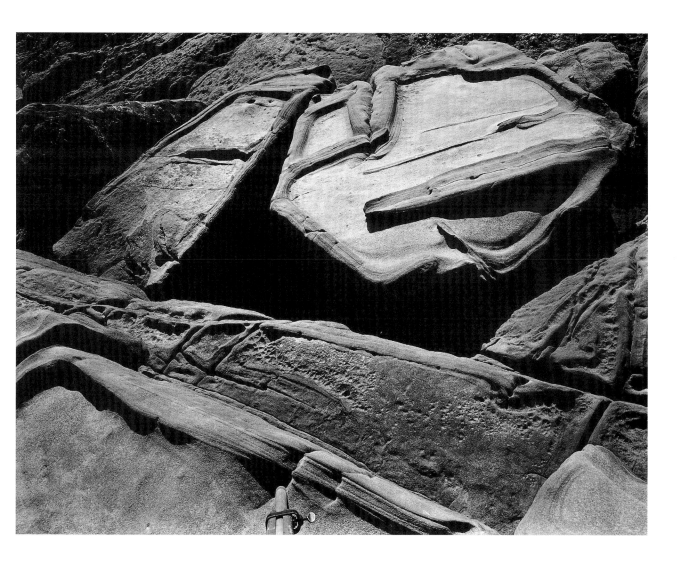

Rock. Point Lobos
Felsen. Point Lobos
Rocher. Point Lobos
1938

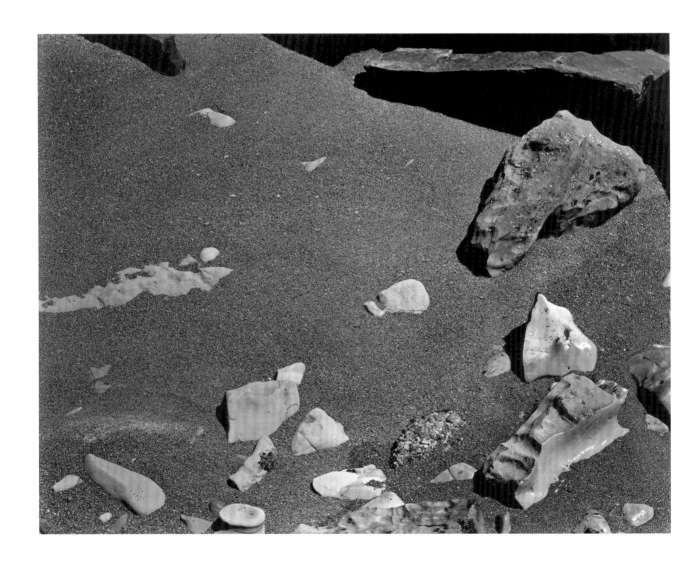

Rocks and Pebbles. Point Lobos
Felsen und Kieselsteine. Point Lobos
Rochers et graviers. Point Lobos
1948

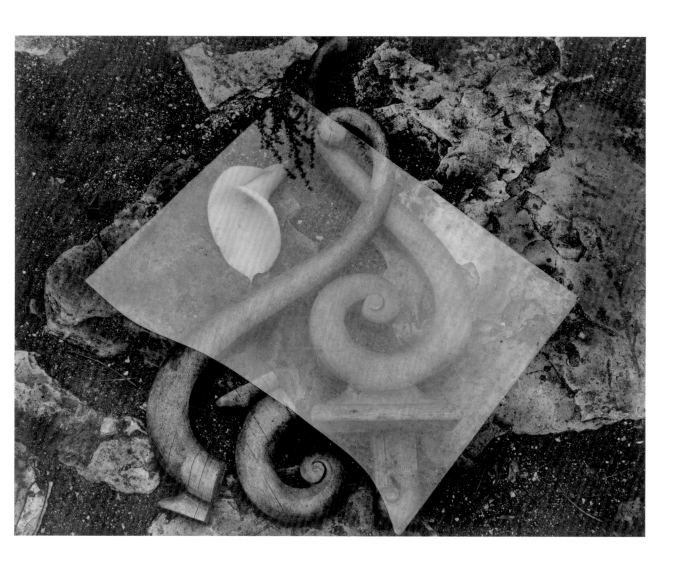

Lily and Rubbish
Lilie und Abfall
Arum et d'échets
1939

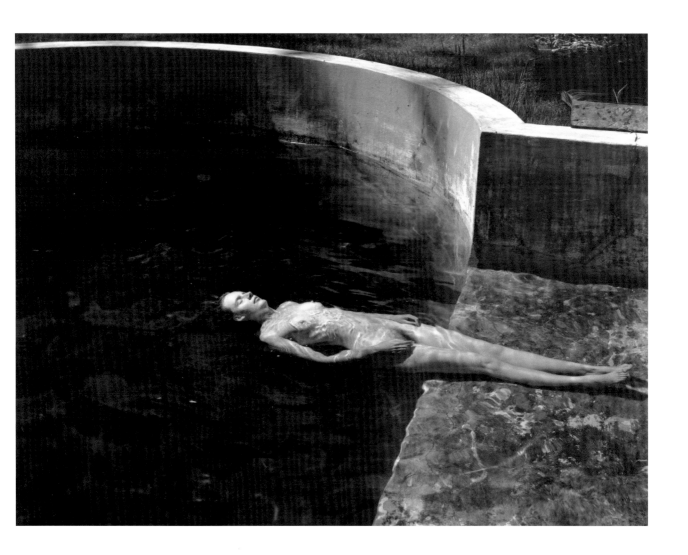

Nude Floating
Schwimmender Akt
Nu flottant
1939

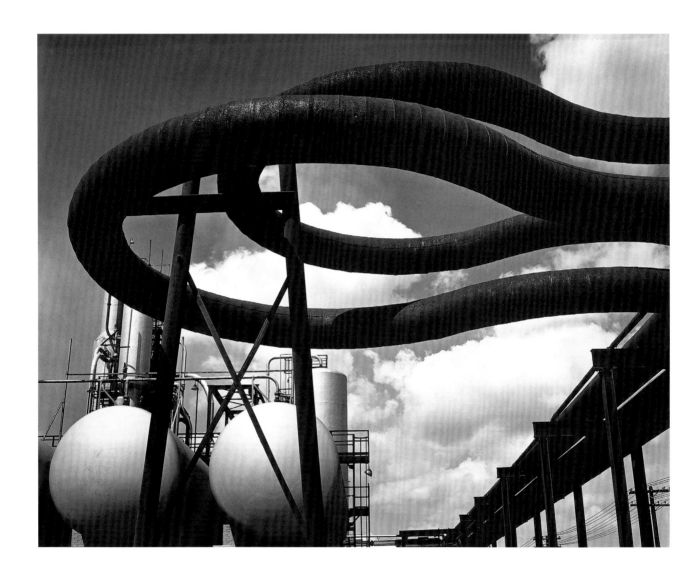

Gulf Oil. Port Arthur, Texas
1941

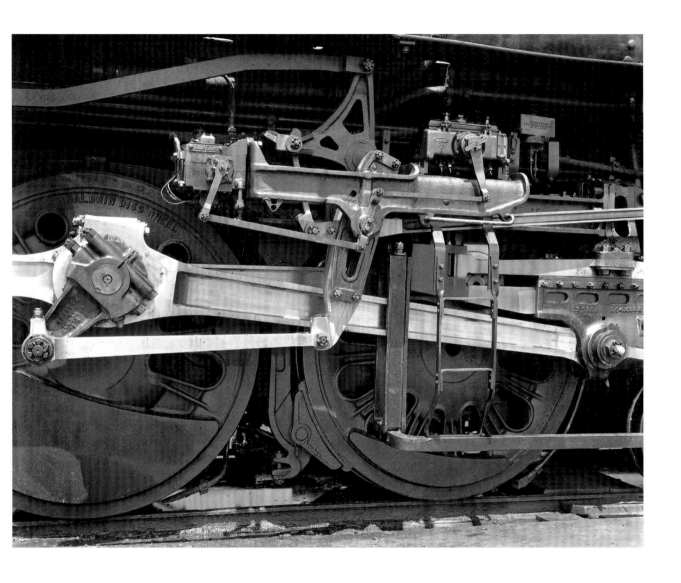

Santa Fe Engine
Santa Fe Lokomotive
Locomotive de Santa Fé
1941

Belle Grove Plantation House. Louisiana
Plantagenhaus in Belle Grove. Louisiana
Maison de planteur à Belle Grove. Louisiane
1941

Taos. New Mexico
1937

Taliesen West. Phoenix, Arizona
1941

Rhyolite. Nevada
1938

Ich versuche nicht mehr, »mich selbst auszudrücken», der Natur meine eigene Persönlichkeit aufzuzwingen. Mir geht es jetzt darum, mich ohne Vorurteil, ohne Verfälschung mit der Natur zu identifizieren, die Dinge wie sie sind, ihr innerstes Wesen zu sehen oder zu erkennen, so daß das, was ich festhalte, keine Interpretation ist - meine Vorstellung davon, was die Natur sein sollte - sondern eine Offenbarung, ein Aufreißen der Nebelwand …

I am no longer trying to " express myself", to impose my own personality on nature, but without prejudice, without falsification, to become identified with nature, to see or know things as they are, their very essence, so that what I record is not an interpretation – my idea of what nature should be – but a revelation, a piercing of the smoke screen …

Je n'essaye plus de «m'exprimer» pour imposer ma personnalité á la nature, mais sans préjugé ni falsification, je tente de m'identifier á la nature, de voir ou de savoir les choses telles qu'elles sont, leur essence même, afin que ce que j'enregistre ne soit pas une interprétation – mon idée de ce que la nature devrait être – mais une révélation, une ouverture dans un écran de fumée …

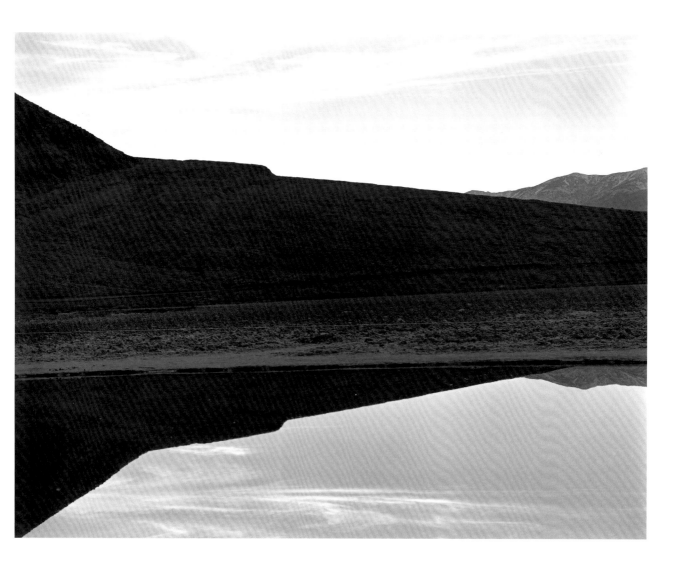

Badwater. Death Valley
1938

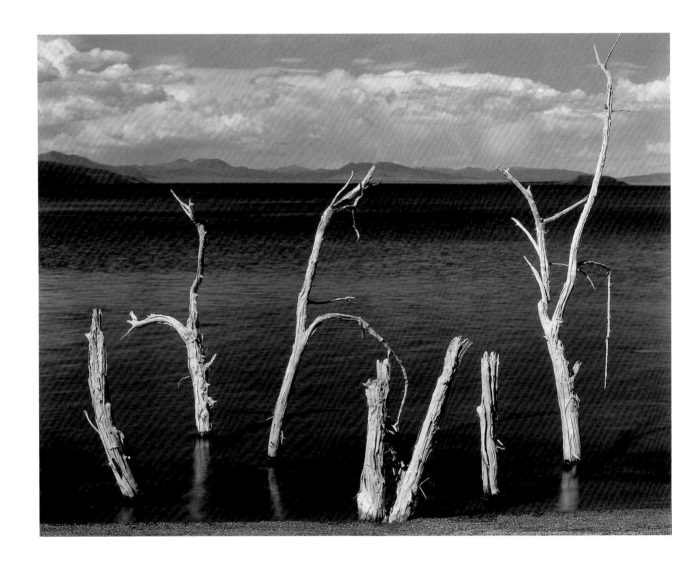

Mono Lake
1937

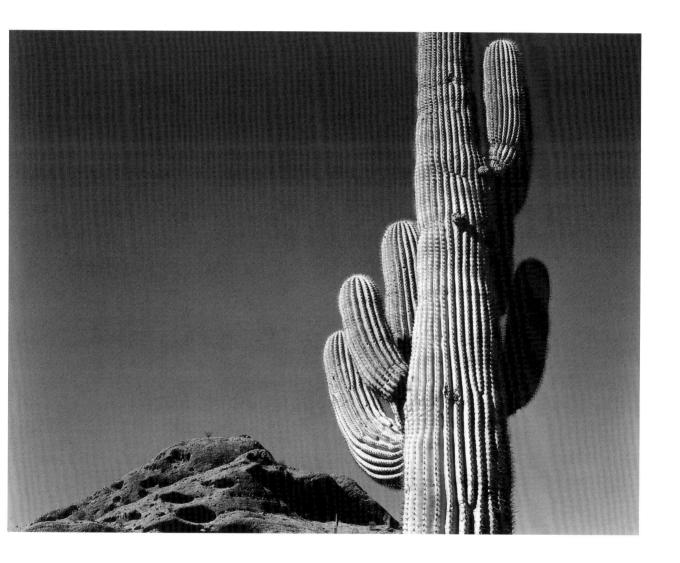

Saguaro. Papago, Arizona
1938

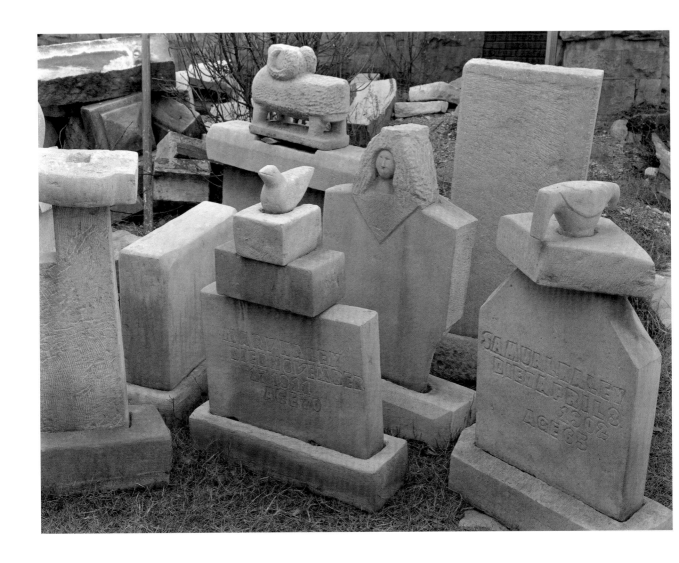

William Edmondson's Sculpture. Nashville, Tennessee
Skulpturen von William Edmondson. Nashville, Tennessee
Sculptures de William Edmondson. Nashville, Tennessee

1941

Leadfield Club
1939

Potato Cellar. Lake Tahoe
Kartoffelkeller. Lake Tahoe
Cave à pommes de terre. Lake Tahoe
1937

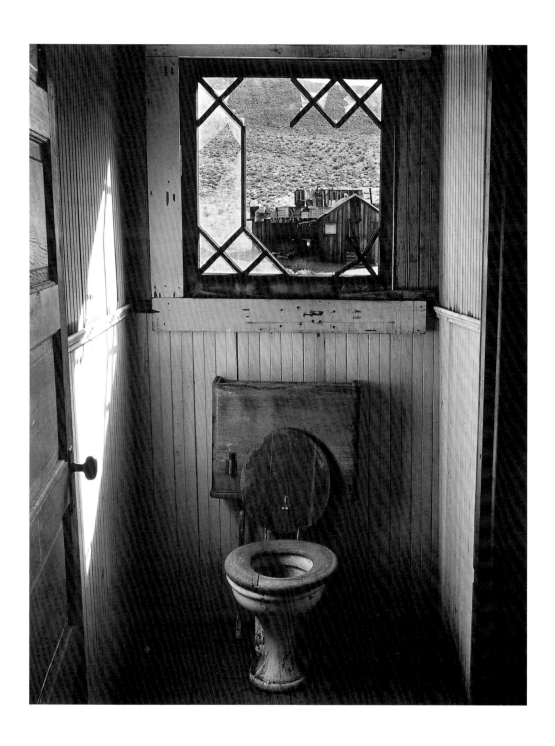

Golden Circle Mine. Death Valley
1939

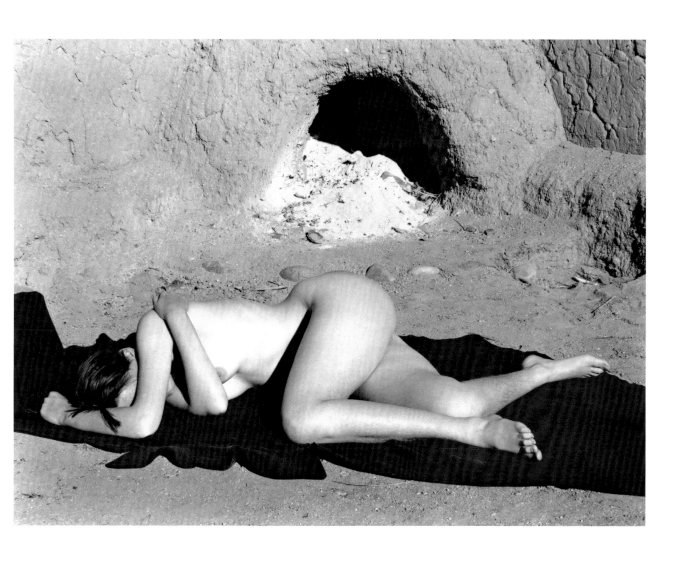

Nude. New Mexico
Akt. New Mexico
Nu. Nouveau-Mexique
1937

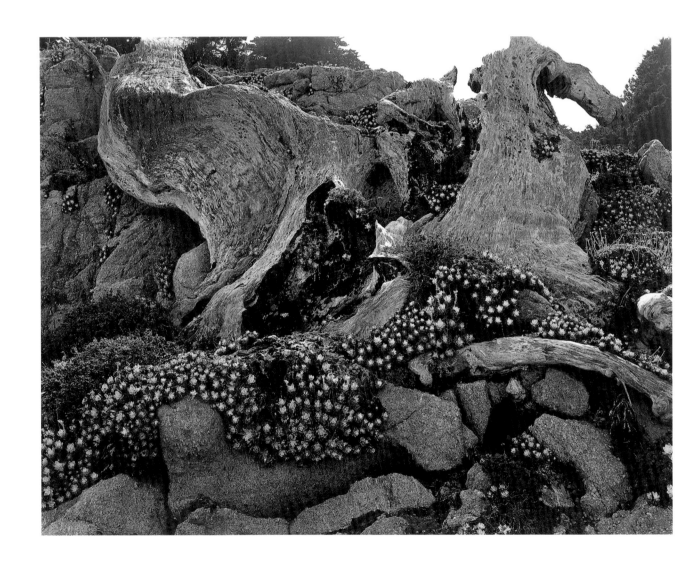

Stonecrop and Cypress. Point Lobos
Steinkraut und Zypresse. Point Lobos
Alysson et cyprès. Point Lobos
1939

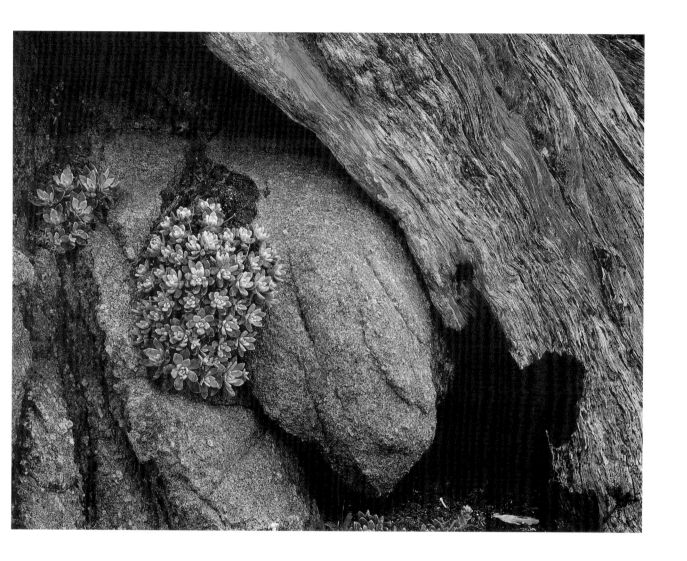

Point Lobos
1941

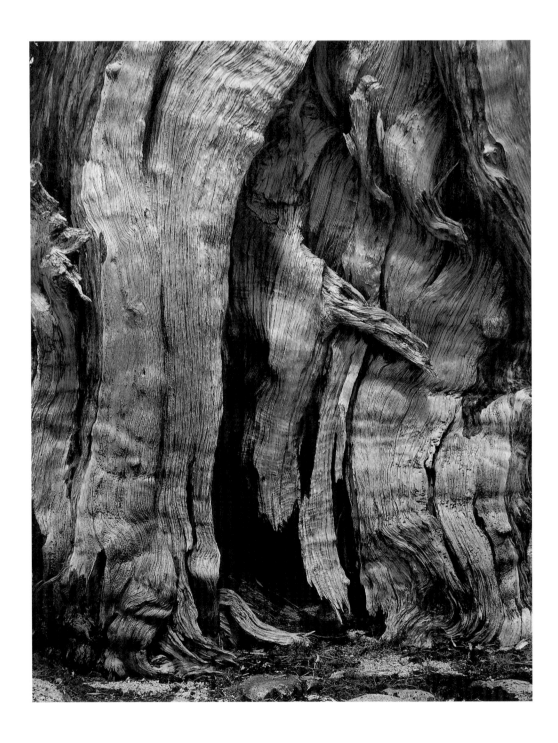

Juniper. Lake Tenaya
Wacholder. Lake Tenaya
Genévrier. Lake Tenaya
1937

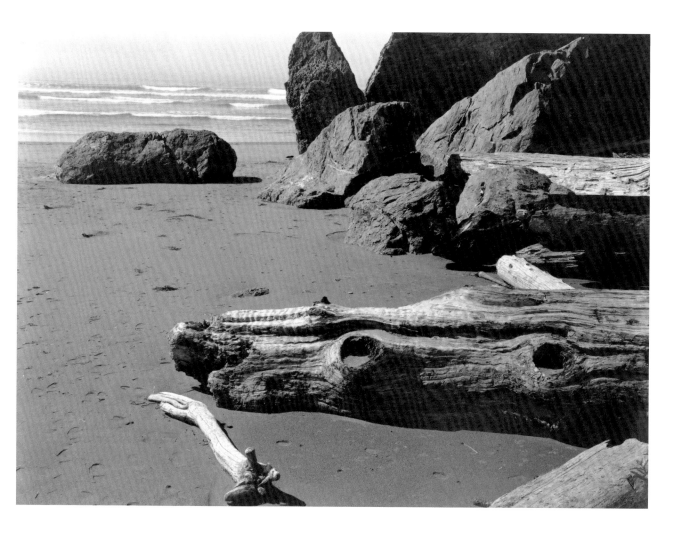

Moonstone Beach
1937

Ich stelle den Künstler nicht als einen kleinen Gott auf ein Podest. Er ist nichts weiter als der Interpret des Unaussprechlichen.

I do not place the artist on a pedestal, as a little god. He is only the interpreter of the inexpressible.

Je ne place pas l'artiste sur un piédestal, comme un petit dieu. Il est seulement l'interprète de l'inexprimable.

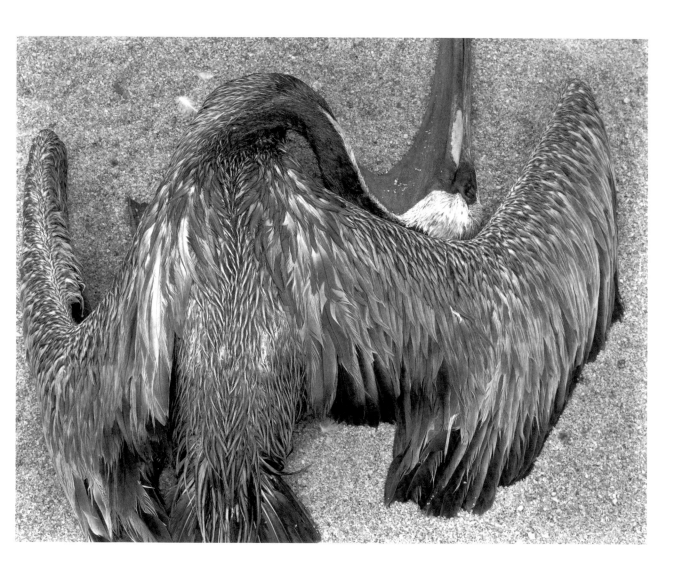

Pelican. Point Lobos
Pelikan. Point Lobos
Pélican. Point Lobos
1942

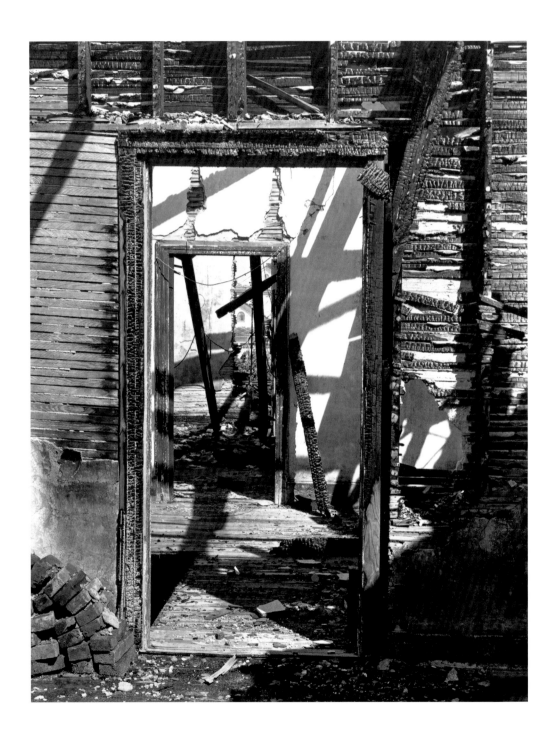

Meraux Plantation House. Louisiana
Plantagenhaus in Meraux. Louisiana
Maison de planteur à Meraux. Louisiane
1941

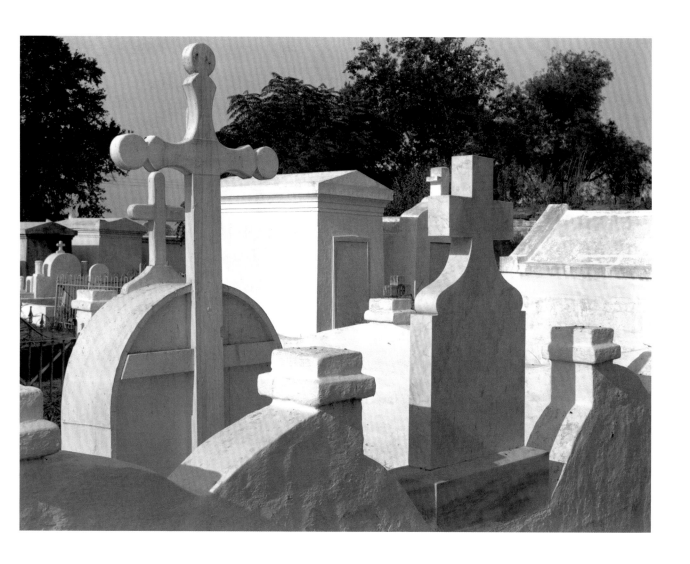

St. Bernard Parish Cemetery. New Orleans, Louisiana
St. Bernard Gemeindefriedhof. Louisiana
Cimetière de la commune St. Bernard. Louisiane
1941

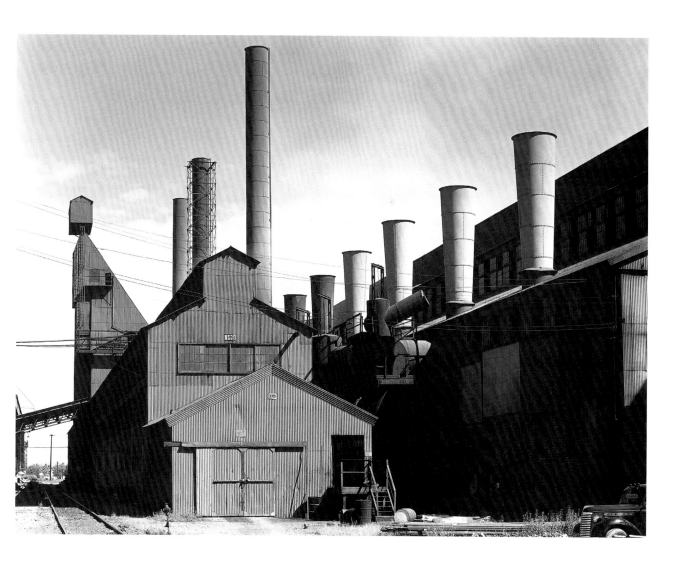

Armco. Middletown, Ohio
1941

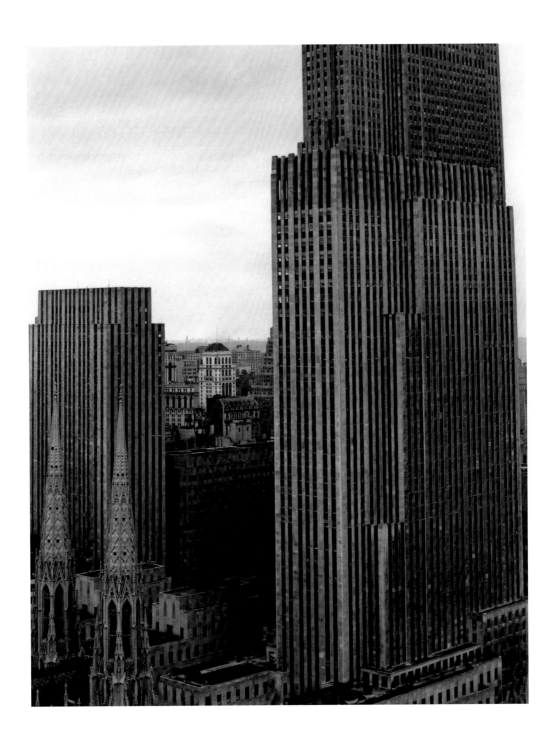

New York
1941

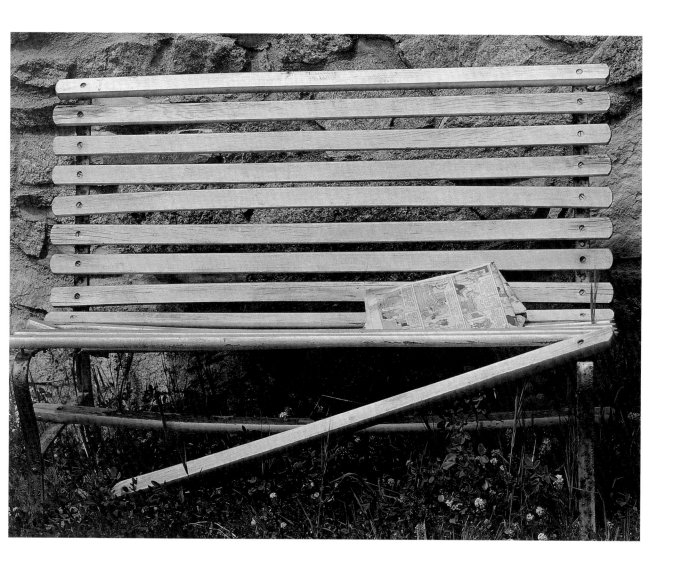

Comics. Elliot Point
1944

Biographie
Biography
Biographie

1886
March 24, born Highland Park, Illinois.

1902
Makes first photographs.

1906
First trip to southern California to visit his sister Mary. Decides to make a career of photography.

1907
Attends Illinois College of Photography.

1908
Moves to southern California and begins to work in the studios of several portrait photographers.

Page of a Daybook Manuscript, June 22, 1930
Seite eines Tagebuchmanuskripts
Page extraite d'un journal

1886
24. März Edward Weston wird in Highland Park, Illinois, geboren.

1902
Er macht seine ersten Photographien.

1906
Er reist zum ersten Mal nach Südkalifornien, um seine Schwester Mary zu besuchen, und beschließt, Photograph zu werden.

1907
Er besucht das Illinois College of Photography.

1908
Er zieht nach Südkalifornien und beginnt in den Studios verschiedener Porträtphotographen zu arbeiten.

1909
Er heiratet Flora Chandler.

1910
Sein Sohn Chandler wird geboren.

1911
Sein Sohn Brett wird geboren. In Tropico, Kalifornien, eröffnet er sein erstes Studio.

1914
Sein Sohn Neil wird geboren.

1919
Sein Sohn Cole wird geboren.

1922
Reise quer durch die Vereinigten Staaten. Besucht seine Schwester Mary in Ohio und photographiert das nahegelegene Armco-Stahlwerk. Reist nach New York City, wo er Alfred Stieglitz, Paul Strand,

1886
24 mars naissance à Highland Park, Illinois.

1902
Prend ses premières photographies.

1906
Premier voyage en Californie du Sud pour rendre visite à sa sœur Mary. Il décide de devenir photographe professionnel.

1907
Suit les cours de l'Illinois College of Photography.

1908
S'installe en Californie du Sud et commence à travailler chez plusieurs photographes portraitistes.

1909
Epouse Flora Chandler.

1910
Naissance de son fils Chandler.

1911
Naissance de son fils Brett. Ouvre son premier studio á Tropico, Californie.

1914
Naissance de son fils Neil.

1919
Naissance de son fils Cole.

1922
Voyage à l'Est. Visite à sa sœur Mary dans l'Ohio et photographies des aciéries d'Armco Steel. Voyages à New York, où il rencontre Alfred Stieglitz, Paul Strand, Georgia O'Keeffe et d'autres artistes importants. S'installe à Mexico avec sa compagne Tina Modotti et son fils Chandler. Il ouvre un studio.

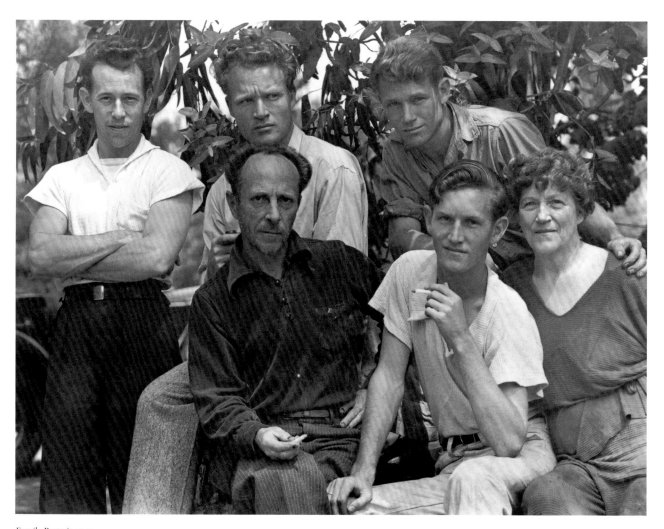

Family Portrait, 1937
Familienporträt
Portrait de famille
Photo: Brett Weston

1909
Marries Flora Chandler.

1910
Son Chandler is born.

1911
Son Brett is born. Opens his first studio in Tropico, California.

1914
Son Neil is born.

1919
Son Cole is born.

1922
Makes cross-country trip. Visits sister Mary in Ohio, and photographs the nearby Armco Steel mill. Travels to New York City, visits Alfred Stieglitz, Paul Strand, Georgia O'Keeffe, and other important artists. Moves to Mexico City with lover Tina Modotti and son Chandler and sets up a studio there.

1925
Revisits southern California for a few months, then returns to Mexico City with Brett instead of Chandler.

1926
Accepts commission along with Tina Modotti to photograph murals, folk arts, and decorative arts for Anita Brenner's book *Idols Behind Altars*. Travels through-out southern Mexico. Returns to live in southern California. Modotti stays in Mexico.

1928
Spends several months in San Francisco and, with son Brett, moves to Carmel, California.

Georgia O'Keeffe und andere wichtige Künstler besucht. Zusammen mit seiner Geliebten Tina Modotti und seinem Sohn Chandler zieht er nach Mexiko-Stadt und eröffnet dort ein Studio.

1925
Nach einem mehrmonatigen Aufenthalt in Südkalifornien kehrt er - diesmal mit seinem Sohn Brett - nach Mexiko-Stadt zurück.

1926
Zusammen mit Tina Modotti nimmt er den Auftrag an, für Anita Brenners Buch *Idols Behind Altars* Wandgemälde, Volkskunst und dekorative Kunstobjekte zu photographieren. Er reist quer durch Südmexiko. Er läßt sich wieder in Südkalifornien nieder. Modotti bleibt in Mexiko.

1928
Er verbringt einige Monate in San Francisco und zieht zusammen mit seinem Sohn Brett nach Carmel, Kalifornien.

1929
Er beteiligt sich an der Ausstellung *Film und Foto* in Stuttgart und betreut den Teil der Ausstellung, der den Photographen von der amerikanischen Westküste gewidmet ist. Er geht eine Lebensgemeinschaft mit der Photographin Sonya Noskowiak ein [bis 1934].

1930
In der Galerie »Delphic Studio« hat er seine erste Einzelausstellung in New York City.

1932
The Art of Edward Weston, das erste Buch über ihn, wird veröffentlicht. Er beteiligt sich an der Ausstellung der Gruppe »f/64« im MH de Young Museum in San Francisco.

1925
Parcourt la Californie du Sud pendant quelques mois, puis retourne à Mexico, accompagné cette fois de son fils Brett.

1926
Il photographie avec Tina Modotti des fresques, des objets d'art populaire et décoratif pour le livre d'Anita Brenner *Idols Behind Altars*. Voyage dans le sud du Mexique. Revient vivre en Californie du Sud. Tina Modotti reste au Mexique.

1928
Séjourne plusieurs mois à San Francisco et s'installe à Carmel, en Californie, avec son fils Brett.

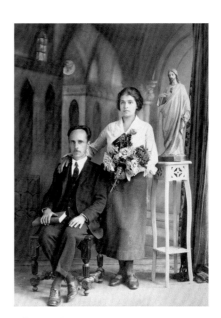

Edward and Tina in Mexico, 1934
Photographer unknown

1929

Exhibits in *Film und Foto* [Stuttgart] and curates the West Coast portion of the exhibition. Begins living with photographer Sonya Noskowiak [until 1934].

1930

Has first one-man-exhibition in New York City at Delphic Studios.

1932

Publication of first book, *The Art of Edward Weston*. Participates in Group f/64 exhibition, MH de Young Museum, San Francisco.

1933

First trip to New Mexico.

1934

Is employed briefly as a photographer for the Public Works of Art Project, a federal project. Falls in love with Charis Wilson.

1935

Moves back to Santa Monica in southern California. Charis follows and moves in.

1937

Receives first fellowship ever awarded to a photographer by the John Simon Guggenheim Foundation. Begins traveling and photographing extensively with Charis in California and other western states.

1938

Receives second fellowship from the Guggenheim Foundation. Commissions son Neil to build a home – known as "Wildcat Hill" – in Carmel Highlands.

1933

Er reist zum ersten Mal in den Bundesstaat New Mexico.

1934

Für kurze Zeit wird er als Photograph für das Public Works of Art Project engagiert, ein Beschäftigungsprogramm der Regierung für Künstler. Er verliebt sich in Charis Wilson.

1935

Er zieht nach Santa Monica in Südkalifornien. Charis folgt ihm nach und zieht zu ihm.

1937

Die John Simon Guggenheim Foundation zeichnet ihn als ersten Photographen mit einem Fellowship

Zohma and Jean Charlot, 1939
Photo: Edward Weston

Brett and Point Lobos, 1942
Photo: Edward Weston

1929

Présent à l'exposition *Film und Foto* [Stuttgart], pour laquelle il s'occupe de la participation californienne. Vit avec la photographe Sonya Noskowiak [jusqu'en 1934].

1930

Première exposition personnelle à New York, aux Delphic Studios.

1932

Publication de son premier livre, *The Art of Edward Weston*. Participe à l'exposition du Group f/64 au MH de Young Museum, à San Francisco.

1933

Premier voyage au Nouveau-Mexique.

1934

Travaille brièvement pour le Public Works of Art Project, un programme culturel fédéral. S'éprend de Charis Wilson.

1935

Revient s'installer à Santa Monica, Californie, en compagnie de Charis.

1937

Reçoit la première bourse jamais accordée à un photographe par la John Simon Guggenheim

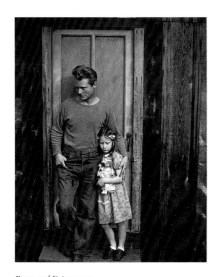

Brett and Erica, 1945
Photo: Edward Weston

1939
Officially divorces Flora and marries Charis.

1940
California and the West published, using photographs from the Guggenheim trips and text by Charis.

1941
Commissioned by the Limited Editions Club to make photographic illustrations for Walt Whitman's *Leaves of Grass*. Travels across the United States until the Japanese bombing of Pearl Harbor forces him to return to California.

1946
Receives the largest retrospective of his lifetime at the Museum of Modern Art, New York. Is divorced by Charis.

aus. Zusammen mit Charis unternimmt er zahlreiche Reisen durch Kalifornien und andere Staaten im Westen, um Landschaften zu photographieren.

1938
Er erhält ein zweites Fellowship von der Guggenheim Foundation. Er beauftragt seinen Sohn Neil, in den Carmel Highlands ein Haus, das später als »Wildcat Hill« bekannt wird, für ihn zu bauen.

1939
Er läßt sich offiziell von Flora scheiden und heiratet Charis.

1940
Das Buch *California and the West* wird veröffentlicht. Es enthält Photographien, die auf den mit den Guggenheim-Stipendien finanzierten Reisen aufgenommen wurden, und einen Text von Charis.

1941
Der Limited Editions Club beauftragt ihn, Walt Whitmans *Leaves of Grass* mit Photographien zu illustrieren. Er reist quer durch die Vereinigten Staaten, bis ihn die Bombardierung Pearl Harbors durch die Japaner zwingt, nach Kalifornien zurückzukehren.

1946
Das Museum of Modern Art in New York richtet die größte Retrospektive seines Werks zu seinen Lebzeiten aus. Er wird von Charis geschieden.

1947
Er experimentiert mit der Farbphotographie.

1948
Er leidet an der Parkinsonschen Krankheit und nimmt seine letzten Photographien auf. Willard Van Dyke dreht über ihn den Dokumentarfilm *The Photographer*.

Foundation. Commence à voyager et à photographier de façon intense en compagnie de Charis, en Californie et dans d'autres Etats de l'Ouest.

1938
Reçoit une second bourse de la Fondation Guggenheim. Demande à son fils Neil de lui construire une maison – appelée Wildcat Hill – dans les hautes terres de Carmel.

1939
Divorce officiellement de Flora et épouse Charis.

1940
Publie *California and the West*, à partir des photos prises grâce aux bourses Guggenheim. Les textes sont de Charis.

1941
Reçoit commande du Limited Editions Club de l'illustration photographique de *Leaves of Grass* de Walt Whitman. Parcourt les Etats-Unis jusqu'à ce que le bombardement de Pearl Harbour par les Japonais l'oblige à rentrer en Californie.

1946
Est l'objet de la plus importante rétrospective de sa vie au Museum of Modern Art, New York. Divorce de Charis.

1947
Expériences de la photographie en couleurs.

1948
Souffre de la maladie de Parkinson. Réalise ses dernières photographies. Il est le sujet d'un film documentaire de Willard van Dyke, *The Photographer*.

1947
Experiments with color photography.

1948
Afflicted with Parkinson's Disease, makes final photographs. Is the subject of a documentary film by Willard Van Dyke called The Photographer.

1952
Under his supervision, a Fiftieth Anniversary Portfolio of twelve original prints is produced. Embarks on a project with son Brett and others to oversee the printing of more than 800 of his favorite photographs.

1958
January 1, Edward Weston dies at Wildcat Hill

1952
Anläßlich seines 50. Jahrestags als Photograph entsteht unter seiner Aufsicht eine *Fiftieth Anniversary Mappe* mit zwölf Originalabzügen. Zusammen mit seinem Sohn Brett und anderen Assistenten nimmt er das Projekt in Angriff, »autorisierte« Abzüge von mehr als 800 seiner Lieblingsphotographien machen zu lassen.

1958
1. Januar Edward Weston stirbt in Wildcat Hill.

1952
Production, sous sa direction, du *Fiftieth Anniversary Portfolio* de douze tirages originaux. Avec son fils Brett et d'autres, il entame un projet de tirage de plus de 800 de ses photographies favorites.

1958
Edward Weston meurt le 1er janvier à Wildcat Hill.

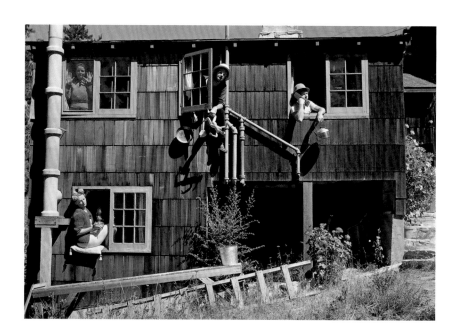

Exposition of Dynamic Symmetry, 1943
Photo: Edward Weston

Bibliography
Bibliographie
Bibliographie

Books by Edward Weston
Bücher von Edward Weston
Livres d'Edward Weston

1932
Merle Armitage.
The Art of Edward Weston.
New York: E. Weyhe

1940
Edward Weston and Charis Wilson.
California and the West.
New York: Duell, Sloan and Pearce

1932
Walt Whitman. Leaves of Grass.
New York: Limited Editions Club
[with photographs by Edward Weston]

1940
Merle Armitage.
Fifty Photographs: Edward Weston.
New York: Duell, Sloan and Pearce

Books on Edward Weston
Bücher über Edward Weston
Livres sur Edward Weston

1983
Peter C. Bunnell.
Edward Weston on Photography.
Salt Lake City: Peregrine
Smith Books

1986
Beaumont Newhall. Supreme Instants:
The Photography of Edward Weston.
Boston: Little, Brown & Co.

1992
Terence Pitts. *Edward Weston:*
Color Photography.
Tucson: Center for
Creative Photography

1993
Amy Conger. *Edward Weston:*
Photographs from the Collection of
the Center for Creative Photography.
Tucson, Center for Creative Photography

1994
Edward Weston: Nudes.
New York: Aperture, 1993.

1995
Karen E. Quinn, et al. *Weston's Westons*:
California and the West.
Boston: Bulfinch Press

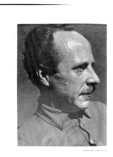

1995
Gilles Mora, editor. *Edward Weston*:
Forms of Passion.
New York: Harry N. Abrams

Cole Weston.
Portraits by Edward Weston.
New York: Aperture

1996
The Daybooks of Edward Weston.
New York: Aperture, 1996. 2 vol.

1998
Charis Wilson. *Through Another Lens:*
My Years With Edward Weston.
San Francisco: North Point Press

Note to the reader:

Text pp. 12-41: All quotations are taken from "The Daybooks of Edward Weston", except for the excerpt from the "Statement" that he wrote for the 1929 catalog "Film und Foto", which can be found in Peter Bunnell, "Edward Weston on Photography".
See the bibliography for references to these publications.

Anmerkung:

Text S. 12-41: Bis auf den in Peter Bunnell, »Edward Weston on Photography«, zu findenden Auszug aus dem »Statement«, das er 1929 für den Katalog zur Ausstellung »Film und Foto« schrieb, entstammen alle Zitate »The Daybooks of Edward Weston«. Nähere Angaben zu diesen Veröffentlichungen finden sich in der Bibliographie.

Note:

Texte pp. 12-41: Toutes les citations ont été empruntées à l'édition du Journal de Weston, à l'exception du texte rédigé pour le catalogue de l'exposition « Film und Foto » de 1929, qui se trouve dans l'ouvrage de Peter Bunnel, « Edward Weston on Photography ».
Voir la bibliographie pour les références de ces publications.

Front cover: *Shells, 1927*
Back cover: *Nude, 1936*

To stay informed about upcoming TASCHEN titles, please request our magazine at www.taschen.com or write to TASCHEN, Hohenzollernring 53, D–50672 Cologne, Germany, Fax: +49-221-254919. We will be happy to send you a free copy of our magazine which is filled with information about all of our books.

© 2004 TASCHEN GmbH
Hohenzollernring 53, D-50672 Köln
www.taschen.com
Original edition: © 1999 Benedikt Taschen Verlag GmbH
Editor: Manfred Heiting, Amsterdam
Layout: Manfred Heiting, Amsterdam
Editorial coordination: Bettina Ruhrberg, Ute Kieseyer, Cologne
Conception of the photo series: Manfred Heiting, Amsterdam,
and Simone Philippi, Cologne
Translation: German translation by Wolfgang Himmelberg, Düsseldorf
French translation by Jacques Bosser, Paris
Typography and cover design: Sense/Net,
Andy Disl and Birgit Reber, Cologne
Photographs by Edward Weston,
Collection Center for Creative Photography, University of Arizona
© 2004 Center for Creative Photography, Arizona Board of Regents
© Text: 1999 Terence Pitts
© Text by Ansel Adams. Used with permission of the Trustees
of The Ansel Adams Publishing Rights Trust. All Rights Reserved.

Printed in Italy
ISBN 3-8228-3486-6